LUMINIST HORIZONS

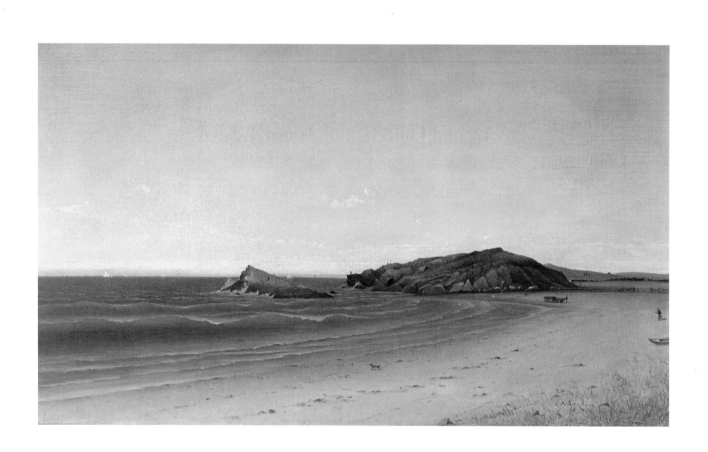

LUMINIST HORIZONS

The Art and Collection of James A. Suydam

KATHERINE E. MANTHORNE AND
MARK D. MITCHELL

INTRODUCTION BY ANNETTE BLAUGRUND

National Academy Museum and School of Fine Arts
NEW YORK

George Braziller, Publishers
NEW YORK

Published on the occasion of the exhibition "Luminist Horizons: The Art and Collection of James A. Suydam" organized by the National Academy Museum and School of Fine Arts (National Academy of Design).

The exhibition and this publication are funded with the generous support of the Henry Luce Foundation, the National Endowment for the Arts, the Lucelia Foundation, the Robert Lehman Foundation, The Brown Foundation, Inc., of Houston, and Furthermore: a program of the J. M. Kaplan Fund.

EXHIBITION ITINERARY

The National Academy Museum (New York, New York)
September 14, 2006–December 31, 2006

The Taft Museum of Art (Cincinnati, Ohio)
January 26, 2007–April 29, 2007

The Hyde Collection (Glens Falls, New York)
June 3, 2007–September 16, 2007

The Telfair Museum of Art (Savannah, Georgia)
October 9, 2007–January 6, 2008

Published in 2006 by George Braziller, Inc., New York

For information, please address the publisher:
George Braziller, Inc.
171 Madison Avenue
New York, New York 10016

Library of Congress Cataloguing-in-Publication Data:

Manthorne, Katherine.
Luminist horizons : the art and collection of James A. Suydam / Katherine E. Manthorne and Mark D. Mitchell ; introduction by Annette Blaugrund.
 p. cm.
Published on the occasion of the exhibition "Luminist Horizons: The Art and Collection of James A. Suydam" held at the National Academy Museum (New York, New York) Sept. 14–Dec. 31, 2006, the Taft Museum of Art (Cincinnati, Ohio) Jan. 26–Apr. 29, 2007, The Hyde Collection (Glens Falls, New York) June 3–Sept. 16, 2007, and the Telfair Museum of Art (Savannah, Georgia) Oct. 9, 2007–Jan. 6, 2008.
Includes bibliographical references.
ISBN-13: 978-0-8076-1573-7 (hardcover)
ISBN-10: 0-8076-1573-0 (hardcover)
ISBN-13: 978-1-887149-15-0 (NAD hardcover)
ISBN-10: 1-887149-15-5 (NAD hardcover)
ISBN-13: 978-1-887149-16-7 (NAD paperback)
ISBN-10: 1-887149-16-3 (NAD paperback)
1. Suydam, James Augustus, 1819-1865—Exhibitions. 2. Landscape in art—Exhibitions. 3. Painting, American—19th century—Exhibitions. 4. Painting, European—19th century—Exhibitions. I. Suydam, James Augustus, 1819-1865. II. Mitchell, Mark DeSaussure, 1975– III. National Academy of Design (U.S.) IV. Taft Museum of Art. V. Telfair Museum of Art. VI. The Hyde Collection. VII. Title.
 ND237.S935A4 2006
 758'.109730740153—dc22
2006012359

Frontispiece: James A. Suydam (1819–1865), *On the Beach, Newport,* 1864, oil on canvas, 18 x 30 inches, Collection of Erving and Joyce Wolf.

Designed by Rita Lascaro

Printed and bound in Singapore
First edition

CONTENTS

Acknowledgments

IF IT WERE NOT FOR FOUNDATIONS AND DONORS loyal to the National Academy and its goal of promoting American art with outstanding exhibitions and scholarly books, we could not maintain the standard of excellence for which we strive. In that regard, we thank the Robert Lehman Foundation for their lead gift to *Luminist Horizons: The Art and Collection of James A. Suydam*; the Henry Luce Foundation, in particular the late Henry Luce III and Program Director for the Arts Ellen Holtzman, for their generous support; the National Endowment for the Arts; the Lucelia Foundation for their ongoing support of our catalogues, in particular Elizabeth Gosnell Miller; The Brown Foundation, Inc., of Houston; and Joan Davidson of Furthermore: a program of the J. M. Kaplan Fund.

For the quality and elegance of this book, our deepest appreciation goes to our publisher George Braziller and his staff, particularly editor Elizabeth Monroe and designer Rita Lascaro. The staff of the National Academy also deserves special thanks: Jean Telljohann, Development Director; Anna Martin, Registrar, and Paula Pineda, Associate Registrar and Coordinator of Rights & Reproduction; Lucie Kinsolving, Chief Conservator, and Nadia Ghannam, Associate Conservator, for all the work they did to restore the Suydam Collection and their work on the exhibition's installation; Charles Biada, Facilities Director; Jonah Ellis, Building Manager; Christine Williams, Communications Director; and the security staff and art handlers. The curators and I would like to thank Daniel Kershaw for his wonderful work in designing the exhibition. We could not successfully do what we do without all of these people who work so diligently behind the scenes.

—Annette Blaugrund

In addition, Mark D. Mitchell and Katherine E. Manthorne offer these special thanks:

I extend my thanks to scholars John Wilmerding and Barbara Novak, who helped to frame the questions and intellectual project of the book and accompanying exhibition during its early planning. I extend particular appreciation to Annette Blaugrund and Katherine E. Manthorne for their support and encouragement throughout the project. I would also like to acknowledge the vital research assistance of colleagues in museums and libraries around the country: Judy Throm and staff, Archives of American Art, Smithsonian Institution; Joanna Schoff, Bartow-Pell Mansion Museum; Jonathan Harding, the Century Association; Sarah Cash and Emily Shapiro, Corcoran Gallery of Art; Barbara MacAdam, Hood Museum of Art, Dartmouth College; Annette Schlagenhauff, Indianapolis Museum of Art; Kevin J. Avery, The Metropolitan Museum of Art; Elliot Bostwick

Davis, Museum of Fine Arts, Boston; Franklin Kelly, National Gallery of Art; Kenneth Maddox, Newington-Cropsey Foundation; Burt Lippincott and staff, Newport Historical Society; Linda Ferber and staff, New-York Historical Society; Christopher Gray, The New York Times; Evan Friss and Maneesha Patel, New York University Archives; Katherine Foster and staff, Philadelphia Museum of Art; Paul Miller and John Tschirch, The Preservation Society of Newport County; Lisa Long and staff, Redwood Library & Athenaeum; John Davis, Smith College; Anthony Janson, University of North Carolina, Wilmington; and Elizabeth Kornhauser, Wadsworth Atheneum Museum of Art. Lynne Ambrosini, Chief Curator at the Taft Museum of Art, Randall Suffolk, Director and Erin Budis Coe, Curator at the Hyde Collection, and Holly Koons McCullough, Curator of Fine Arts and Exhibitions at the Telfair Museum of Art, have been enthusiastic partners at the traveling exhibition's venues. A number of dealers, private collectors, and other supporters, with their steadfast dedication to American art, provided invaluable assistance in locating Suydam's works and primary materials: Alexander Boyle, Lillian Brenwasser, John Driscoll, Stuart Feld, Justin Ferate, Howard Godel, Frederick Hill, Roger King, Betty Krulik, Henry and Sharon Martin, Louis Salerno, Alison Smith, William Vareika, Bruce Weber, Eric Widing, and Deedee Wigmore. The staffs of numerous key research and historical institutions around New York have also assisted with the research for this book and exhibition, including the New York Public Library, Columbia University Libraries, New-York Historical Society Library, New York Society Library, Archives of American Art, Smithsonian Institution, Museum of the City of New York, and New York Genealogical and Biographical Society. Special thanks are owed to the several student interns who contributed to this book: Mia Khimm, Diana Pilipenko, Catherine Roach, and Amy Stokes. I extend personal thanks to my wife, Becca, for her constant support and encouragement.

—Mark D. Mitchell

I began conducting research on Suydam during graduate studies at Columbia University with Linda Ferber. Barbara Novak then led a seminar that organized the exhibition "Next to Nature," where she was assisted by fellow student Annette Blaugrund, now Director of the National Academy. I thank them as my three godmothers of this project. Mark D. Mitchell has been an exemplary co-curator. Together we received counsel from numerous individuals and institutions, who are listed in this Acknowledgments section. Here I extend my special thanks to James Callow, David Dearinger, Kenneth Maddox, Merl Moore Jr., Vincent Nardiello, Si and Victoria Newhouse, Allen Staley, Joan Washburn, and Erving and Joyce Wolf. Donald Clark was generous in countless ways. My family members—Katherine F., Joseph, Jay, Patricia, and Mark Manthorne—have made major contributions to this and all my work. James L. McElhinney shared insight into being a landscape painter.

—Katherine E. Manthorne

Introduction

In the Thick of Things:
Suydam and the New York Art World

Annette Blaugrund

LUMINISM. This enigmatic word has enjoyed varying definitions that extend from American artists' recurring concern with qualities of light and atmosphere, but is explored here for the first time as it relates to the life and work of the nineteenth-century master James Augustus Suydam (1819–1865). Although the term still lacks a definitive meaning, it is illuminated herein by the shared practice of an intimately-related group of artists of which Suydam was an integral part during the 1850s and 1860s. Suydam's short but influential life affords an opportunity to revisit luminism's origins and place it in context.

As the essays in this book reveal, James A. Suydam made important contributions to the development of landscape painting in America, assembled an impressive collection of American and European art that he bequeathed in its entirety to the National Academy Museum and School of Fine Arts, New York and spearheaded the funding of the Academy's first permanent home, which immediately became the locus for contemporary American art upon its completion in 1865. Suydam's greater achievement may be his vital role among the innovative artists known today as luminists.

Although James Suydam (FIG. 1) began his career as a professional

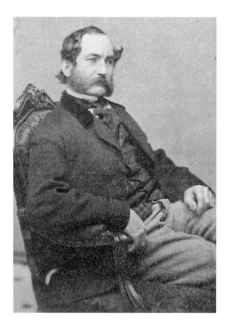

FIG. 1 *James A. Suydam*, ca. 1862, carte-de-visite, Photographs of Centurions, vol. 1, Century Association, New York.

artist when he was well into his thirties, he was from the outset affiliated with New York City's most esteemed art organizations: the venerable National Academy of Design (now called the National Academy Museum and School of Fine Arts); the exclusive Century Association; and the prestigious Tenth Street Studio Building. Born into a merchant family of some wealth, Suydam was a patron of the arts as well as an amateur painter turned professional and was personally acquainted with some

of the most important artists of his day. His major contributions to the Hudson River School are his serene luminist paintings, which his peers referred to as simple, beautiful, delicate, and "expressive of the pensive moods of Nature," and his art-related activities.[1] An exhibition of his paintings and collection and the scholarly consideration of his work are long overdue. My purpose here is to reveal the immediate context for his work, especially his relationship to the Academy.

The National Academy of Design was established to promote American art through exhibitions and to provide instruction for art students. It was conceived at the end of 1825 and inaugurated in 1826 by such Hudson River School artists as Thomas Cole and Asher B. Durand, under the guidance of its founding president Samuel F. B. Morse (President 1826–45, 1861–62). Modeled after the Royal Academy of Arts in London, the nascent Academy set high standards, encouraged professionalism among resident artists, and broadened their political and social milieu. Also integral to the Academy's mission was the Annual Exhibition of contemporary American art, an event that has continued without interruption since 1826. Morse hoped that these exhibitions would inform the taste of the American public and that as taste developed so would artistic standards. The Annuals provided one of the few venues for exhibiting the work of living artists in the early to mid-nineteenth century and were unique in this country.[2] Contributing to them was considered both an obligation and a privilege for Academicians. In those years, non-Academicians' work was displayed side by side with that of the Academicians, a great opportunity for emerging artists (FIG. 2). Heated critical reviews in contemporary periodicals enlightened and lured new audiences to the Academy.

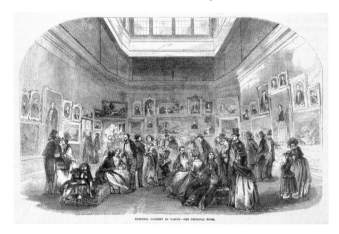

FIG. 2 *National Academy of Design—The Principal Room*, wood engraving, *Illustrated News* (7 May 1853), p. 296, National Academy Museum Archive.

Suydam was inspired to study painting and drawing during a trip to Europe between 1842 and 1845, where he met and traveled with the artist Miner K. Kellogg, an Honorary Member of the Academy. After returning to New York, Suydam continued to pursue his artistic inclinations; by the early 1850s he had become friends with Academy members John F. Kensett and Sanford R. Gifford. It was probably due to their encouragement that he exhibited at the National Academy's Annual exhibition for the first time in 1856 and regularly submitted his paintings until his untimely death at the age of forty-six in 1865. In 1858, Suydam was made an Honorary Member of the Academy, which meant that he was probably still considered an amateur or a patron. In 1861, only three years later, his status was elevated to full Academician.[3] Yet he must have considered himself a practicing artist by 1859, when first he listed himself in the New York directory as an artist with a studio at 15 Tenth Street.[4]

In 1863, within two years of his becoming a full Academician, he was elected to the Council, the governing body of the institution, and served until his death. He was also instrumental in raising money for the Academy's first permanent home located on Fourth Avenue and Twenty-third Street (FIG. 3). Designed by Peter Bonnett Wight (1838–1925), this High Victorian Gothic structure, nicknamed the Doge's Palace for its resemblance to that famous Venetian building, was the epitome of the Academicians' desire for a well-designed edifice that signified the importance of the arts of design. Suydam was appointed treasurer of the Fellowship Fund, the capital development committee formed to raise money for the new building.[5]

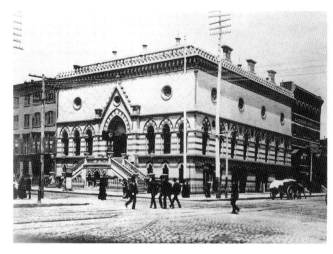

FIG. 3 Peter Bonnett Wight (1838–1925), *National Academy of Design,* opened 1865, National Academy Museum Archive.

In a report to the Council, Suydam stated that as of January 1863 he had raised $54,800 (that is equivalent to about $853,000 today), $50,000 of which he invested at 5 percent interest.[6] Not only did he personally contribute over one thousand dollars to the Fellowship Fund, but he and his committee were also able to attract a number of other subscribers at that amount including Samuel F. B. Morse, and collectors Robert Hoe, John T. Johnston, Robert M. Olyphant, and Marshall O. Roberts, all members of the Century Association, discussed below.[7] President Daniel Huntington commended Suydam and his committee for "the zeal with which they have hunted the men of taste and fortune from their homes . . . till they pinned them to a Fellowship."[8] Suydam's success as treasurer of the Fellowship Fund Committee probably led to his being appointed Treasurer of the Academy, a term curtailed by his death in September 1865. When the Academy opened its new purpose-built site at the beginning of that year, the Civil War was ending and it consolidated the Academy's position as the center of the New York art world for the next decade.

Suydam was also active at the Century Association, a club established in 1847 for gentlemen who were engaged in or interested in literature, the fine arts, and the promotion of social intercourse. Although the majority of the Association's forty-two founding members were artists, others were merchants, authors, men of leisure, physicians, bankers, clergymen, and lawyers. As time passed, the proportion of artists and writers increased and interest in promulgating American art and literature became paramount.

Membership in the Century was exclusive to those who were considered successful, well bred, and well heeled, and James Suydam was triply suitable as an amateur artist, patron, and well-to-do merchant.[9] His election gave him access to artists who also may have influenced and supported his decision to turn from amateur to professional. There he would have rubbed shoulders

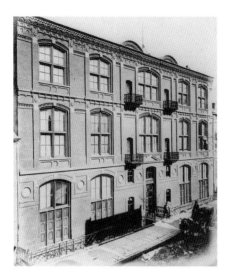

FIG. 4 Richard Morris Hunt (1827–1895), *Tenth Street Studio Building,* 1857, Prints & Drawings Collection, The Octagon, The Museum of the American Architectural Foundation, Washington, DC.

with many Academicians including Durand (President of the Academy from 1845 to 1861), Huntington (President of the Academy from 1862 to 1869), and Henry Peters Gray, with whom he worked on the Fellowship Fund Committee and who served as the Academy's President from 1870 to 1871.

The Century held exhibitions of its artist members' work, formed an art collection by the acceptance of a painting or sculpture in lieu of an initiation fee, and bought work in support of its members. In 1862, it purchased seven paintings by Academicians to form the nucleus of a permanent collection and gallery.[9] The Century and the Academy were so closely related, not only by their shared members, but also by their common goals to promote American art and encourage American artists, that Academy meetings were sometimes held at the Century's headquarters on Fifteenth Street. Suydam's dual membership in the Century and the Academy provided a close network of friends and colleagues who encouraged his artistic efforts.

In 1858, the year he was made an Honorary Member of the National Academy, Suydam moved his workspace into a unique location—the Tenth Street Studio Building (FIG. 4). The first modern centralized facility constructed to completely serve artists' needs, the Studio Building became a national prototype for studio buildings.[10] Artists from all over the country congregated within its walls to work, teach, talk, and, most important, exhibit and sell their art. Wealthy patrons, influential critics, and the inquisitive public came to the Artists' Receptions in the building's exhibition hall, and these events helped to transform Greenwich Village into a hub for the visual arts. The building quickly became celebrated for its innovative modern design as well as for its distinguished roster of tenants. During its first decade, the Tenth Street Studio Building was the unofficial headquarters of the New York or Hudson River School artists, of which Suydam was considered a part. Most of the tenants were members of the Academy and the Century as well, so he was right at home among the who-was-who of the New York art world that also included a distinguished group of writers and architects.

Suydam was among the building's first tenants. During the seven and a-half years of his tenancy at Tenth Street, Suydam came into contact with Frederic Edwin Church, Gifford, George Boughton, John Casilear, William M. Hart, Richard William Hubbard, Louis Rémy Mignot, John George Brown, and Worthington Whittredge, artists whose paintings he bought. Suydam also knew many of the resident writers including the critic Henry Tuckerman, who probably used his tenancy for direct access to the residents, whom he described in his *Book of the Artists* (1867), one of the earliest biographical histories of American art. Tuckerman's book includes a long entry about Suydam, and it proclaimed

that he "devoted his time and no small part of his income to the encouragement of art, and the succor of unappreciated merit."[11]

We know that Suydam formed close personal relationships with his neighbors. In 1857, he bought Mignot's *Sources of the Susquehanna*, which was exhibited at the Academy that year, and later served as a groomsman at Mignot's wedding.[12] These two men, along with Casilear, Gifford, Régis-François Gignoux, Hubbard, and sculptor Launt Thompson, founded the Artists' Fund Society to raise money for impoverished artists and their families by holding exhibitions and auctions. Suydam was also invited to participate in a Baltimore & Ohio Railroad outing to observe and paint the route from Baltimore, Maryland, to Wheeling, Virginia, between June 1 and 5, 1858, a sign that he was already recognized by patrons as well as peers. In addition to the National Academy Annual exhibitions, he exhibited at such regular venues as Sanitary Fairs, which raised money to support the Northern army with supplies during the Civil War, the Brooklyn Art Association, the Pennsylvania Academy of the Fine Arts, the Boston Athenaeum, and, notably, at the Artists' Receptions at the Tenth Street Studio Building.

The Tenth Street Receptions were events to which large numbers of people were invited to view and, hopefully, purchase works by resident artists. The artists selected and installed these in-house exhibitions where visitors wandered from studio to studio in an atmosphere made

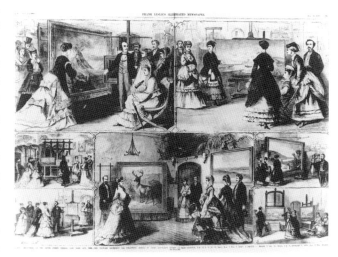

FIG. 5 *Artists' Receptions at the Tenth Street Studio, New York City,* wood engraving, *Frank Leslie's Illustrated Newspaper* (23 January 1869), p. 297, Museum of the City of New York.

congenial with music and refreshments (FIG. 5). Suydam served on the organizing committee with Albert Bierstadt and Whittredge for one of these events and with William J. Hays and Gifford for another, underscoring his active participation in life at the Studio Building.[13]

Suydam's studio was located on the third floor along with his friend Gifford's. Most of the Tenth Street studios were functional and less elaborate than the later studios of Albert Bierstadt and William Merritt Chase. While no image of Suydam's has survived, we can conjecture that it was modestly furnished with an easel, a simple table and chairs, a bookcase, a cabinet for pigments and brushes, perhaps a plaster cast, an Oriental rug, and the ubiquitous pot-bellied stove. Suydam's studio would have been distinguished by his luminist paintings and his extensive collection of contemporary American and European art. The *Crayon*, one of the country's earliest art journals, noted in 1858 that "Mr. Suydam's studio is more than usually attractive."[14]

That Suydam was in the thick of things and well acquainted with his neighbors is again made clear in a letter he wrote to his friend Kensett from Cold Spring, New York, on August 7, 1860.

He reported that William Haseltine had left the area because his wife was pregnant and commented on Church's large and lucrative commission, adding that William Hart's commission was also still viable. Jervis McEntee, he said, was back from the Civil War and was at home, having given up his studio in the Tenth Street Studio Building,[15] that Gifford and Whittredge were in the Catskills, Casilear in the White Mountains, Mignot at Stockbridge, while Hubbard, Hays, Hart, Thompson, and Gignoux were all at the Tenth Street Studio Building.[16] Suydam was without doubt an integral member of the National Academy, the Century Association, and the "fraternity" of artists in the Tenth Street Studio Building. Their like constituents and parallel missions unquestionably connected the three institutions, all committed to the advancement of American art.

When Suydam died, he bequeathed ninety-two contemporary American and European paintings to the Academy, the organization's single most important gift of nineteenth-century art and one that formed the nucleus of the Academy's outstanding permanent collection. Many of these had been bought directly from artists, a number of whom were fellow Tenth Street Studio Building tenants, as well as from friends, auctions, artists' sales, and fairs. According to the critic Tuckerman, Suydam's purchases provided both an economic and psychological boost to emerging artists, such as McEntee: "With that sympathetic appreciation of true merit and promptness to encourage genuine talent, which was so noble a trait of the late James A. Suydam, he purchased this picture (Melancholy Days). It was the first work of McEntee's that gave him the peculiar reputation he enjoys in landscape art."[17]

Suydam also left $50,000 to the Academy to establish a permanent fund for use at the discretion of the Council for the "instruction of the Arts of Design." By 1870, a medal in his name was created by the school and was used specifically for excellence in the life class. Among the recipients of the Suydam Silver medal was Marsden Hartley in 1902.[18] Over the years, the prize was expanded to both bronze and silver medals awarded simultaneously to students of the antique and still life classes in addition to the life class. Suydam's name was thereby perpetuated among art students at the Academy's school.

The encomiums after Suydam's death poignantly underscored his love and devotion to art. Kensett eulogized him at the October 9, 1865 Council meeting, saying that he was one of the most valued and efficient members and officers and that he was zealously devoted to the Academy.[19] Suydam returned the admiration of his fellow Academicians by leaving his collection to the Academy along with money to subsidize the continuation of the organization. It is not known whether he formed his collection with a plan to bequeath it to an institution, but we do know that his wish, made two days before his death, was to leave it to the National Academy of Design. The Academy honored his memory with an exhibition of his work and his collection in December, 1865 as part of the Sixth Annual Artists' Fund Society Exhibition and later with the medal in his name. We honor Suydam once again with this catalogue that accompanies the retrospective exhibition of his work and his collection, which has served for so many years as the foundation of the Academy's outstanding collection.

Tuckerman memorialized him best: "In the death of Mr. James A. Suydam, American art has met with more than a common loss; and the group of painters that make a social influence so personal and delightful as that of our New York artists, have lost a sincere and active friend, a high-bred and true gentleman, a genuine and refined painter. Mr. Suydam was a quiet and gentle nature, an exquisite and conscientious artist."[20]

NOTES

1. Typescript of Sanford R. Gifford's eulogy, October 9, 1865, Council Meeting. Sanford Gifford, Manuscript Memoir of James A. Suydam, 1865. National Academy Museum Archives.
2. It was not until the 1870s that museums were established and galleries flourished.
3. Initially, the Academy had three classes of membership: National Academicians (NA), Associate National Academicians (ANA, a category eliminated in 1994), and Honorary Members (HM, eliminated in 1863). Associates were required to present a portrait of themselves, while full Academicians, professional artists of renown elected to the Academy by their peers, were asked to contribute a representative example of their work. The contribution of these works has been the continuing source of the Academy's notable collection of more than seven thousand paintings, sculpture, prints, and architectural materials that includes one of the largest holdings of portraits of American artists.
4. The address of the Tenth Street Studio Building changed to 51 West Tenth Street in 1866. Suydam's home remained at 25 Waverly Place, near Kensett's studio at Waverly House, 497 Broadway at Fourth Street; Kensett had that address from 1856 to 1866. See my "'Up Through the Snow' to Kensett's Studio," *Archives of American Art Journal* 23, no. 3 (1983): 31–32, which documents Kensett's various studios.
5. The committee included Chairman Henry Peters Gray, Secretary Thomas Hicks, along with members George Baker, Daniel Huntington, Kensett, and J. Q. A. Ward.
6. Thomas S. Cummings, *Historic Annals of the National Academy of Design from 1825 to the Present Time* (Philadelphia: George W. Childs, Publisher, 1865), 329, and Fellowship Fund Records, National Academy Museum Archives.
7. Unmicrofilmed William Page Papers, Archives of American Art, Smithsonian Institution, Washington, DC.
8. Eliot Clark, *History of the National Academy of Design, 1825–1953* (New York: Columbia University Press, 1954), 79.
9. Linda H. Skalet, "The Market for American Paintings in New York 1870–1915" (PhD diss., 1980, Johns Hopkins University, 1980), 77.
10. See my dissertation, "The Tenth Street Studio Building" (PhD diss., Columbia University, 1987) for further information.
11. Henry T. Tuckerman, *Book of the Artists: American Artist Life, Comprising Biographical and Critical Sketches of American Artists: Preceded by an Historical Account of the Rise & Progress of Art in America* (1867; repr. New York: James F. Carr, 1967), 540.
12. Katherine E. Manthorne and John W. Coffey, *The Landscapes of Louis Rémy Mignot, A Southern Painter Abroad* (Washington and London: Smithsonian Institution Press for the North Carolina Museum of Art, 1996), 106.
13. I am grateful to William H. Gerdts for making his file on Suydam from the Abigail and William H. Gerdts Library available to me. There I found an additional invitation card.
14. *Crayon* 5, no. 3 (Feb. 1858): 59.
15. That must have been temporary since McEntee continually listed himself in the New York City directory at the Tenth Street Studio Building from 1859 to 1891.
16. Kensett Papers, Archives of American Art, Smithsonian Institution, reel N68-85, frame 307, mentioned in Marc Simpson, Andrea Henderson, and Sally Mills, *Expressions of Place: The Art of William Stanley Haseltine* (San Francisco: The Fine Arts Museums of San Francisco, 1992), 163.
17. Tuckerman, *Book of the Artists*, 545. McEntee's painting is now lost.
18. Katherine Manthorne's entry on Suydam, in Barbara Novak and Annette Blaugrund, eds., *Next to Nature: Landscape Paintings from the National Academy of Design* (New York: Harper & Row, Publishers; and National Academy of Design, 1980), 58.
19. David B. Dearinger, *Paintings and Sculpture in the Collection of the National Academy of Design*, vol. 1, 1826–1925 (New York: Hudson Hills Press, 2004), 522.
20. Tuckerman, *Book of the Artists*, 540.

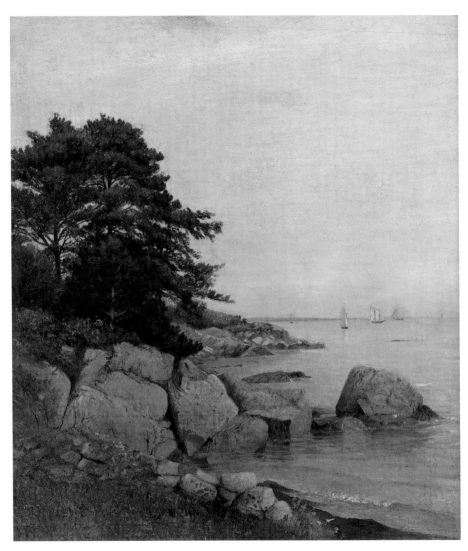

FIG. 1.1 James A. Suydam (1819–1865), *Beverly Rocks*, ca. 1860, oil on canvas, 11 3⁄16 x 9 1⁄2 inches, National Academy Museum, NA Diploma Presentation.

Chapter 1

Becoming a Landscape Painter

Katherine E. Manthorne

It's true he didn't write many. But they were most beautiful.
Even one is a lot, for certain things.
—Saul Bellow, *Humboldt's Gift* [1]

JAMES SUYDAM PAINTED AND EXHIBITED during the ten years that were pivotal to the development of American landscape art, between 1856 and 1865. During those years he produced a small, gem-like body of work including *Paradise Rocks, Newport* (FIG. 3.1) that alone ensures his place among its masters. His artist-friend Sanford R. Gifford explained the essence of his work thus: "Although he was not lacking in full appreciation of what is splendid or imposing in nature, his peculiar sympathies led him to prefer the simpler, quieter phases, those phases which win our affection rather than those that compel our admiration and wonder." [2] Gifford's words underscore the affinities Suydam's art shared with luminism, a mode of American landscape painting characterized by a tightly controlled horizontal structure and radiant light. Indeed the pioneering scholar of luminism, John I. H. Baur, recognized him as "one of the most quietly lyrical" among its practitioners. [3] Yet for all the interest luminism has stirred, neither Suydam nor his collection has received the proper scholarly attention each deserves.

Family Background

Suydam was born on March 27, 1819, in New York City, a member of a well-to-do family that was of Dutch descent on the paternal side and French on the maternal side. [4] His father, John Suydam (1763–1841), ran a dry goods firm and became one of the city's prominent merchants. John's marriage to Jane Mesier (1778–1864) in 1800 in Poughkeepsie, New York, when he was thirty-eight, came as a surprise to his family, who assumed he would remain a bachelor. [5] Together John and Jane produced a large family: Catherine Matilda; Henry; Peter Mesier; John R.; Letitia Jane; Eliza, who drowned at Trenton Falls in central New York state; David Lydig (FIG. 1.2), who was the executor of James's will; Maria Louisa, who died when she was two years old; Maria Louisa; James

FIG. 1.2 Henry Ulke (1821–1910), *Portrait of David Lydig Suydam*, ca. 1865–70, watercolor on paper, Museum and Library of the Maryland Historical Society, Baltimore.

Augustus; and Jane.[6] Suydam died on September 15, 1865 of dysentery while on a sketching tour in the White Mountains. His funeral was held in New York City at St. Mark's in the Bowery Episcopal Church, followed by a memorial at the National Academy.[7]

At age nineteen James Suydam attended the University of the City of New York (now New York University). He earned the equivalent of an undergraduate degree in the late thirties and then completed medical studies in 1842. He never seems to have practiced medicine; Gifford observed that he found it unsuitable to his artistic leanings and soon turned to architecture, which was "an admirable discipline whereby he prepared himself for that exactness and thoroughness which characterized his later studies."[8] His educational years coincided with difficult economic times in the city. Known as "the year of national ruin," 1837 ushered in what was probably the most severe financial downturn until the Great Depression of the 1930s. "This is the most gloomy period which New York has ever known," wrote Philip Hone. "All is still as death, no business is transacted."[9] The following year the Suydam family patriarch bought the property at Waverly Place where the future artist resided until his death.[10] The fact that Mr. Suydam was able to purchase real estate at the precise moment when the city's economy had ground virtually to a halt suggests that his income was sound. John Suydam died in 1841; perhaps his death released the future artist from the necessity of working, and an inheritance allowed Suydam the opportunity to travel abroad.

European Travel and Artistic Beginnings

In 1842 James Suydam departed for a three-year trip to Europe, where his extensive exposure to the masterpieces of art and architecture convinced him to follow his own artistic calling.[11] He journeyed in the company of one of his brothers, Peter Mesier. Arriving in Florence in 1843, they met Miner K. Kellogg, an American artist who took them under his wing. "Suydam had as yet no practical knowledge of Art," Kellogg later recalled, "but was so appreciative of its beauties that I gladly accompanied him through the Galleries and Churches and directed his special attention to those paintings best calculated to form correct judgment in Art."[12] For the next few years Kellogg guided James and Peter Mesier on their tour of the great art treasures of Europe and the Near East. Sometimes Kellogg traveled with them side by side, but at other times when he could not, he provided letters of introduction and suggestions on what to see and do.

Suydam was fortunate to have come under the tutelage of Kellogg, who, during his many years abroad, had become a respected art connoisseur. The American art critic and collector James Jackson Jarves regarded him as "one of the few American artists qualified by study and experience to speak intelligently of old masters."[13] We can only imagine the instructional benefit and

enjoyment Kellogg added to Suydam's stay in Florence and later their journey through northern Italy where, he explained, "Travelling by Vetturino [charter carriage] allowed us all the leisure time we desired to examine the treasures and monuments of art which abound in every principal city of Lombardy—such as Bologna, Reggio, Moderna, Parma, and to sketch if we liked any noted or picturesque object by the way-side."[14] The high points of the journey were further elaborated upon in a letter to the sculptor Hiram Powers:

> I stopped over a day in Bologna to my great delight and was surprised at finding so many fine pictures by the Carracci, Guido &—passed a short time in Moderna and Reggio, where were many interesting sights—and at Parma we worshipped a day or two at the shrine of the great Correggio, most of which time I was perched high in the cupola of the Cathedral studying the wonders of art. We visited Cento the Birth place of Guercino and saw some of the noblest of his works in very excellent preservation, We paid a short visit to the house of Petrarch . . . and brought away sketches of things inside & out.[15]

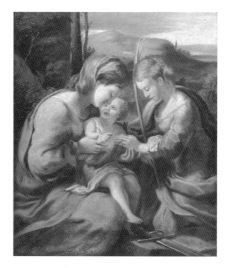

FIG. 1.3 Unknown artist, after Correggio, *Marriage of Saint Catherine*, undated, oil on canvas, 10¾ x 8¹³⁄₁₆ inches, National Academy Museum, Bequest of James A. Suydam.

We can imagine Suydam following Kellogg into the cupola and worshipping "a day or two at the shrine of the great Correggio." Perhaps it was at this time he acquired the *Marriage of Saint Catherine* (FIG. 1.3), after Correggio.[16] Eventually they made their way to Venice, where Kellogg remained, while Suydam and his brother proceeded on to Milan, and then Switzerland, Germany, and France. They would meet up with their guide again later.[17]

Kellogg had traveled for a time in the Near East in the early 1840s. His great fascination with those lands manifested itself in a variety of ways including his many renderings of Orientalist nudes and idealized images of Greek and Circassian girls, several of which are in the Suydam Collection (FIG. 1.4). Travel writer Bayard Taylor's account of a visit to Kellogg's studio in Florence suggests the kind of enthusiasm for "things Eastern" he instilled in all those who came in contact with him: "At [Hiram Powers's] house I met Kellogg, an American painter of very great talent, who has been traveling in Greece, Egypt, Syria, Asia Minor, and Turkey. . . . He was

FIG. 1.4 Miner K. Kellogg (1814–1889), *Circassian Girl*, undated, oil on panel, 9 x 6⅞ inches, National Academy Museum, Bequest of James A. Suydam.

at Thebes, was thirty days on and around Mount Sinai, and spent nine months in Constantinople. He has set me half crazy to travel there, but I cannot."[18]

A similar experience undoubtedly prompted Suydam's departure for Constantinople in 1844. After a trip through Turkey (and likely Greece, although no mention of it has turned up in the records) of apparently several months duration, the Suydams rendezvoused with Kellogg at the beginning of January 1845 on the island of Malta. Gifford reported that Suydam made ample notes of his travels and that it was during his journeys with Kellogg that his love for drawing developed. The sketches said to have been done on this journey unfortunately are unlocated; we can only assume, in their absence, that Suydam's experience with the light and terrain of Italy and the Near East reinforced the understated and refined qualities that became the hallmark of his work.[19] From Malta they sailed to Naples, passing through Italy as they made their way back to New York.[20] After this intense introduction to the great monuments of Europe and the Near East, it is little wonder that upon Suydam's return home he began to apply himself to a life of painting and collecting.

Artistic Debut

Suydam made his artistic debut at the National Academy of Design Annual exhibition in March 1856, an event later recalled by Gifford:

> *I remember strolling through the rooms of the Academy of Design in 1856 with a brother artist, when our eyes were arrested by a quiet unobtrusive small landscape, composed of meadows, shut in by hills and distant mountains, with grey sky and gleams of light streaking over the meadows. We did not recognize the style of any known artist. "Who painted this?" we both exclaimed. It was so true simple and beautiful. On examination we found the initials; it was by Suydam, and was soon pointed out and admired by the best judges. He had been pursuing his studies assiduously at Conway and this was the first result.[21]*

Initially we are inclined to take Gifford's account at face value: a quiet man who had been content to work in private for the sheer love of art had secretly decided to enter the fray of public exhibition with a painting entitled *From North Conway*. Sadly this work, like many for which we have records, remains lost or unidentified, but we can actually deduce a good deal from Gifford's account. For one thing we begin to wonder how Suydam—given the procedure for submitting an entry to the exhibition—could have kept his plan from colleagues. Besides, there is evidence that other friends, including Frederic Edwin Church and Benjamin Champney, had seen him hard at work on some pictures. The more we think about it, the more improbable it seems that his close associate could have been ignorant of his submission or of the style in which he painted. Gifford's narrative belongs instead to the artistic myth making connected with salons and academies, especially with what Thomas Crow has called "the myth of the surprise invader."[22]

In the context of Gifford's statement, which was penned for Suydam's Memorial, it was important to legitimize his colleague's endeavors as a painter through the official auspices of the Academy. In this retelling, his work was not admitted through the intervention of friends. Rather, they deny any knowledge of his submission, thereby emphasizing that by virtue of his talent alone Suydam gained recognition and praise. The anonymity of his entry was a requisite condition for his initiation in this artistic brotherhood; details are sacrificed to a higher purpose. Gifford thus perpetuated the idea that Suydam was no "mere amateur" but a competent artist who could win recognition on his own merit in a fair and open competition. The importance of the National Academy as the arena in which this was carried out had significant implications for the artist as well as for the institution.

Suydam's choice of North Conway as subject matter for his first exhibited work is telling. Located in New Hampshire's White Mountains, North Conway had become, as one observer put it in 1855, "the pet valley of our landscape painters."[23] No exception, Suydam made a number of summer sketching tours among the gentle slopes, picturesque lakes, and clear light. From this debut submission of *From North Conway* to his last sketching tour when he died there in September 1865, contemporary accounts record his activities and pictures of the region. *Lily Pond* (unlocated), exhibited in 1857, was described as "a White Mountain scene, and a faithful portrayal of nature studied. This picture shows a fine feeling and marked artistic power."[24] That summer he "was again patiently at work at Conway," where Champney reported seeing him once more in March 1858 "busy too working for dear life for the *grand opening*," referring undoubtedly to the National Academy exhibit where Suydam showed *Moat–Mountain, Conway* (unlocated) and *Conway Meadows* (FIG. 1.5).[25] Regarding these works, Gifford observed that "their delicacy and truth established their reputation as a faithful student of nature," and that Suydam was elected a professional Honorary member of the Academy.[26] Another view (FIG. 1.6) features a gentle peak, a winding river, and pine trees contained within an oval frame. The principal interest is its golden-orange sunset against which the landscape forms are silhouetted.

Artist-Amateur

Even a brief overview of Suydam's background makes it apparent that the origin of this well-to-do gentleman's artistic calling was markedly different from that of the majority of his compatriots. Economic necessity forced many artistic hopefuls to take up the engraver's burin to support themselves while they attempted to master oil paints; travel often had to be postponed for lack of funds. Suydam's avocation, by contrast, was born out of the cultural opportunities he enjoyed, including a university education and a Continental Grand Tour of several years duration. He had little formal art training but received the equivalent of private tutoring from artist-friends as the outgrowth of social relations. In his capacity as collector and patron, furthermore, he exerted a significant influence on a number of his contemporaries. Suydam was, in the best sense of the term, an artist-amateur: that is, one who loves, is fond of, or has a taste for art and who cultivates it as a pastime rather than as an occupation. From the time of his first showing at the Academy,

FIG. 1.5 James A. Suydam (1819–1865), *Conway Meadows*, ca. 1857, oil on canvas, 11 x 20 inches, private collection, courtesy Brock & Co., Carlisle, MA.

he was singled out as "the exemplar of amateur painters, a shining light to all young men of means, who have life and labor to spare, and none of the necessity to work, which drives us poor artists unwillingly to our labors."[27]

Throughout the 1850s, Suydam was often referred to as an amateur, and his steadfastness and devotion to art held up as a model for other men of wealth and position to emulate. Tuckerman considered this status a pertinent fact of his artistic profile: "one of the few American artists whose competent fortune exempts him from the necessity of toil," he wrote, "he devoted his time and no small part of his income to the encouragement of art, and the succor of unappreciated merit."[28] The emphasis on the point of Suydam's fortune is intriguing, especially in view of the fact that several of the artist's colleagues—notably Church and Gifford—had family wealth sufficient to free them from the "necessity to work," but which in the critic's mind did not carry the same implications.[29] Clearly an independent income was a necessary but not a sufficient condition for amateur status. Class, too, comes into it. Suydam was from an old Dutch family that went back to early days of New York and was therefore part of a New World aristocracy in Knickerbocker New York.

FIG. 1.6 James A. Suydam (1819–1865), *A Landscape at Sunset with Sailboats in the Distance*, undated, oil on board, 7 ½ x 6 inches, unlocated.

More than one writer saw his work, untainted by the daily demands of the marketplace, as pure as nature itself: "Mr. Suydam exposed but one picture at the last exhibition of the Academy of Design [in 1865], and I may say he seldom if ever exhibited more than two or three pictures at a time. He seemed entirely oblivious of the public, and he painted his simple little landscapes out of pure love of nature."[30] This freedom allowed him to work on a small scale and to explore all the ramifications of an artistic problem without the pressure to produce works of novelty and diversity, without the need to please the crowd. On one occasion, for example, he produced a group of canvases of marshland subjects, each painted at half-hour intervals. This series (unlocated) was an important exercise for the artist's sensitivity to light and atmosphere.[31] Perhaps, however, he would not have done them if he had had to consider first their potential monetary value. Frequently he painted pictures that had little ostensible subject beyond a colored sky over a slip of marshy terrain. These habits led to charges of weakness and monotony from those who had eyes only for large-scale landscapes of identifiable and perhaps even spectacular sites, rendered in the tightly finished detail then in vogue. But for those who understood Suydam's intent to create what were in essence tonal poems, there were "no pictures that are more charming, more opposed to sensationalism, more peculiar and delightful, than the few he has given to American art."[32] Freed from worries over sales, the amateur felt no necessity to censor his impulses but allowed them to surface freely, and to express themselves in provisional or experimental form.

It is perhaps in the manner Suydam perceived himself, in the way he envisioned the creative act, that distinctions between him and his contemporaries become more apparent. The amateur's ideal of art making was completely antithetical to the Romantic image of the brooding genius, slaving away at his painting in isolation. For Suydam, painting was a shared way of life, rather than a solitary calling. He took great pleasure in his contacts with fellow artists and was deeply loyal and committed to them. Their society opened a new way of life for him, and it is doubtful if he would have initiated or continued his artistic endeavors he had not been a part of the group he affectionately referred to as his "fraternity of artists." These attitudes are entirely consistent with Martin Hardie's characterization of the amateur as one who "liked to draw and paint in company."[33] For Suydam, art was integrally tied to friendship and communal activities with other painters, as evident in letters he wrote throughout his career. To Kellogg, recently departed for Europe, he wrote in the autumn of 1850:

> *During your absence the fine Arts have gone at a snail's pace. I have executed but one piece, and this is still on the easel, and a copy of the old willow, which I think I have improved upon. I cannot tell you how much I miss you. I have no longer any one to talk or consult with about art, and when I think of the pleasant hours we spent together it makes me sad; however,* faux de mieux *I must try and find some clever artists this winter with whom I may associate, for it is dull work to plod alone.*[34]

More than a decade later, in August 1861, he was still expressing the same sentiment to Kensett: "I have been at work but it drags its slow pace along without a companion."[35] In between, however, the need for a sense of community was fulfilled, when he made the acquaintance of Durand, Kensett, and others, and with their fitting company was able to realize his ideal of artistic life.

Making Oneself Useful

The very years that Suydam painted, from 1855 to 1865, witnessed the consolidation of an American way of life that made his position as a moneyed man of leisure superfluous and even distasteful to the majority of his countrymen.[36] Suydam found himself in an ambiguous position not only in American society in general but also in relation to other artists. "You know how professionals despise amateurs," Mary Cassatt wrote to her sister-in-law, revealing anxiety about status and identity.[37] The dilemma of the amateur should be viewed also against a strong Protestant work ethic prevalent in the nineteenth-century Northeast. Industry and the condemnation of idleness, which began in Colonial America as religious virtues, had become secularized and incorporated into the patterns of society at large. In this context a gentleman of wealth was regarded in a poor light if he did not have some occupation. Artists frequently complained that in American mercantile society they were accorded little respect. The amateur had money, but did not work for a living: the yardstick by which men were judged. Hence the emphasis Tuckerman and others placed on Suydam's commitment was his seriousness of purpose.

Suydam's dilemma was not unlike that of Henry James's character Rowland Mallett in his early novel *Roderick Hudson* (1875). Taking personal stock, the wealthy Mallet reflects, "in truth, with his means, his leisure, and his opportunities, what had he done? He had a lively suspicion of his uselessness." [38] His solution was a Grand Tour, "for in the way of activity it was something definite at least to be going to Europe and to be meaning to spend the winter in Rome." [39] The dialogue that followed his cousin Cecilia's demand for more specifics of his plan points up his dilemma:

> *What is it you mean to do in Europe? She asked lightly, giving a turn to the frill of her sleeve—just such a turn as it seemed to Mallet to bring out all the latent difficulties of the question.*
> *"Why, very much what I do here," he answered, "No great harm!"*
> *"Is it true," Cecilia asked, "that you do no great harm? Is not a man like you doing harm when he is not doing positive good?"* [40]

The ensuing scolding she delivered articulated society's silent expectations of Mallet, of Suydam, and certainly of the author James himself; if left unmet, they then lead to the artist-intellectual's sense of ineffectiveness and even failure. Shortly after this exchange, Mallet made the acquaintance of the young American sculptor Roderick Hudson, and became his patron and guardian. And although Hudson's ultimate suicide calls into question the wisdom of Mallet's choice, his sense of futility is temporarily assuaged by adopting the role of what Cecilia termed "a connoisseur." [41]

Like James's character, Suydam could have been dismissed as socially irrelevant, even impotent, had he filled his time exclusively by frequenting gentlemen's clubs and dabbling in literature and culture. As it was he devoted himself not only to his own art making but also to the collecting of art and to solidifying the future of the National Academy by raising funds for the construction of the new building. Only after his death in 1865 when his bequest to the Academy was announced, did the public realize the extent of his commitment. He had amassed a large collection of high-quality contemporary American art and willed it to an institution open to the public at a time when the country could not boast a single major art museum. In 1865 this was an exceptional act.

Suydam inhabited a transitional moment in American society. His standing in the 1850s and during the war years was distinct from the reevaluation his reputation underwent after his death, in the later 1860s and beyond. The expectation for such men to do "positive good" was articulated not only in fiction but also by the critic James Jackson Jarves, who in his books and essays published during the 1860s helped to redefine the terms of the amateur's contract with society. He related the amateur's status to larger obligations that grew out of the new role art and culture were to play in the post–Civil War era. Jarves and other observers of the art scene of the 1860s believed that any hope for American art lay with the amateur. The founding of museums and other institutions, as they saw it, depended not so much upon the artists themselves but upon

such individuals in whom wealth and culture were united. In that respect Suydam certainly ful-filled his obligations; he encouraged his colleagues through sales and bequeathed this private col-lection of art to the National Academy, where it has continued to serve the needs of the artistic community and public alike. It was especially important to establish a permanent collection of the best of American art when public galleries were few and far between, both in New York and the country at large (The Metropolitan Museum of Art; the Museum of Fine Arts, Boston; and the Corcoran Gallery of Art, for example, were only founded in 1870). Tuckerman's assessment in 1867 of Suydam's status also suggests that he had risen to the challenge and had found a way to do "positive good": "Of an old and well-known New York family, he offered the pleasing excep-tion of an American gentleman of independent means and social position, devoting himself to a refined and noble object, with disinterested zeal and sympathy."[42]

Religion/Spirituality

The Mesiers were founding members of the Zion Church in the area around Wappingers Creek in southeastern New York state. We learn also from Henry Suydam that "among the events at Wappingers Creek of which my mother told me was the story of the Knocking Girl," suggesting that a fascination with spiritualist phenomenon that was part of what is sometimes called the Great Awakening in upstate New York was a component of their family life.[43] The Suydam chil-dren grew up with stories of the supernatural, of the possibilities of the spirit world. We wonder, too, whether James might have shared his brother Henry's commitment to the life of the spirit, embodied in several books he published. Henry's book *Gathered Thoughts* (1886), for example, is a compilation of spiritualist observations and meditations; while not in any sense a formal study of religion, the very act of composing such a volume indicates a certain commitment and seriousness of purpose. While published long after the death of James Suydam, such books iden-tify a strain of spiritual belief espoused by family members.

Gifford's account of James's deathbed scene reveals more of his distinctive life of the soul:

> *From the first he seemed to feel that his illness would be fatal. I often endeavored to dissi-pate this feeling by trying to interest him in actual things but with little success. Much of the time his thoughts seemed to be occupied with the mysteries beyond this life. He rarely made any reference to his religious faith either while in health or during his illness; but it was easy to perceive that he was a sincere Christian and that his life, whose natural tendencies were toward all that is noble true and good, was also governed by religious principle.*[44]

Made all the more poignant as Gifford had only learned shortly before that time that his own eld-est and closest brother Charles had committed suicide, this account underscores the profile of a man who had a rich spiritual life, which merged his own depth of feeling for nature with memo-ries of family rituals. Huntington's postscript strengthens this assumption: "To the above account by Mr. Gifford, of our friend's last days, I shall add but a little gleaned from other sources. A lady,

Miss Woolsey, gently and piously ministered to his wants, preparing nourishment with her own hands, reading to him from the book of common prayer passages familiar from his childhood."[45]

The description of Suydam's final moments confirms a picture of a man of deep if personalized faith: "He conversed with the Episcopal clergyman of the place, breathed at intervals a simple prayer, and in the full faith of the Redeemer yielded his spirit up to God."[46] His friend of a quarter century, Miner Kellogg, was involved with Swedenborgian ideas through friendships with William Page and especially Hiram Powers.[47] It is possible that he served a conduit for spiritualism for his protégé. Certainly these inclinations made Kellogg especially sensitive to the distinctive quality of Suydam's spiritual life, which he eloquently summarized: "Suydam loved Beauty and Truth for their own sakes, and he sought in a humble spirit to embody them on the canvas. This love was only surpassed by the affection he lavished when [sic] his fellow man; and, in my opinion, the true secret of his beautiful character and the success which followed his labors, may be framed in the deeply *religious* [emphasis original] attributes in his heart which impelled him to act conscientiously in all the duties and relations of life."[48]

Among the Hudson River Painters

The details of Suydam's life between 1845 and 1855 remain somewhat sketchy. He resided at the family home at 25 Waverly Place off Washington Square; city directories listed a second business address that he shared with his brother John, identified as "merchant." In 1853–54 both James and John dropped the business address and in 1858–59 James added "artist" after his name in the directory along with a studio address, 15 Tenth Street (the Tenth Street Studio Building), which remained unchanged until his death. It seems then that he maintained some connection to the family business until the early 1850s.

Between 1846 and 1855 he owned property in his own name outside New York City in Pelham called Oakshade, directly adjacent to what is now the Bartow-Pell Mansion Museum.[49] By 1847 he had renewed his acquaintance with Kellogg, who was managing the touring exhibition of Hiram Powers's *Greek Slave* throughout the United States (1847–51). Suydam passed part of the summer of 1850 in the Catskills, where he began to work in watercolor (although none has been identified). And in the following year Kellogg could report Suydam's graduation to oil paints: "He set up his easel at home in Pelham and made his first essays in oil painting from Nature."[50] This was the first hint that he was painting outdoors in oil, a practice he would apparently continue for the remainder of his career. That autumn, with his friend once again departed for Italy, Suydam felt acutely the want of artistic companionship. This gap soon began to be filled as he made the acquaintance of several New York–based painters and profited from their camaraderie.

By the early 1850s Suydam was in touch with some of the best-known and established figures in the city. Exactly how and when this artist-amateur with little training beyond a European Grand Tour and some lessons in drawing and sketching from Kellogg entered the inner circle of the Hudson River School is a fascinating question, the implications of which are explored throughout our text. Early sources credit Suydam's early training to the tutelage of

Asher B. Durand and John F. Kensett. Durand's reluctance to take on pupils, well known through his introductory "Letters on Landscape Painting," make it unlikely that Suydam studied with him formally; but by spring 1851 Suydam owned Durand's *Landscape* (FIG. 4.2), which would have provided a vivid model, and awakened in him new directions for his talents.[51]

Kensett's efforts at formal instruction were similarly limited. He "tried his hand at teaching a group of New York ladies to paint, and it is said that he taught the amateur landscape artist James Suydam," as John K. Howat observed, "but these are the only known attempts by Kensett at formal instruction.[52] The fact that a canvas by Kensett was another of Suydam's initial art purchases does suggest a seminal early link between them. "In his first efforts he was happily advised by his friend Kensett," as Gifford put it, "and frequently afterwards profited from his counsel."[53]

With the encouragement of Durand and Kensett, Suydam applied himself more rigorously to his studies. His friend and fellow painter Benjamin Champney was particularly struck by the dedication to art he manifested from the outset. "How Suydam keeps up his pluck," Champney reported to Kensett in February 1856. "He is a regular Brick and will accomplish much if he continues on the same road."[54] His predictions were verified when in the spring of that year Suydam made his debut at the National Academy with *From North Conway*. Immediately it was recognized as one of "those few pictures" which in their "search for truth" gave the *New York Times* reviewer hope for the future of American art.[55] It was an auspicious beginning for him, whose unique style continued to be praised for the qualities of beauty, truth, and simplicity so admired in this debut exhibition picture.

He adopted the established seasonal travel of landscape painters, traveling in the late spring, summer, and early fall and confining himself to the studio to complete canvases in the winter months. In the summer of 1857 he headed to the White Mountains to make studies in preparation for the pictures he submitted to the National Academy exhibition the following Spring.[56] *View of Mt. Washington from the Conway Meadows* (FIG. 1.7) is likely the work he exhibited there in 1858 with the abbreviated title *Conway Meadows*. It demonstrated a marked advancement in composition and atmospheric effects, as one reviewer noted, "Suydam has two excellent pictures illustrative of New Hampshire scenery, Mote Mountain and Conway Meadows, both indicating a fine sense of light, a feeling for the picturesque, and growing command of technical requisites."[57] Relatively small in scale, it presents an interesting alternative to the majority of contemporary treatments of Mt. Washington where it looms large and dominant, befitting what is the highest mountain in the northeastern United States. Instead, Suydam created a flat open foreground of green meadow that occupies almost the lower half of the composition; in so doing, he downplayed the peak's formidable dimensions and tamed it within the conventions of the picturesque.

This canvas marks a turning point in his work. Kensett found it sufficiently pleasing that he acquired it for his own collection, where it remained until his death. At the sale of his holdings, Daniel Huntington then purchased it (for $155), perhaps cognizant of its value as a souvenir of shared experiences and friendship. Indeed *View of Mt. Washington from the Conway Meadows* is something of a transitional picture. In terms of subject, Suydam had not yet found the terrain

FIG. 1.7 James A. Suydam (1819–1865), *View of Mt. Washington from the Conway Meadows*, ca. 1860, oil on canvas, 14 x 20 inches, Dr. Michel Hersen and Victoria Hersen.

most congenial to his sensibility. The artist clearly enjoyed the experience of being among the mountains, but as he wrote to Kensett from another locale, he had difficulty formulating his visual impressions of their vistas: "The scenery here is pretty good but not what I expected. The mountains are too near which on a clear day makes them very hard to paint and the river runs through a broad stony way while it is itself a narrow stream."[58] Suydam's own peculiar feeling for nature found its most complete pictorial expression in the quiet expanses he was on the verge of discovering along the salt marshes and seashore of Long Island and New England. In atmospheric handling it is a harbinger of things to come, as he was already moving toward the subtlety of tone and lightness of touch that will become his signature. Suydam identified himself for the first time as "artist" in the city directory for 1858/1859 and added a studio address in the Tenth Street Studio Building. He also earned the designation of Honorary Member of the National Academy in 1859, a clear indicator that he was well on his way to becoming a landscape painter.

Turn to the Sea

After a few years of painting the inland scenery of New York State and the White Mountains of New Hampshire, Suydam began to cast about for more congenial subject matter. "Suydam, in the early part of the summer, devoted himself to trees, and in the latter part to coast scenery of Massachusetts," the *Crayon* reported in 1859, adumbrating the shoreline subjects for which he is best remembered.[59] This transfer of interest was growing, as indicated by the contents of the exhibitions: "A great change has taken place in the migratory habits of our landscape painters during the past few summers. They resort more and more to the sea-side and less to the mountains for their studies than was their wont, and there is a prospect of there being 'water, water everywhere' by-and-by in our exhibitions."[60] By the following year a writer for the *Cosmopolitan Art Journal* found the shift even more emphatic. In contrast to the "singular lack of devotees" to seascape in the past, the National Academy Annual of 1860 now displayed an increasing number of "water and sea-sky" pictures. Singling out Suydam and Heade as leaders of this new direction, the reviewer applauded this development.[61]

Previously, the sea had been the purview of a handful of artists who specialized in marine subjects. Now landscapists were turning to the seashore. What motivated this new attention to the coast? And what was the significance of the sites they favored? They were particularly sensitive to the nuances in character from one locale to another. Suydam, for example, preferred Beverly and Nahant, Massachusetts and often traveled from spot to spot along the shore until he found a place that possessed the precise look and feel he sought. John F. Kensett led the way in exploring the coast and establishing it firmly within the American landscape painter's repertoire. As early as 1854 Kensett's friends tried to lure him up to the White Mountains and away from the coastal subjects that they found strange for him to be pursuing, as indicated in Champney's letter from North Conway: "We have a very pleasant congregation of artists here at present and they are all anxious you should be added to our number. Huntington, Hubbard, Gifford, Colman, Etc., are still here and Colyer is expected. . . . Now do come and leave those odd rocks and water scapes and try us here for a while."[62]

Even if Champney was blind to the attractions of the coast, Suydam was not. He eagerly accompanied Kensett on his explorations of the New England shoreline, bringing his own perspective and needed encouragement to their endeavors. By the summer or early fall of 1857 Suydam was sketching regularly along the coast, for in the spring of 1858, a review of the Boston Athenaeum Annual Exhibition reported: "The painting by Mignot, 'Tropical Sunset,' and the 'Coast Scene' by Suydam, are opposite in character and treatment, and yet both are rare gems."[63]

Kensett-Suydam Friendship

"No artist of that period exerted a more healthful influence upon the body at large and upon the art of our country than did John F. Kensett," Worthington Whittredge noted in his autobiography.[64] Kensett was held in universal esteem. Suydam was of a gentle disposition and was frequently praised for his good efforts in the cause of art. Numerous sources document the close association the two "kindred spirits" enjoyed from the early 1850s until Suydam's death in 1865. The circumstances of their actual meeting remain uncertain. Perhaps they were introduced by Kellogg or a neighbor on Waverly Place, where they both resided. We know that in 1852 Suydam purchased a *Study from Nature* by Kensett (FIG. 4.5) at a sale of the American Art-Union, the first of a group of his works that he acquired. Making arrangements for a trip to the White Mountains in 1855, Church implored Kensett to induce Suydam to join them, indicating their close association. Shared patrons rarely communicated with one without mentioning the other. In October 1859 Robert M. Olyphant wrote to Kensett: "I should like to have been one of the party at Mount Morris in July. . . . How did your friend Suydam like it? Remember me to him."[65] Correspondence between the two artists documents joint sketching tours, meetings to discuss their studies, and loans of sketch boxes and other treasured painting equipment.[66] Even within the small community of the New York painters, these references signal us to their special bond, which had a direct impact on their art. Suydam's early pictures show the influence of his friend and mentor. Before long, however, he rivaled and even surpassed Kensett in certain respects, including increasingly reductive compositions and gradation and tonal effects. At the same time, Kensett's appropriation of key elements of his friend's compositional choices and atmospheric handling, as I discuss below, intensified after Suydam's untimely death in 1865.

Suydam and Kensett, Kensett and Suydam; even in the tightly knit circles of midcentury American painters, where male-male friendships were the norm, theirs stood out both in their own day and in ours. Their names were linked together, their art compared. Clarence Cook, in a notice of 1866, mentioned the work of both, then added that Suydam was very fond of Kensett. His emphasis is telling, for he deliberately did not say that they were good friends, but rather indicated a one-sided direction of affection. Kensett, sociable and well-connected, was probably less reliant on Suydam than Suydam was on him. There is also the fact that Kensett had a close personal relationship with the German-born painter Louis Lang, with whom he lived for many years. But Lang was a figure painter, not a landscapist. Lang would not have functioned as

Kensett's sketching companion, nor did he share in his close study of favored spots at Newport, Rhode Island or elsewhere along the New England coast. Current thinking would have us believe that Suydam was a mere follower of his mentor Kensett. John Driscoll, Mark Sullivan, and John K. Howat mention Suydam in passing as Kensett's pupil or imitator. Kensett was, of course, the more established, professionally successful painter whom Suydam unquestionably admired. None of these constructs, however, accounts for their kinship. For Suydam clearly had something to offer Kensett.

Over the fifteen or so years of their acquaintance, they often painted side by side and overlapped in their subject repertoires. They collected each other's pictures. They worked for the same patrons and shared concentric circles of friends. They nudged each other along, I would argue, toward an altered mode of landscape expression, with the coast as vehicle, to express quiet and repose. They both relied on reductive contours, which were the minimal vehicles often for evocations of mist and fog.

Part of what intrigues us here is the nature and importance of artistic friendships, a subject that remains relatively unexplored. In the world of the Hudson River School there were many alliances. Among them the Kensett-Suydam relationship stands out, in my mind, so it is a mystery why it has been omitted from the scholarship. Consider a passage from Suydam's letter to Kensett, reporting the preparations he finished to his painting box: "Your box is all finished and with the new palette I think you will like it. It looks like new. I prepared [it] myself with gum shellac. It is smooth and when the color is wiped off there remains none in the pores as is often the case with a new one."[67] Discussions of the painting materials continued, as indicated by a letter of December 17, 1862: "Please send by the bearer your large sketching box and the little walnut one I let you have last summer."[68] At first reading Suydam comes off as deferential, performing a menial task for the revered Kensett. The New York art world saw many such instances. Martin Heade ran errands for Church, picked up canvases, and handled transactions when his friend was away in exchange for the use of his studio. Preparing a paint box or a palette, however, is another matter; artists were extremely particular about how these objects were treated and usually took care of such things themselves. These acts Suydam performed for Kensett were therefore highly personal, a measure of their shared intimacy.

Conversations between the Work of Kensett and Suydam

We need to find a new language to articulate the relationship between these two artists, moving beyond categories like "influence" or "imitation." Concepts taken from Mikhail Bakhtin's dialogical system can provide alternatives. Yve-Alain Bois borrows a definition from the circle of Bakhtin in which he replaces the notion of "influence" with *active understanding*. This forces us to shift attention away from the interaction between individuals. Instead, the conversation we are interested in is between works of art, as Bois clarifies: "It should be noted . . . that the dialogue at issue. . . . is conducted not between two individuals talking, but between their works of art. And in works of art, as in personal conversations, a non-reply is a reply of sorts, if only a negative one: there are several

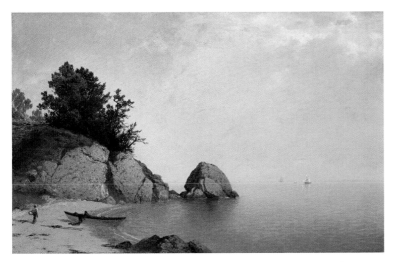

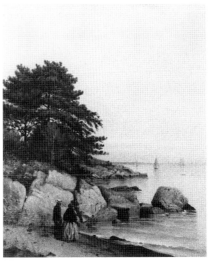

FIG. 1.8 John F. Kensett (1816–1872), *Beach at Beverly*, ca. 1869/1872, oil on canvas, 21¹⁵⁄₁₆ x 34 inches, National Gallery of Art, Washington, DC. Gift of Frederick Sturges, Jr. (1978.6.5). Image © Board of Trustees, National Gallery of Art.

FIG. 1.9 James A. Suydam (1819–1865) and William John Hennessy (1839–1917), *Foggy Morning, L.I.*, ca. 1860, oil on canvas, 12 x 10 inches, private collection.

stretches of time where Matisse and Picasso seem to ignore each other completely–even aggressively so." [69] Let us turn therefore to a dialogue between a landscape by Suydam and one by Kensett.

Suydam's *Beverly Rocks* (FIG. 1.1), thought to be his diploma piece for the Academy, immediately calls to mind a number of Kensett's pictures, such as *Beach at Beverly* (FIG. 1.8). In a like manner, both artists juxtapose the granite surfaces of the shoreline rocks with the hypercalm sheet of water into which they extend, and with the hazy atmosphere that engulfs them. Both measure space in controlled intervals, marked by shoreline waves, jetties, and tiny sailboats hovering on the horizon. One is even tempted, momentarily, to assume that they both depict the same locale, so close do the configurations of boulders appear at first glance. The pictorial arrangements, however, are different. First, there is the format of the canvas; Kensett's is horizontal, and almost twice as long as it is high, while Suydam's is vertical. Kensett's picture therefore sets up a contrast between mass and void, which pulls the eye off to the right along the limitless horizon. Suydam's choice of vertical orientation, on the other hand, creates a compressed space in which our eye seems to ricochet off one side of the canvas and then the other as it tries to follow the contours of shoreline rocks and jetties back to the horizon line. Rocks, trees, and distant sailboats all clamor for attention within the comparatively compressed confines of Suydam's canvas.

More revealing of Suydam's struggle to resolve form and atmosphere in his work is a second comparison between his *Foggy Morning, L.I.* (FIG. 1.9) and Kensett's *Beach at Beverly*. Again, Suydam has chosen the vertical orientation and Kensett the horizontal. What is more interesting

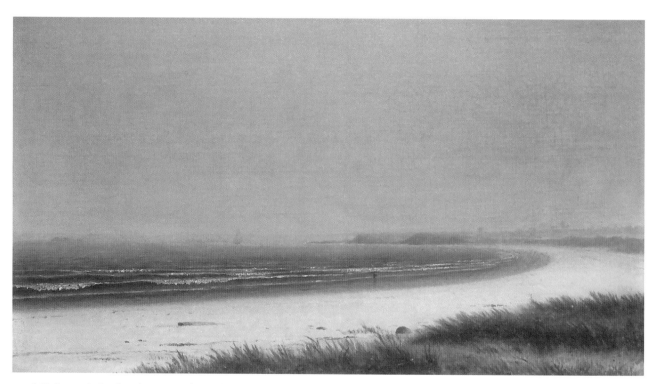

FIG. 1.10 James A. Suydam (1819–1865), *Beach Scene, Newport* (*Fog at Narragansett*), 1860, oil on canvas, 9 ½ x 16 ¼ inches, private collection, courtesy Betty Krulik Fine Art Limited, New York.

here is that both artists have now populated the foregrounds of the previous pair of images. While the male figure with his boat seems at ease in the surroundings of Kensett's painting, Suydam's couple—dressed in their Sunday finery—appear strangely out of place in this freshly observed scene from nature. Indeed, the addition of the figures seems to have been problematic, for visible even with the naked eye are pentimenti, traces of the artist's attempts to place them correctly in the space. These figures were, in fact, added by another hand, that of William John Hennessy.[70] Whether Suydam made a first attempt, scraped it away, and then enlisted Hennessy's help is uncertain; what is certain is that he always had difficulty with figure painting. These and other comparisons demonstrate, however, that even when Suydam was closest to Kensett, his images contain odd spatial pulls and tensions within them. Such features set him apart from his more experienced and sophisticated luminist counterparts and align him more closely with his more primitive, self-trained roots.

Suydam's *Beach Scene, Newport* (FIG. 1.10) ostensibly takes as its subject a site along the Rhode Island shore. It is organized around the golden sandy stretch of beach, which draws the viewer's eye from left to right across the foreground and up into its curl, where the land meets the horizon line demarcating water from sky. In its reduction of landscape elements to these minimal contours, *Beach Scene, Newport* invites comparison with works by Kensett including his *Eaton's Neck,*

Long Island (FIG. 1.11) painted twelve years later. The pervasive stillness, the anonymous reach of land, and the interest in the almost palpable sea air are strikingly similar in the two works. Yet even here, where they closely approximate one another, Kensett is immediately distinguishable from Suydam in his reliance on what we might call "weighted compositions," in which heavy, rocky masses protrude above the horizon line and serve to anchor the scene in space. Suydam, by contrast, confines

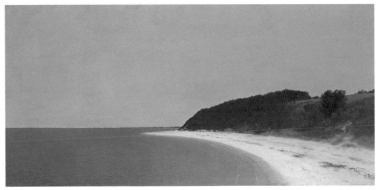

FIG. 1.11 John F. Kensett (1816–1872), *Eaton's Neck, Long Island*, 1872, oil on canvas, 18 x 36 inches, The Metropolitan Museum of Art, New York, Gift of Thomas Kensett, 1874 (74.29). Photograph ©The Metropolitan Museum of Art.

the landscape forms below the horizon in a manner that allows them to hover on the surface, in direct defiance of their material substance. Suydam produced pictorial statements of startling reductiveness. While their outward subject may be the beach at Newport or elsewhere, their true interest lies in the hazy-luminous atmosphere itself.

Suydam's death in 1865 was not the end of the dialogue with Kensett, but rather it initiated another phase. Kensett continued to meditate on the work of his old friend via the art that still hung on his walls, and on those owned by colleagues.[71] Here analogies to the famous relationship between Matisse and Picasso, despite the chronological gulf, are relevant to our discussion of Suydam and Kensett. As Bois observes about "the moving canvases Picasso realized shortly after

Matisse died," and that "in these works from the *Women of Algiers* series (1954–55) begun only a few weeks after Matisse's death, to the numerous *Studio at "La Californie"* paintings and *Women in a Rocking Chair* (1956), one can read Picasso's growing openness for Matisse's art, as if earlier cautions were cast to the winds."[72]

I propose that Kensett, in works such as *Eaton's Neck* and others of the late 1860s and early 1870s, responded to Suydam's *Beach Scene, Newport.* For in that small picture of 1860 Suydam had reduced land, sea, and sky to their most elemental and thereby deflected efforts to read a narrative from them. Most of his pictures lack narrative and evoke mood through tone and atmosphere. No other artist of the period would have left a canvas so daringly empty. After his friend's death Kensett must have pondered his work anew and, in a more receptive state of mind, utilized their lessons in creating the minimalist character of his own late work.

Plein Air Painting

Despite dialogue with Kensett, Suydam independently developed his own mastery in the handling of light and atmosphere. In fact these elements were his primary tropes. Tuckerman remembered especially "the few pictures of our coast scenery or of twilight which he loved to paint," and, indeed, the motif of sunset was one of his favorites. Pictures such as *At River's Bend* (FIG. 1.12) are the product of hours of outdoor study. Often he retreated to the flat expanses of the salt marshes. There "he would linger till twilight darkened the canvass [*sic*]" to record accurately the shifting effects of clouds and color. Undoubtedly the product of such labors is *Twilight, Salt Lake, Narragansett* (FIG. 1.13), a small horizontal image on which the narrow jetties of land appear as dark silhouettes about to dissolve in the gloaming. Such subtlety of expression could only be achieved by this plein air work, which must also lie behind *Twilight* (FIG. 1.14). This small panel, now badly deteriorated, once must have been a jewel-like picture of the mill set against the evening sky. One can imagine the artist returning to the marshes day after day in his efforts to capture in these pictures a special tinge of light characteristic of a particular moment in the passage from day to night. The fact that in 1859 the *Crayon* reported "Suydam has painted a second twilight scene, this time being about half an hour earlier than his picture of the Windmill" demonstrates that knowledgeable observers regarded his pictures as highly nuanced renderings of the passage of time and of the related changes in light.[73] His twilight landscapes were understood as part of an implied series.

Transition: From Private to Public Voice

Suydam's election to full membership to the National Academy in 1861 marked a turning point in his art. The pictures done after that date display more fully elaborated compositions and greater expertise in the handling of oil paints to describe natural effects. At the same time he seemed more self-assured and confident of his powers as an artist. As his compositions achieve fuller resolution, so the canvases themselves increased in size and began to bear a full signature and date (earlier works, by comparison, bore only his initials, usually etched into the wet paint with a brush handle). The later works seem to be intended, in other words, as public statements rather than private

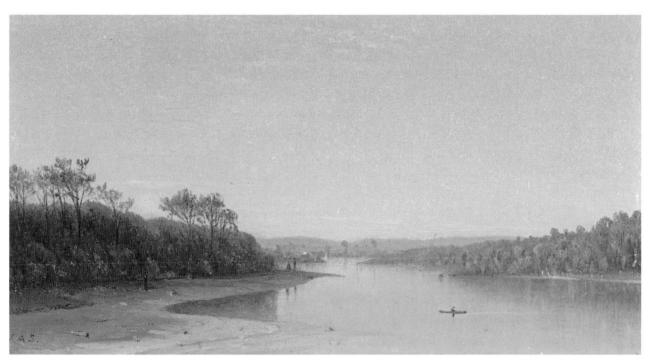

FIG. 1.12 James A. Suydam (1819–1865), *At River's Bend*, ca. 1855, oil on canvas laid down on artist's board, 5 x 10 inches, private collection.

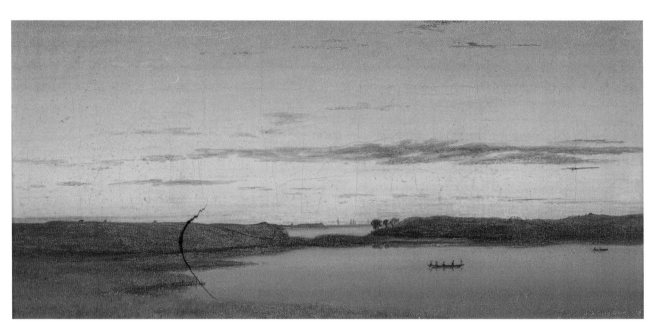

FIG. 1.13 James A. Suydam (1819–1865), *Twilight, Salt Lake, Narragansett*, ca. 1858, oil on canvas, 7 x 14⅛ inches, Century Association, New York, Edward Slosson Bequest, 1871.

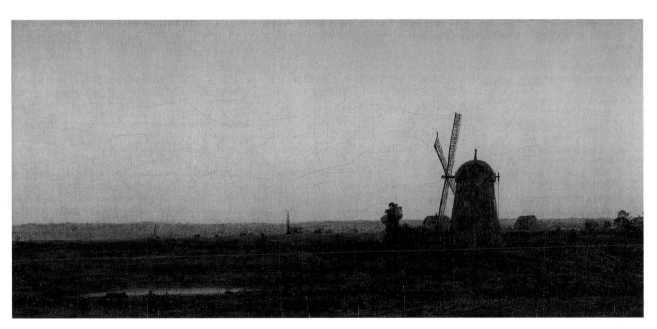

FIG. 1.14 James A. Suydam (1819–1865), *Twilight*, undated, oil on canvas, 6 x 12 inches, National Academy Museum.

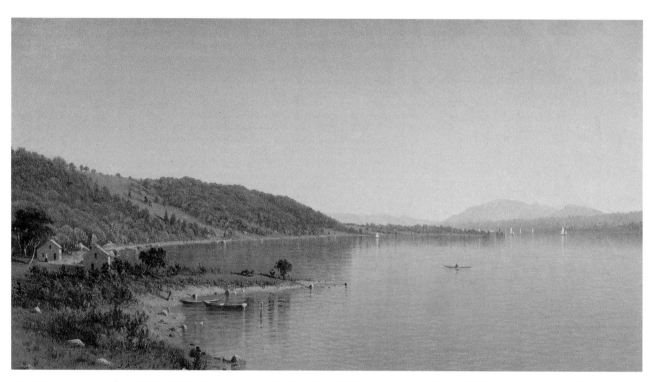

FIG. 1.15 James A. Suydam (1819–1865), *Hook Mountain, Hudson River*, 1863, oil on canvas, 12½ x 21¾ inches, Ann and Lee Higdon Collection.

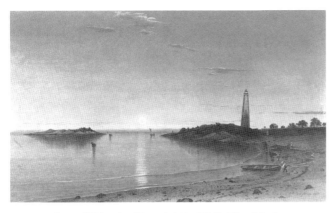

FIG. 1.16 Samuel Valentine Hunt (1803–1893), 5⅜ x 9 inches, engraving after James A. Suydam (1819–1865), *Long Island Sound*, ca. 1863, collection of Olana State Historic Site, New York State Office of Parks, Recreation and Historic Preservation.

FIG. 1.17 Engraving after James A. Suydam (1819–1865), reproduced as an illustration for Edmund Waller's poem, "The Seas are Quiet," in *Festival of Song: A Series of Evenings with the Poets* (New York: Bunce and Huntington, 1866). The Research Libraries, The New York Public Library, Astor, Lenox and Tilden Foundations.

essays. In the estimation of his colleagues at the Academy, as in his own mind, he had reached a milestone in his development. It was perhaps this change that prompted diarist George Templeton Strong's reminiscence that "Poor Jem Suydam . . . devoted himself to landscape art some years ago, first as an amateur and then professionally."[74] This brief period from 1861 until his death in 1865, then, gave rise to the works of his artistic maturity: *Hook Mountain, Hudson River* (FIG. 1.15), which "created some sensation" when it was shown at the National Academy Annual;[75] *View on Long Island*; *Long Island Sound* (FIG. 1.16); *On the Beach, Newport*; and *Paradise Rocks*. As will be discussed in the following chapters, his mature phase coincided with a greater effort on his part to exhibit more widely; he showed his work from 1861 to 1865 at the Brooklyn Art Academy (with a posthumous entry in November 1867) and at numerous locales around the country.[76]

Tuckerman singled out *Long Island Sound* for illustration in the deluxe edition of his book and described as follows:

> *It possesses that coolness of tone and tenderness of expression which formed the principal charms of his pictures. The hour represented is just at sunset, when the last rays of the sun shine on the summit of the lighthouse, while its base is in full shadow. The full moon has just risen, and its beams make a broad pathway from the beach to the horizon across the calm waters . . . The sandy beach, with an occasional rock, green and slimy with salt waves, jutting above its level, marks the foreground. A boatman is in the act of drawing upon the sands his light skiff, and . . . several other figures are discernible. In the distance, a rocky island slightly wooded is reflected in the calm waters, and a few clouds, their edges tinged by the rays of the setting sun, float in the mid-heaven. The quiet, thoughtful character of this picture is eminently pleasing and suggestive.*[77]

Long Island Sound repeats the formal arrangement of *Hook Mountain, Hudson River*, where the orderly planar geometries are broken by the strong curve of the shoreline. It appears also in his illustration for Edmund Waller's poem "The Seas are Quiet . . ." published in *Festival of song* (FIG. 1.17).[78] The motif manifests a confluence with Joseph Mallord William Turner, who employed this curved or vortical configuration for its most sublime expression in works such as *Snowstorm: Steamboat off a Harbor's Mouth* (exhibited 1842; National Gallery, London) and in his earlier, well-known *Snowstorm: Hannibal and his Army Crossing the Alps* (1812; Tate Collection). Americans of this period were aware of Turner through their readings of John Ruskin. Their real acquaintance with his work came primarily through the media of prints and book illustrations, where the linear treatment was far more congenial to them than was what Durand called "Turner's excesses" on his canvases. Prints and illustrated books in Suydam's library (see Appendix 3) such as Turner's *Liber Fluviorum: or River Scenery of France* and *Harbours of England* with commentary by Ruskin would all have supplied needed compositional models.

The graphic image of the vortex became a symbol of Turner's preoccupation with light, as Adele Holcomb has discussed.[79] Studying Turner's prints, the Americans further translated the vortex into the terrestrial motif of the curved beach. They then combined this with the schematic treatment of the sun and its reflection on the water—overexaggerated in the prints—to express their parallel striving toward the luminous core. Suydam's *Long Island Sound* exemplifies his utilization of these Turnerian schema as a means to establish light as the picture's symbolic center.

This very synthesis of light and terrestrial motif recurs in some of the finest luminist compositions including, by Fitz Henry Lane (formerly known as Fitz Hugh Lane),[80] *Owl's Head, Penobscot Bay* (1862), *Norman's Woe* (1862), and *Brace's Rock* as well as Heade's *Stranded Boat* (1863). The pictures derive their power, in part, from the tension between the insistent planar classicism and the articulation of anticlassical tendencies in the organic curve of sand. They represent the artist's desire for a haven safe from the storm-tossed waves and brutal winds of the North Atlantic. Suydam's implementation of this compositional motif demonstrates his continuity with a harmonious worldview characteristic of luminism.

The worldly and experienced Miner Kellogg claimed of his protégé that "no artist that I know more fully manifests his personal character in his Works" than Suydam.[81] The link between the character of the artist and the art he or she produced, as nineteenth-century observers interpreted it, was close indeed. It provided the foundation for Henry T. Tuckerman's aesthetic: "The disposition or moral nature of an artist directly and absolutely influences his works. We constantly talk of a 'feeling for color'—of a picture exhibiting a fine or true 'feeling,' and theirs instinctively recognize a transfusion of the natural sentiment and tone of mind into and through the mechanical execution, design, and spirit of a pictorial work."[82] Daniel Huntington echoed these ideas when he reported, "When rallied on his choice of quiet subjects [Suydam] replied, 'I must paint what I feel.'"[83] He insisted that painting is based above all on feelings, on emotional expression. His art was not based in scientific or even transcendental realism, but was instead eminently poetic. Suydam was the consummate poet of the palette.

NOTES

1. Saul Bellow, *Humboldt's Gift* (New York: Pengin Books, 1996), 311.

2. Sanford Gifford, Manuscript Memoir of James A. Suydam, 1865, National Academy Museum Archive, unpaginated.

3. John I. H. Baur, "A Tonal Realist: James Suydam," *Art Quarterly* (Summer 1950): 221.

4. Suydam was baptized on July 4, 1819. "Record of the South Reformed Dutch Church on Garden Street in New York," type-script by Royder Woodward Vosburgh, 1921, New York Historical Society.

5. Henry Suydam, *History and Reminiscences of the Mesier Family of Wappingers Creek: Together with a Short History of the Zion Church* (Privately printed, 1882), 20.

6. Family records indicate that Catherine Matilda Suydam married Philip M. Lydig; Henry Suydam married Mary Reese; Peter Mesier Suydam remained unmarried; John R. Suydam married Ann Lawrence; David Lydig Suydam remained unmarried; the surviving Maria Louisa married Jacob Reese; Letitia Jane Suydam married Charles Jeffrey Smith; and James Augustus Suydam remained unmarried. Ibid., 32–34.

7. "Obituary of James A. Suydam," *New York Evening Post*, 16 September, 1865, n.p. According to the Burial Record of St. Mark's, Suydam was interred within the church vault on September 19, 1865.

8. Gifford, Manuscript Memoir of James A. Suydam.

9. For a discussion of the contrasting impact of the economic downturn on the Blakelock family, see Glyn Vincent, *The Unknown Night: The Genius and Madness of an American Painter* (New York: Grove Press, 2003), 40.

10. Following her husband's death in 1841, Jane Mesier Suydam (fifteen years her husband's junior) resided with James at Waverly Place until her own passing in 1864, just a year before her son's. We can imagine that the relationship between the unmarried artist-son and widowed mother, who lived alone together for more than twenty-five years, must have been close.

11. Suydam and his brother Peter Mesier applied for their passports on November 5, 1842. Register of Passports, National Archives, New York, reel M1371, 124.

12. Miner K. Kellogg, to Daniel Huntington, 1 May 1866, National Academy Museum Archive (hereafter cited as Kellogg to Huntington).

13. James Jackson Jarves, *The Art-Idea*, ed. Benjamin Rowland Jr. (Cambridge, MA: Belknap Press, 1960), 99.

14. Kellogg to Huntington.

15. Kellogg to Powers, 6 June 1843, Hiram Powers Collection, Cincinnati Historical Society; my thanks to Mrs. Ronald D. Shepherd, Curator of Manuscripts, for assistance with these references

16. Mary Cassatt was also interested in Correggio and made at least one copy of the female figure after him. Her work after the Civil War engages a different dimension of Correggio than that which interested Suydam in the 1840s. But so many painters in the second and third quarters of the nineteenth century did draw inspiration and guidance from the study of his work that this represents an important aspect of his European experiences. See Nancy Mowll Mathews, ed. *Cassatt and Her Circle, Selected Letters* (New York: Abbeville, 1984).

17. Kellogg to Powers, 8 July 1843: "...the Suydams are well at Geneva—they go to Munich." Hiram Powers Collection, Cincinnati Historical Society.

18. Bayard Taylor to Franklin Taylor, 26 October 1845, in *Life and Letters of Bayard Taylor,* eds. Marie Hansen-Taylor and Horace E. Scudder (Boston: Houghton Mifflin, 188), 1:57.

19. Gifford, Manuscript Memoir of James A. Suydam.

20. Kellogg wrote to Hiram Powers from Malta on January 4, 1845: "The Suydams are here on their way to Italy from Constantinople and are off to day and will put this into the Post at Naples." Hiram Powers Collection, Cincinnati Historical Society.

21. Gifford, Manuscript Memoir of James A. Suydam.

22. Thomas Crow, *Painters and Public Life in Eighteenth-Century Paris* (New Haven and London: Yale University Press, 1985), 138.

23. [Daniel Huntington], "Flake White," *Crayon* 3 (1856): 29–30, 379–80.

24. "Sketchings. National Academy of Design," *Crayon* 4 (July 1857): 221.

25. Benjamin Champney to John F. Kensett, 16 March 1858; John F. Kensett Correspondence, Edwin D. Morgan Collection, New York State Library at Albany. Copies, Archives of American Art, Smithsonian Institution, reel N68-85 (hereafter cited as Kensett Correspondence).

26. Gifford, Manuscript Memoir of James A. Suydam.

27. Mummy [Alvan Fisher], "Letter from North Conway," October 1856, *Crayon* 3 (1856): 348.

28. Tuckerman, *Book of the Artists*, 540.

29. Ibid. Also see Kevin Avery who states: "Because of family wealth, Gifford was one of the few American painters of his day not compelled to paint for a living," in Barbara Novak and Annette Blaugrund, eds., *Next to Nature. Landscape Painting in the National Academy of Design* (New York: National Academy of Design, 1980), 44–45.

30. Remarks by Huntington quoted in Tuckerman, *Book of the Artists*, 541.

31. "Domestic Art Gossip," *Crayon* 6 (March 1859): 91.

32. Remarks by Huntington quoted in Tuckerman, *Book of the Artists*, 541.

33. Martin Hardie, *Water-Colour Painting in Britain*, ed. Dudley Snelgrove (London: Batsford, 1967–68), 3:266.

34. Suydam to Kellogg, September 1850, Miner K. Kellogg Papers, Cincinnati Historical Society.

35. Suydam to Kensett, 7 August 1861, Kensett Correspondence.

36. We might compare this to the status of ministers, who Ann Douglas, in her *The Feminization of American Culture* (New York: Knopf, 1977), argues belong in the female sphere.

37. Quoted in Griselda Pollock, *Mary Cassatt* (London: Jupiter Books, 1980), 13.

38. Henry James, *Roderick Hudson* (1875 first serial publication; Oxford: Oxford University Press, 1980), 4–5.

39. Ibid., 5.

40. Ibid., 50.

41. Ibid., 63.

42. Tuckerman, *Book of the Artists*, 540.

43. Suydam, *History and Reminiscences of the Mesier Family*, 22–23.

44. Gifford, Manuscript Memoir of James A. Suydam.

45. Daniel Huntington, Manuscript Memoir of James A. Suydam, ca. 1865, National Academy Museum Archive, n.p.

46. Ibid.

47. On Kellogg's involvement with spiritualism, see John Davis, *The Landscape of Belief: Encountering the Holy Land in Nineteenth-Century American Art and Culture* (Princeton: Princeton University Press, 1996), 103–6.

48. Kellogg to Huntington.

49. According to research conducted by Joanna Schoff of the Bartow-Pell Mansion, he bought Oakshade for $9,000 and sold it for $27,000—equivalent to about $610,000 in today's purchasing power.

50. Kellogg to Huntington.

51. Clara Erskine Clement and Lawrence Hutton, *Artists of the Nineteenth Century and their Works* (Boston: J. R. Osgood and Company, 1884), 280.

52. John K. Howat, *John Frederick Kensett, 1816–1872* (New York: American Federation of Arts, 1968), n.p.

53. Gifford.

54. Benjamin Champney to John F. Kensett, 12 February 1856, Kensett Correspondence.

55. "Second Notice of the National Academy of Design Exhibition," *New York Times*, 4 April 1856, 2.

56. Gifford, Manuscript Memoir of James A. Suydam.

57. "Sketchings. Exhibition of the National Academy of Design," *Crayon* 5 (May 1858): 147.

58. Suydam to Kensett, Kensett Correspondence.

59. "Domestic Art Gossip," *Crayon* 6 (December 1859): 399.

60. "Review of the National Academy of Design Exhibit, " *New York Daily Tribune* March, 1860, n.p.

61. "Academy of Design Exhibition," *Cosmopolitan Art Journal* (June 1860), 81.

62. Champney to Kensett, 3 September, 1854; John F. Kensett Papers Archives of American Art, Smithsonian Institution, reel 1533.

63. "Domestic Art Gossip," *Cosmopolitan Art Journal* 2 (1858): 184

64. John I. H. Baur, ed., "The Autobiography of Worthington Whittredge, 1820–1910," *Brooklyn Museum Journal* 1 (1942): 60.

65. Olyphant to Kensett, 3 October 1859; Kensett Correspondence.

66. Letters written from Suydam to Kensett from 1858 to 1862, for example, can be found in the Kensett Correspondence.

67. Suydam to Kensett, New York, 21 August 1860, Kensett Correspondence.

68. Suydam to Kensett, New York, 17 December 1862, Kensett Correspondence.

69. Yve-Alain Bois, *Matisse and Picasso* (Paris: Flammarion; Fort Worth, Texas: Kimbell Art Museum, ca.1998), 16.

70. A painting is listed in the auction catalogue of Samuel Avery's private collection as "#53. James A. Suydam, deceased. *Foggy Morning* (Figures by W. J. Hennessy)." See *Catalogue of the Private Collection of Oil Paintings by American Artists made by*

Samuel P. Avery, during the past 15 years and now to be sold on account of his going to Europe (New York: Leeds, 4 February 1868). Interestingly, Hennessy also painted the figures in no. 36 in the same catalogue, William Stanley Haseltine's *Narragansett Rocks*.

71. Kensett had in his possession until his death several works by Suydam; see *The Collection of over Five Hundred Paintings and Studies by the Late John F. Kensett* (New York: s.n., March 1873[?]). Lang owned *Foggy Morning, L.I.* (1866), which must hung in the quarters he shared with Kensett.

72. Bois, *Matisse and Picasso*, 16–17.

73. "Domestic Art Gossip," *Crayon* 6 (March 1859): 91.

74. Allan Nevins and Milton Halsey Thomas, eds, *The Diary of George Templeton Strong* (New York: Octagon Books, 1974), 2:99.

75. Ila Weiss, *Poetic Landscape: The Art and Experience of Sanford R. Gifford* (Newark, Delaware: University of Delaware Press, 1987), 260. The painting was also included in a small group of his works assembled for the 1866 National Academy exhibition following his death. It likely had its genesis in a trip the artist made in August 1862, during the second summer of the Civil War.

76. Clark S. Marlor, *A History of the Brooklyn Art Association with an Index of Exhibitions* (New York: James F. Carr, 1970).

77. Tuckerman, *Book of the Artists*, 540. The engraving was reproduced again in *Appleton's Journal* 2 (November 27, 1869), opposite 449.

78. [Frederick Saunders], *Festival of Song: a Series of Evenings with the Poets* (New York: Bunce and Huntington, 1866). Suydam's illustration appears on page 59.

79. Adele M. Holcomb, "The Vignette and the Vortical Composition in Turner's Oeuvre," *The American Quarterly* 33 (Spring 1970): 27.

80. A new preface to John Wilmerding's monograph, now entitled *Fitz Henry Laane* (1971; repr., Danvers, MA: Bradford & Bigelow, 2005), explains the correction to Lane's name.

81. Kellogg to Huntington.

82. Tuckerman, *Book of the Artists*, 514. The remarks were made in the context of his discussion of Kensett.

83. Huntington, Manuscript Memoir of James A. Suydam.

FIG. 2.1 Daniel Huntington (1816–1906), *James Augustus Suydam, NA*, 1862, oil on canvas, 30 x 25 inches, National Academy Museum, Bequest of James A. Suydam.

Chapter 2

ORDER IN CIVIL WAR NEW YORK

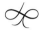

Mark D. Mitchell

How she led the rest to arms, how she gave the cue, . . .
How Manhattan drum-taps led.
—Walt Whitman, *Leaves of Grass*[1]

JAMES SUYDAM WAS ELECTED to full membership in the National Academy of Design in May 1861, just a month after Southern troops fired on Fort Sumter and began the Civil War. Suydam's career as a professional artist largely coincided with the war, and his death in September 1865 came just five months after its conclusion. No other artist's professional life so closely paralleled national events, and Suydam's mature art was greatly influenced by his time. During this later portion of his brief career, Suydam demonstrated new ambition in his art and new dedication to the service of his art community and country.

Although Suydam did not fight in the war—at age forty-one when the war began, he was already well beyond the thirty-five-year age limit of the 1863 draft—his experiences in Civil War New York had a defining influence on his art. In the midst of the city's deteriorating and sometimes chaotic social conditions, Suydam created an art of order and helped to advance a national institution, the National Academy of Design. Daniel Huntington's 1862 portrait of Suydam (FIG. 2.1) poses him before a turbulent, overcast seascape, not at all the serene climate for which Suydam's own art was admired, but rather a brooding stormscape that conveys his awareness of Suydam's personal experience during the war.

The View from Washington Square

Understanding Suydam's New York in the midst of the war is essential to understanding his art, because his life there influenced the most personal, unique qualities of his work. In a letter to John F. Kensett written during the summer of 1861, Suydam exclaimed that creating art felt like "all vanity and vexation of spirit" when "the sad state of the country comes to mind."[2] While his art of the 1860s documented a personal struggle with the trials of war, his actions contributed to

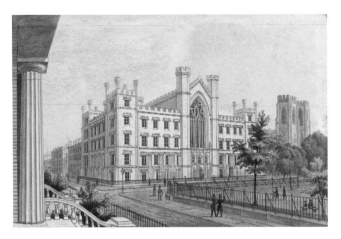

FIG. 2.2 Anonymous, *University of the City of New York, Washington Square*, 1850, watercolor on paper, 6 x 9 1/16 inches, I.N. Phelps Stokes Collection, Miriam and Ira D. Wallach Division of Art, Prints and Photographs, The New York Public Library, Astor, Lenox and Tilden Foundations.

FIG. 2.3 View looking northeast from the roof of University of the City of New York (NYU), 1859. The Suydam home was in the row of townhouses visible at the lower right. The Library Company of Philadelphia.

the Union cause. The struggle to preserve order, a leading attribute of Suydam's landscape art, also characterized his life in New York.

New York City's nineteenth-century growth is difficult to grasp, because it was meteoric. Between 1800 and 1860, Manhattan's population expanded from 60,515 to 813,669, a town to a metropolis, and suffered an array of growing pains as the city's infrastructure struggled to keep pace.[3] Strikes and riots regularly brought simmering class conflict to the streets, where it could not be ignored or obscured, including forty-two protests in 1864 alone. Historian Sean Wilentz has observed that the onset of the Civil War "did not end the tensions of class or the ongoing struggles in the workshops" demanding higher wages and political reform.[4] To maintain stability in the increasingly crowded city, the wealthy moved into protective enclaves that were removed, though never far, from disease-prone and crime-ridden districts, such as the infamous Five Points slum.

In 1838, Suydam's family moved from a mansion at 4 Broadway to a Greek Revival townhouse at 25 Waverly Place in the fashionable Washington Square area. Across the street from their new home stood the imposing main building of the University of the City of New York (FIG. 2.2), where James attended college. Suydam would continue to list the family home as his primary residence until his death.[5] His experience of New York City during the antebellum and Civil War era, therefore, derived primarily from the vantage of Washington Square (FIG. 2.3).

Henry James later wrote that the area enjoyed "a kind of established repose which is not of frequent occurrence in other quarters of the long, shrill city."[6] James' 1881 novel *Washington Square* offered eloquent glimpses of life there during the period: "The ideal of quiet and genteel retirement, in 1835, was found in Washington Square, where the doctor built himself a handsome,

modern, wide-fronted house, with a big balcony before the drawing-room windows, and a flight of white marble stairs ascending to a portal which was also faced with white marble. This structure, and many of its neighbors, which it exactly resembled, were supposed . . . to embody the last results of architectural science, and they remain to this day very solid and honorable dwellings."[7] Though no photographs document the Suydam residence, period insurance maps show its basic layout during the 1850s (FIG. 2.4).[8] The structure was a "first class" brick or stone building on a corner lot at the intersection of Greene Street and would therefore have enjoyed more sunlight and air circulation than most of its neighbors. These were desirable features in an era when disease was rampant in American cities; fresh air and sunlight were believed to fight illness.

Both the Suydam and James families inhabited coveted properties adjacent to the landmark group of Greek Revival townhouses that lined Washington Square North known as The Row (FIG. 2.5). Built in 1833, The Row exerted considerable influence upon architectural taste and led to the construction of similar residences in the area, including the Suydam home. Greek Revival construction itself imposed classical order and balance upon the unruly, heterogeneous architectural styles of New York. Grouping together to create a consistent aesthetic, the rowhouses established a sense of community and conformity to which many affluent New Yorkers hoped to belong. Historian Luther Harris has observed, "No laws or codes then ensured such uniform compliance [with the prevailing architectural style], but social rigidity did, and it had the unintended benefit of fending off a hodgepodge of designs" around Washington Square.[9] This was the environment of classicism and communal influence in which Suydam lived his adult life.

FIG. 2.4 William Perris (d. 1862), *New York City* (detail, Suydam residence circled), 1857, engraving, The Lionel Pincus and Princess Firyal Map Division, The New York Public Library, Astor, Lenox and Tilden Foundations.

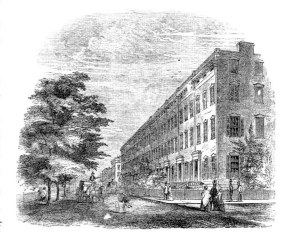

FIG. 2.5 *Waverley Place*, ca. 1850, engraving, Museum of the City of New York.

By the 1860s, Washington Square had consolidated its leadership of American intellectual and artistic culture. The Tenth Street Studio Building, Century Association, New York Society Library (a private subscription library to which Suydam also belonged), Astor Place Opera House, and National Academy of Design were all located within six blocks of the Suydam home.

FIG. 2.6 *The Riots in New York: Destruction of the Coloured Orphan Asylum*, 1863, engraving, Picture Collection, The Branch Libraries, The New York Public Library, Astor, Lenox and Tilden Foundations.

FIG. 2.7 Thomas Hicks (1823–1890), *Harriet Beecher Stowe*, 1855, oil on canvas, 20 x 16⅝ inches, National Academy Museum, Bequest of James A. Suydam.

Moreover, New York University rented studios in its main building to numerous leading American artists, including Samuel F. B. Morse and Daniel Huntington, over the course of mid-century. The proximity of these leading institutions meant that Suydam had virtually no need for the chaotic main avenues and omnibuses that were so critical for many New Yorkers' daily travels between areas of the city. Though his daily peregrinations between home, work, and social club required virtually no exposure to other areas of the city, the war made the presence of New York's underclass inescapable.

Rising tensions in New York erupted with the institution of the military draft in 1863. In urban areas such as New York, dissenting Democrats found a ready audience for fear mongering and race-baiting. Underemployment and minimal public services in heavily Irish working-class neighborhoods fed disenchantment and disillusionment with the war's purpose. As historian James McPherson has succinctly summarized: "Crowded into noisome tenements in a city with the worst disease mortality and highest crime rate in the Western world, working in low-skill jobs for marginal wage, fearful of competition from black workers, hostile toward the Protestant middle and upper classes who often disdained or exploited them, the Irish were ripe for revolt against this war waged by Yankee Protestants for black freedom."[10] The culmination was "the worst riot in American history," pitting rioters against several regiments of federal troops who fired directly into crowds during July 1863 (FIG. 2.6). More than one hundred people were killed, though several contemporary journals reported deaths in the thousands. On top of their widespread physical destruction and looting, rioters attacked any

50

well-dressed individual found in the streets. New York's veneer of order and civility was irreversibly shed.

Suydam's personal allegiance to the Union and abolition is clear from both his writing and his art collection. His ownership of Thomas Hicks's 1855 portrait of *Harriet Beecher Stowe* (FIG. 2.7), the polemical author of *Uncle Tom's Cabin* (1852), is a revealing example of the latter.[11] By 1857, more than half a million copies of *Uncle Tom's Cabin* were in circulation, igniting abolitionist sentiment throughout the North and making Stowe a national icon. Hicks's portrait provided the basis for Stowe's canonization in the American literary pantheon in his composite portrait of *Authors of the United States,* known today only through an 1866 engraved reproduction by Alexander Hay Ritchie.[12] Hicks's portrait was taken from life, one of dozens that he likely painted as studies for the *Authors,* and Suydam's choice of this particular portrait for his collection conveys a sense of the degree of his commitment to abolition.

Patron and Patriot

Suydam was keenly aware of society's inequities. He kept reminders of the struggles of the poor close at hand, including French artist Octave Tassaert's *Poverty* (FIG. 2.8), which he purchased in 1857 and exhibited in his studio.[13] The work depicts a young woman huddled in a doorway in the midst of winter, her hands joined in futile prayer. The figure's pallor and gaunt features suggest she will not survive to bring her bales of sticks home. The composition implies that her life is as fragile as the sticks she carries. Tassaert's harsh depictions of poverty gained modest critical recognition, but differed in kind from the more common and cheerful genre scenes of working-

class life that prevailed during the period. Suydam's purchase of *Poverty* in the midst of the economic depression that followed the Panic of 1857 conveys his awareness of the widespread suffering in New York during the period.

As Suydam entered his own professional maturity, his collecting appears to have undergone a simultaneous shift toward the charitable encouragement of his younger peers. Suydam was relatively upbeat when he described the conditions for artists in 1861, writing that "[t]he times are hard but notwithstanding there are commissions given."[14] On his own part, however, instead of collecting major works by leading American and European contemporaries, as he done during the 1850s, Suydam increasingly supported the work of American artists such as John George Brown (1831–1913) and William Parsons Winchester Dana (1833–1927), both more than a decade his junior. Suydam's encouragement of his peers would become one of the attributes that his eulogists remembered of him. National Academy President Daniel Huntington wrote that Suydam's "charities were generous and his liberality often bestowed

FIG. 2.8 Octave Tassaert (1800–1874), *Poverty,* 1856, oil on canvas, 22 x 18¼ inches, National Academy Museum, Bequest of James A. Suydam.

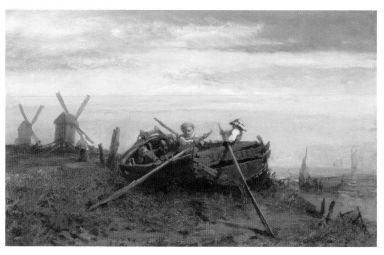

FIG. 2.9 John George Brown (1831–1913), *The Victim*, 1861, oil on canvas, 14 x 12 inches, National Academy Museum, Bequest of James A. Suydam.

FIG. 2.10 William Parsons Winchester Dana (1833–1927), *Admirals in Embryo*, ca. 1862, oil on linen, 10⅜ x 16 inches, National Academy Museum, Bequest of James A. Suydam.

on struggling artists, but he never lisped a word of them, and it is only by his books since his death that the extent of his beneficence has become known."[15]

Suydam's collecting, like his own painting, declined during the war. The works that he did acquire, such as Brown's *The Victim* (FIG. 2.9) of 1861 and Dana's *Admirals in Embryo* (FIG. 2.10) of about 1862, embody the relative youth of their creators as well as the theme of childhood that runs through Suydam's collection.[16] Both Brown and Dana also overlapped with Suydam at the Tenth Street Studio Building, offering a likely context for his purchases of their works: Brown moved there in 1861 and Dana arrived in 1863.[17] Suydam's patronage of the works of emerging artists who depicted contemporary culture and concerns, even if couched in youthful terms, portrays his own search for understanding of the new cultural landscape that the Civil War created.

Suydam kept a low public profile during his lifetime, but his contributions as a power broker in the New York art world were publicly acknowledged after his death. His friend Worthington Whittredge, reflecting back upon the National Academy's first half century in 1875, indicated that the institution owed "an equal debt" to its founding president Samuel F. B. Morse and to Suydam: "One commenced, the other perpetuated the Academy."[18] Suydam's leading contribution during the 1860s was undoubtedly his service as treasurer of the Academy's Fellowship Fund, created to pay for a lavish new home for the institution that was completed in 1865, shortly before Suydam's death. In that role, Suydam's background and cultural heritage in New York contributed to his success.

Suydam's involvement in the Fellowship Fund and his later bequest most clearly document his commitment to the endurance of New York's culture of art during and after the Civil War.

Officially created in January of 1863, the Fund was chartered "separate from the ordinary Treasury of the Academy... [and] devoted to perfecting the building, sustaining the schools, and generally advancing the interests of the Academy."[19] Its primary function, however, was to support the construction of the Academy's new building, which had moved regularly between quarters since 1826 and had to arrange a temporary space in most years for its sprawling Annual exhibitions. Acknowledging the enormous growth and popularity since its founding, the Academy's leadership felt that a single, integrated edifice was needed to consolidate the institution's activities and standing, but should not bankrupt the institution with its construction costs.

In his role as the Fund's treasurer, Suydam reached out to New York's leading citizens, utilizing his influence as a former merchant and a member of one of the city's oldest Dutch families. Suydam's ancestor, Hendrick Rycken Suydam, had arrived in what was then New Amsterdam in 1663, just a year before the British took control of the city and renamed it New York.[20] The Suydam family exercised considerable influence in early New York as one of the city's leading merchant families, a lasting reputation that persisted throughout the nineteenth century. Lineage was a significant component of identity in nineteenth-century New York because of the city's rapid development as a veritable boom town. Cultural heritage provided a stable source of identity in an urban culture that changed daily.

FIG. 2.11 Eastman Johnson (1824–1906), *The Art Lover*, 1859, oil on canvas, 12⅜ x 15 inches, National Academy Museum, Bequest of James A. Suydam.

In March 1862, Suydam was elected to membership in the St. Nicholas Society, a heritage organization founded in 1835 by Washington Irving devoted to the history of New York City, particularly its early Knickerbocker history, signaling Suydam's personal investment in the topic.[21] His admiration for Dutch culture extended to both his art collection and his own art. He owned Eastman Johnson's *The Art Lover* (FIG. 2.11) of 1859, which depicts a young Dutch girl in studious contemplation of an illustrated book.[22] More than many of his American colleagues, Suydam also expressed interest in the iconic Dutch windmill. The only buildings featured in Suydam's known works are windmills. Two of his paintings prominently feature them, *The Windmill* (FIG. 2.12) and *Twilight* (FIG. 1.14), and several others include them in the distance. Dana's *Admirals in Embryo* similarly includes windmills prominently in the composition. Suydam's interest in New York's cultural heritage, his family history, and his wealth collectively provided recognition among and access to the city's leading figures, whom he would recruit as subscribers to the Fellowship Fund.

FIG. 2.12 James A. Suydam (1819–1865), *The Windmill (Easthampton, Long Island)*, ca. 1864, oil on canvas, 6¼ x 10¼ inches, Century Association, New York, William Cullen Bryant Collection.

The Fund bridged the gap between the basic, functional structure that the Academy could afford and the final, landmark structure designed by Peter Bonnett Wight. Donors subscribed to the Fund at three levels—Fellowship, Life Fellowship, and Fellowship in Perpetuity—for which they received various benefits and access to the Academy's exhibitions and programs. As the Academy's first historian Thomas Seir Cummings observed two years later, "It is scarcely necessary to say that the Fellowship Fund proved an immense, a wonderful success."[23] Suydam not only became a Fellow in Perpetuity himself, but was credited with obtaining high-level support from New York's wealthiest citizens, who provided the vast majority of funding for the Academy's new home.[24]

The genius of the Fellowship Fund was its financing, through which Suydam transformed a local initiative into a patriotic investment. Instead of dividing the Fund's accumulating savings between local and federal bonds, as initially proposed, Suydam invested entirely in Union War Bonds. The effect was to convert a seemingly ill-timed fundraising program in the midst of war into a civic campaign. Created shortly after the Union's qualified victory at Antietem in September 1862 and Lincoln's ensuing issuance of the Emancipation Proclamation, the Fund capitalized on a moment of relative strength. Suydam was aware of the progress of the war and doubtless considered its conduct as he and the other trustees of the Fund planned their own "indefatigable" campaign. Daniel Huntington recalled their strategy in terms of military metaphors, as Suydam and his colleagues "hunted the men of taste and fortune from their homes to Wall Street, and from Wall Street again to their homes" and "invaded even the sacred privacy

FIG. 2.13 *Grand Staircase, National Academy of Design*, engraving, published in *Harper's Weekly* (3 June 1865), p. 348, National Academy Museum Archive.

of the evening domestic circle" to recruit subscribers.[25] A soft-spoken man by nature, Suydam paid a price for his active participation in the Fellowship Fund, complaining to friends that it drained his energies and diverted attention from his art. His achievement in the form of the new building, however, was impressive and led to his election as the Academy's overall treasurer in 1865.

The new building involved years of planning, beginning with its search for a property in 1859, and Suydam reportedly "took a very prominent part in its construction."[26] The building's exotic exterior announced the Academy's link to Europe's architectural history, while the interior was designed to suit the Academy's several functions as a school, clubhouse, and art gallery. The lower level housed the Academy's school, and was designed to provide daylight in the classrooms and study alcoves. The second, or main, floor was entered directly from the exterior via a double staircase and contained various reception and meeting rooms as well as

the Academy's lecture hall. The uppermost floor was dedicated to exhibition space illuminated by skylights. A ring of galleries surrounded the crest of the building's grand staircase. That innermost space was reserved for the display of works in the Academy's permanent collection (FIG. 2.13) and was undoubtedly where Suydam envisioned his own collection on display when he wrote his will in September 1865, just months after the new building opened.[27]

Going Public

Suydam's practice as a professional artist during the 1860s was distinctly modern. Deeply affected by the developments in the world around him, Suydam transformed his art from a personal statement into a public discourse. Stepping outside of his guarded, private lifestyle as a wealthy New Yorker, he expressed himself more directly to the public and contributed to the improvement of art's status in the United States by enhancing its primary engine, the National Academy of Design. Despite the apparent conflict with his essentially quiet, reserved character, Suydam established a more public presence during the 1860s both with his art and his service, adopting the role of cultural advocate at one of the most challenging moments in American history.

As Suydam's ambitions grew, so too did his art. His exposure to the public realm of New York was challenging but led him to address the stresses and conflict of urban city life more directly with his art. The reformist impulse that characterized the period affected Suydam's art as well as his desire to become more involved at the Academy. Keenly sensitive to the pressures of business and urban life, Suydam created paintings that offered viewers a break from the urban environment. Equipped with a broad array of aesthetic experience after his travels through Europe and the Middle East in the company of Miner Kellogg, and prepared by his travels through the American landscape in search of respite for himself, Suydam developed a highly personal mature style during the early 1860s that offered viewers a reassuring balance of realism and evocation along the coast of the Northeast during its quietest phases.

Reformism reached into all areas of American culture. In response to deteriorating conditions in New York's working-class neighborhoods, government and various charitable organizations introduced extensive social reforms in hopes of quelling the violence and enhancing living conditions. Among the most aggressive measures undertaken during this period was the organization and development of Central Park under Frederick Law Olmsted and Calvert Vaux's *Greensward Plan*, 1857–61 (FIG. 2.14). Characterized in reformist parlance as the "lungs" of the city, Central Park became, with the help of thousands of Irish laborers, a healthful, accessible retreat for all New Yorkers. The park was designed to be a model, instructing visitors in good aesthetics and encouraging civil behavior. Olmsted's approach to design was premised upon the landscape's ability to inspire healthful psychological effects.

In a manner reminiscent of Suydam's approach to landscape painting, Olmsted sought to "recognize and enhance the natural character of the site" and "to refresh and delight the eye and through the eye, the mind and spirit."[28] Olmsted's stated objective was intended to be subtle, not overwhelming: "the highest value of a park must be expected to lie in elements and qualities of

scenery to which the mind of those benefiting by them is liable, at the time the benefit is received, to give little conscious cogitation."[29] Olmsted carried out his work at the very moment that Suydam arrived at his mature aesthetic and made his works larger scale and more public. Hanging in the Academy's galleries or in the homes of his patrons, Suydam's paintings offered restorative, calming vistas to urban viewers, as they did for the artist himself.

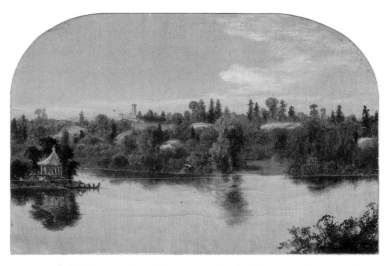

FIG. 2.14 Frederick Law Olmsted (1822–1903) and Calvert Vaux (1824–1895), designers, *Greensward Plan* for Central Park, study of "Effect Proposed," 1857. Courtesy NYC Municipal Archive.

Suydam became an artist during a transitional moment in American life. During the mid-nineteenth century, professionalism took hold in a manner that shifted the groundwork of American society. Professionalization meant specialized study in a given field, supplanting more general classical preparation as the primary qualification for advancement. The Civil War precipitated the change as well, hastening the country's industrialization and establishing ever more complex systems and technology. The war also changed Americans' appreciation of the applications of knowledge. Characteristic of the transformation were the armies that fought the war itself. Both North and South entered the conflict in 1861 with loosely organized state and local militias that evolved into disciplined, specialized regiments by the war's end. Virtually every segment of American culture was affected by professionalization, from business to education, and from government to the ministry, leaving little room for the speculative theoretical approaches that characterized American thought before the war. This was an era of utility.

In art, however, professionalization remained an ongoing and imperfect aspiration in the early 1860s. The founding charter of the National Academy of Design in 1826 addressed its organizers' early recognition of the need for standards in the fine arts to advance the field. In lieu of reliance upon the indulgent generosity of wealthy amateurs and patrons, the National Academy was placed "under the exclusive control and management of, the professional Artists, in whom alone it was contended could Art, and its general dissemination, be properly placed."[30] Although education was a critical component of the new Academy, offering professional training to students, that training was by no means essential, and many distinguished American artists of the day were either self-taught or trained as apprentices, with only minimal exposure to academic training and art theory. The most significant factor in achieving professional recognition as an artist remained financial success.

During the mid-nineteenth century, professional standing was synonymous with election to full membership in the National Academy, a distinction that Suydam received in 1861. Only professional artists residing in New York were eligible to become full National Academicians. Suydam's election reflected changes to his identity on several levels: stylistically, he worked in a larger, more public scale that attracted greater critical recognition and patronage of his art; professionally, he sought opportunities to serve the community of artists and enhance their standing; and personally, he developed strong relationships with colleagues and emulated their seasonal travel and work habits. Between 1858 and 1861, Suydam transformed himself from a dedicated amateur to an accomplished peer.

Suydam's establishment of a signature style around 1860 was integral to his emergence as a professional artist. Indebted to John F. Kensett, Durand, and other Hudson River School models for his experiments and adaptations of the 1850s, Suydam charted a more consistent and personal aesthetic course in the early 1860s. Peaceful coastal views became his trademark, and his delicately graded skies were favorably compared to Kensett's finest work.[31] Suydam's later art, however, is recognizable by its level of abstraction, heightened use of local color, miniaturized figures, and truncated perspective, all of which appear to be legacies of his earlier, more intimate compositions. Little evidence of further stylistic change can be found in Suydam's work after about 1860. He appears to have settled upon his personal approach and held to it during the ensuing years. That basic grammar permitted considerable latitude to explore color, composition, atmospheric effect, and form in a mode that critics often compared to poetry.

Perhaps the signal development in Suydam's art that reflected his professional transformation, however, was his increased production of larger-scale works. The scarcity of Suydam's dated paintings makes this evolution difficult to chart definitively, but most of the larger compositions that are dated, including *Paradise Rocks, Newport*, fall between 1860 and 1865. These also appear to be the works that Suydam publicly exhibited and that established his professional reputation. Showing works of the same size as those of Kensett, Gifford, and Worthington Whittredge, Suydam positioned himself as their equal.

During the 1860s, scale was a relative term. Frederic Edwin Church, Thomas Moran, and Albert Bierstadt created ever larger compositions to evoke awe of the enormity of natural phenomena around the world, from the Rocky Mountains, to the polar glaciers, to the Andes. These landscapes of discovery, depicting areas far beyond the scope of recreational travel for most Americans, immersed viewers in exotic lands, filling their field of vision and transporting them from their urban surroundings. Suydam was personally aware of the effects of such enormous compositions and their origins in contemporary German art, as he owned both Andreas Achenbach's vast *Off Ostend* (FIG. 2.15) and Achenbach's student Albert Flamm's only slightly smaller *Roman Campagna* (FIG. 2.16). Both paintings were created in 1859, and Suydam likely acquired them from the International Art Institution in New York at the same time in 1861.[32] The pair is exceptional in Suydam's collection in both scale and treatment, and their simultaneous acquisition points to a new dimension in his collecting that coincided with the growth of his pro-

FIG. 2.15 Andreas Achenbach (1815–1910), *Off Ostend*, 1859, oil on canvas, 49¾ x 68 inches, National Academy Museum, Bequest of James A. Suydam.

FIG. 2.16 Albert Flamm (1823–1906), *The Roman Campagna*, 1859, oil on canvas, 43 x 62¾ inches, National Academy Museum, Bequest of James A. Suydam.

fessional ambition. Though Suydam did not explore such scale in his own art—even *Paradise Rocks* does not approach them—his use of panoramic effects and open expanses of space suggests a conceptual influence.

For Suydam, even a moderate change in scale amplified the effects of miniaturization of figures and spatial truncation that are among his works' most identifiable characteristics. Painting larger scenes required that he populate the landscape with proportionally larger figures, which he did not.[33] Suydam evidently preferred to render the human figure in minute proportions, dwarfing them in his larger landscapes. Even in his smaller compositions, such as his early *At River's Bend* (FIG. 1.12), the figure is often reduced beyond scale. Ironically, given his lack of attention to the figure in his later views, Suydam's earliest known work, a drawing entitled *Going Fishing* (FIG. 2.17) of 1848, shows a figure from the back in accurate scale. In his later work, however, the artist consistently reduced his figures, giving considerably greater visual and symbolic priority to the landscape's inanimate features.

As much as Suydam reduced his figures in his larger compositions, he also truncated his sites' topographies. In his view of Spouting Rock in Newport, entitled *On the Beach* (FIG. 3.23), Suydam dramatically expanded the foreground water and sand to create a vertiginous expanse leading up to the rocky promontory. Although the foreground arc of beach or river was a staple of Suydam's work throughout his brief career, it grows in relative significance in the larger compositions. As his paintings grew, the subtle spatial effects of his small works became dramatically more pronounced: the long arcs of beach at low tide broaden, the structures of rocks along the horizon attenuate and are more articulated, figures multiply and their activities become apparent, and the sense of space itself becomes more voluminous.

FIG. 2.17 James A. Suydam (1819–1865), *Going Fishing*, 1848, graphite, pen and ink, and watercolor on paper, 4¾ x 5¹⁵⁄₁₆ inches, Collection of Mr. and Mrs. Stuart P. Feld, New York.

Whereas some of Suydam's earlier beaches extend indefinitely along the horizon, the later, larger works such as *On the Beach, Newport* tend to incorporate more sky and movement into space, rather than sweeping primarily along the horizon laterally. The vantage point in *On the Beach, Newport* is elevated, yet the rocks themselves are massed at the horizon and rendered larger relative to the proportion of the beach in the present day (FIG. 3.24). Suydam simultaneously pushed back the rocks toward the horizon and made them larger proportionally so that they become monumentalized relative to the landscape. Size, space, and proportion are dynamic variables in Suydam's works that he manipulated for impact in his larger compositions.

Under Kensett's influence, as Katherine Manthorne has explored in the preceding chapter, the massings of rocks and headlands in Suydam's early coast scenes provided important composi-

tional brackets at the edges of his paintings, as in the intimate depiction of *Beverly Rocks* (FIG. 1.1). Suydam never employed as much detail or specificity in his modeling of rock formations as Durand and Kensett did, but instead emphasized their basic colors and shapes. That primary attention to shape and color, rather than texture, expanded considerably in Suydam's paintings of the 1860s. His representations of well known landmarks such as Spouting Rock and Paradise Rocks make this deliberate emphasis clear, as the artist selected his vantage points to accentuate the most sharply angled facets of his subjects.

Although the most notable development of Suydam's work around 1860 was the introduction of large-scale compositions, he did not cease to paint smaller works altogether. Vignettes such as *Twilight* (FIG. 1.14) provide selective glimpses of his continued interest in intimate works during his later career. *Twilight* was likely a study for a larger composition, but conveys a sense of compact eloquence characteristic of his smaller works. Perhaps the defining theme of Suydam's work, as he reduced his larger landscapes into formal groupings to accentuate their expressive aspects, was his decision to distill for his viewer the essence of a scene. Although opposite in scale, the one is oriented toward a broader public, while the second encourages an intimate, private experience for a single viewer at close proximity.

In both of these modes, public and personal, Suydam successfully displayed his abilities as a technician of gentle tonal gradation and as a portraitist of nature at rest. Critics and fellow artists alike admired Suydam's work for these two qualities and regularly cited them as the distinguishing facets of his art. As one eulogist wrote, Suydam "has always given us nature in repose, and has expressed the sentiment of peace, of stillness, of brooding love."[34] The adjective "poetic," however, was most often invoked to describe his work during his lifetime. Suydam and his peers, particularly Gifford and Kensett, were referred to as poets for their emotively evocative sensibilities.

In contrast to the sublime, dramatic power of Church's, Moran's, and Bierstadt's western and foreign compositions, the artists of Suydam's circle gravitated toward more pastoral, contemplative subject matter in the northeastern United States. In the midst of sectional tumult, the counterpoint between the bombast of Church's fiery eruptions abroad and Suydam's ordered, domestic scenes suggest opposite sides of the same coin as responses to national crisis. The earlier works by Church in Suydam's collection, particularly the *Scene on the Magdalene* (FIG. 2.18), approximate the subtle impact and technique in Suydam's mature compositions, though often with a more threatening undertone. The prowling crocodile and choking vines in Church's *Magdalene* convey a sense of danger that he would accentuate in later compositions. Suydam, in contrast, moved toward ever more stable, ordered renderings of nature moving north from New York, rather than south toward the Mason-Dixon Line. Suydam's project was an affirmation of American cultural identity rooted in the more orderly natural landscape of the Northeast.

Stylistically, Suydam's development toward a larger-scale aesthetic during the 1860s offered him the opportunity to participate in the more public role of art in the formation of Northern cultural identity during the Civil War. His contribution on this level may be characterized as a

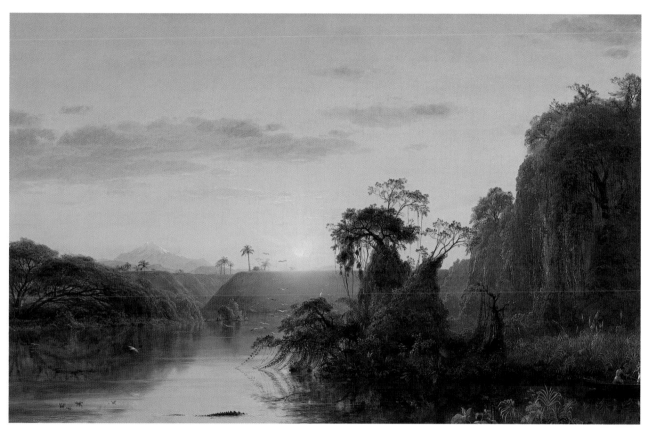

FIG. 2.18 Frederic Edwin Church (1826–1900), *Scene on the Magdalene,* oil on canvas, 28¼ x 42 inches, National Academy Museum, Bequest of James A. Suydam.

deliberate vernacular. Building on the foundation of the earlier Hudson River School style, Suydam cultivated a sense of intuitive, "poetic" response to the landscape, specifically the landscape of the Northeast. Painting against the more populist grain of artists such as Church and Bierstadt, Suydam provided a contemplative distillation of the landscape that heightened its expressive aspects in a form that his artist peers and already initiated collectors could readily interpret. His mannered approach attests to the strength of his underlying artistic project.

With an increased public presence as a regular exhibitor of competitively larger scale works at the National Academy's Annuals, Suydam drew new patronage and critical interest in the press. From various auction records, the identities of some of his patrons are known, and they include several of the leading New York collectors of the period, such as Samuel Putnam Avery, Cyrus Butler, Robert M. Olyphant, Marshall O. Roberts, and Suydam's own mentor John F. Kensett. Olyphant, a friend of Kensett's, was perhaps the most sympathetic patron of their new aesthetic, while Roberts, a shipping and railroad magnate, is believed to have owned the largest collection of American art in the country, including Emanuel Leutze's *Washington Crossing the Delaware.*[35] Suydam's paintings were in distinguished company during his lifetime, attesting to their resonance among his contemporaries in New York.

NOTES

1. Walt Whitman, *Leaves of Grass* (New York: Vintage Books/Library of America, 1992), 416.
2. Suydam to Kensett, 7 August 1861, private collection.
3. Kenneth T. Jackson, ed., *The Encyclopedia of New York City* (New Haven, CT: Yale University Press; New York: The New-York Historical Society, 1995), 923; Edward K. Spann, *The New Metropolis: New York City, 1840–1857* (New York: Columbia University Press, 1981), 242–80.
4. Sean Wilentz, *Chants Democratic: New York City & the Rise of the American Working Class, 1788–1850* (New York: Oxford University Press, 1984), 395.
5. The street numbering of Waverly (occasionally spelled Waverley) Place later changed, so that the current number no longer reflects the location of the Suydam home. The building was demolished in 1874 to make way for a nine-story commercial building. See Luther S. Harris, *Around Washington Square: An Illustrated History of Greenwich Village* (Baltimore: Johns Hopkins University Press, 2003), 97.
6. Henry James, *Washington Square* (1881; repr., New York: The Modern Library, 2002), 19.
7. Ibid.
8. For more on these maps, designed by British engineer William Perris, see Paul E. Cohen and Robert T. Augustyn, *Manhattan in Maps, 1527–1995* (New York: Rizzoli, 1997), 128–29.
9. Harris, *Around Washington Square,* 25. Harris notes that the Italianate did not replace the Greek and Roman Revival styles as the prevailing architectural aesthetic in New York until the later 1840s.
10. James M. McPherson, *Battle Cry of Freedom* (New York: Oxford University Press, 1988), 609.
11. Suydam's family appears to have shared his abolitionist stance. After Suydam's death, his siblings sold the family home to a prominent abolitionist Thaddeus Hyatt in May 1873 for a dollar, presumably as a donation toward one of his causes. Office of the City Register, New York, Liber 1250, p. 621. Suydam's brother Henry was also memorialized upon his death in 1888 as a correspondent and friend of Stowe's father, the influential abolitionist Henry Ward Beecher ("Funeral of Henry Suydam," *New York Times* [26 September 1888], 9).
12. Alexander Hay Ritchie (1822–1895) after Thomas Hicks (1823–1890), *Authors of the United States,* 1866, engraving on paper, 19¾ x 34⅛ inches, National Portrait Gallery, Smithsonian Institution, Washington, DC (NPG.76.90).

13. Anonymous, "Domestic Art Gossip," *Crayon* 5 (March 1858): 88.

14. Suydam to Kensett, 7 August 1861, private collection.

15. Daniel Huntington, "Manuscript Memoir of James A. Suydam," ca. 1865, National Academy Museum Archive, typescript, 9. Suydam's papers and account books are unlocated, and Huntington's observation is the only record of their existence in 1865.

16. The latter date corresponds to when Dana returned to the United States from his study abroad. The painting was exhibited at the Academy's Annual the following year, and Suydam was not yet listed as the painting's owner in the exhibition's catalogue. Suydam likely purchased the work after seeing it there. See Clara Erskine Clement and Laurence Hutton, *Artists of the Nineteenth Century and their Works* (1879; repr., St. Louis, North Point, Inc., 1969), 1:80.

17. Annette Blaugrund, *The Tenth Street Studio Building: Artist-Entrepreneurs from the Hudson River School to the American Impressionists,* exh. cat. (Southampton, NY: The Parrish Art Museum, 1997), 133–34. Suydam's patronage of fellow Tenth Street residents was by no means unique, as he also appears to have bought works by Sanford Gifford and William Hart within a year of their moves to the building during the later 1850s. Ibid., 39, 42.

18. Worthington Whittredge, Annual Report, 1875, National Academy Archive, 14. I am grateful to John Davis for drawing my attention to this reference.

19. Thomas Seir Cummings, *Historic Annals of the National Academy of Design, New-York Drawing Association, Etc., with Occasional Dottings by the Way-Side, from 1825 to the Present Time* (Philadelphia: George W. Childs, 1865), 314.

20. George Norbury Mackenzie and Nelson Osgood Rhoades, *Colonial Families of the United States of America* (Baltimore Genealogical Publishing Company, 1966), 510.

21. Francis J. Sypher Jr., ed., *The Saint Nicholas Society: A 150 Year Record* (New York: The Saint Nicholas Society, 1993), 104.

22. Barbara J. MacAdam, *Marks of Distinction: Two Hundred Years of American Drawings and Watercolors from the Hood Museum of Art*, exh. cat. (Hanover, NH: Hood Museum of Art, Dartmouth College; Manchester, VT: Hudson Hills Press, 2005), 86.

23. Cummings, *Historic Annals*, 315.

24. Clement and Hutton, *Artists of the Nineteenth Century,* 2:280.

25. Cummings, *Historic Annals*, 327.

26. Clement and Hutton, *Artists of the Nineteenth Century*, 2:280.

27. Cummings, *Historic Annals*, 349.

28. Charles E. Beveridge and Paul Rocheleau, *Frederick Law Olmsted: Designing the American Landscape* (1995; rev. ed., New York: Universe Publishing, 1998), 31, 33.

29. Ibid., 31.

30. Cummings, *Historic Annals*, 5.

31. Henry T. Tuckerman, *Book of the Artists*, (New York: G.P. Putnam, 1867), 541.

32. David B. Dearinger, ed., *Paintings and Sculpture in the Collection of the National Academy of Design, Volume 1, 1826–1925*, New York: Hudson Hills Press, 2004), 4, 195. Writing in 1869, Gifford shared Suydam's admiration for Flamm "whose pictures [sic] of the campagna in the Suydam collection in the academy is as beautiful as it is true." Cited in Ila Weiss, *Sanford Robinson Gifford (1823–1880)* (PhD diss., Columbia University, 1968; published, New York and London: Garland Publishing, 1977), 289.

33. The only instance in which one of his paintings has slightly larger figures, *Foggy Morning*, was a collaboration with figure painter William John Hennessy (1819–1917).

34. Cited in John I. H. Baur, "A Tonal Realist: James Suydam," *Art Quarterly* 13, no. 3 (Summer 1950): 225.

35. John K. Howat, "Private Collectors and Public Spirit: A Selective View," in Catherine Hoover Voorsanger and John K. Howat, eds., *Art and the Empire City: New York, 1825–1861*, exh. cat. (New York: The Metropolitan Museum of Art; New Haven, CT: Yale University Press, 2000), 100–101.

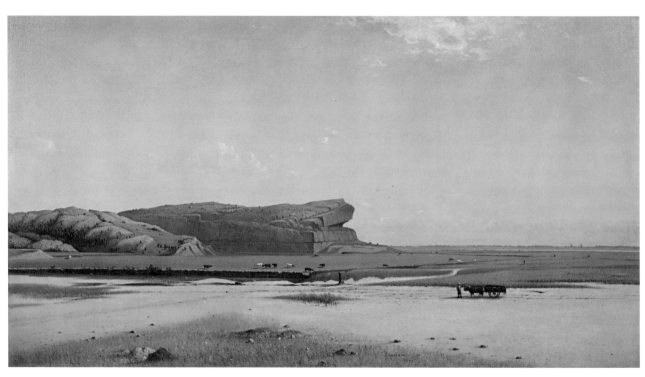

FIG. 3.1 James A. Suydam (1819–1865), *Paradise Rocks, Newport*, 1860, oil on canvas, 25 x 45 inches, National Academy Museum, Bequest of James A. Suydam.

Chapter 3

Newport and the Illusion of Art

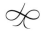

Mark D. Mitchell

> One great charm of Newport scenery is its modesty: it has
> no massive cliffs that extort wonder and admiration, its
> hills are hardly more than gently rolling undulations.... It
> is like a grand landscape in miniature.
>
> —Henry James, "Art"[1]

DURING THE LATER 1850s and 1860s, Newport became James Suydam's signature subject. His depictions of its natural landmarks and beaches, including his masterwork, *Paradise Rocks, Newport* (FIG. 3.1), are infused with a unique degree of originality and intellectual engagement. The region's long philosophical tradition appealed to the artist's capacious intellect and invested the landscape itself with significance for his art. Here, Suydam and his colleagues investigated the underpinnings of art, revisiting assumptions about painting and its relationship to perception. In Newport, Suydam and his colleagues explored received ideas about realism and the nature of vision itself in the midst of the Civil War.

Newport of the mid-nineteenth century, however, looked very different from the Newport of the Gilded Age that has become engrained in the popular American imagination for its grand architectural follies and elite social life. Vastly overshadowed by its development in subsequent decades, antebellum and Civil War Newport had a different and more intimate appeal. Even the region's basic appearance during Suydam's time comes as a surprise to twenty-first-century eyes. The late nineteenth-century reintroduction of trees to the landscape, which had been almost completely deforested since the beginning of the century, along with rapid architectural development and shoreline reconstruction, has fundamentally transformed Newport since Suydam's day.

His first visit to the Newport area likely occurred in the summer of 1858, and he appears to have returned there regularly during the 1860s.[2] In the spring of 1859, Suydam exhibited two works, *Fog at Narragansett* (now known as *Beach Scene, Newport,* FIG. 1.10), a theme that he would repeat in his 1863 *Newport Beach* (FIG. 3.2), and *Narragansett Shore,* at the National

FIG. 3.2 James A. Suydam (1819–1865), *Newport Beach*, 1863, oil on canvas, 18 x 30 inches, private collection, courtesy of Nan Chisholm Fine Art.

Academy. According to Daniel Huntington, the paintings "enhanced his reputation with all who could appreciate his sweet quiet feeling and expression of the pensive moods of Nature."[3] Suydam's immediate interest in the more peaceful aspects of the area's scenery suggests that he arrived with a sense of what he was looking for already in mind.

The Philosophical Landscape

The serene beauty of Newport's coastline has attracted artists to the southern tip of Rhode Island's Aquidneck Island (regularly translated as the "Isle of Peace") since the Colonial era. During the nineteenth century, Newport was widely believed to be located along the route of the tropical current known as the Gulf Stream, a theory that was trumpeted in articles and guidebooks to the region to explain its temperate climate. The area does enjoy milder seasonal variation than much of New England, and artists have often noted the quality of Newport's uniquely "chastened" light.

Unlike many of America's best-known views, famous for historic events that occurred there or for breathtaking scale, Newport's most iconic site, Paradise Rocks, was a literary and philosophical landmark first and foremost, rather than a scenic one. Under the protective outcropping of the upper rock stratum, which was somewhat more visible in the nineteenth century (FIG. 3.3) than it is today, the area's most celebrated early resident, philosopher and theologian George Berkeley (1685–1753) was believed to have written a seminal philosophical treatise. That work, *Alciphron, or, The Minute Philosopher*, was required reading in Suydam's time. The serene and literary associations of Newport provided the "civilized" aspects that attracted Suydam and his friends John F. Kensett, Worthington Whittredge, and Sanford R. Gifford during the 1850s and 1860s.

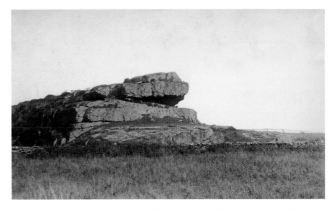

FIG. 3.3 Paradise Rocks, ca. 1900, photograph, Newport Historical Society, RI.

Berkeley (FIG. 3.4), an Episcopal minister later made bishop of Cloyne, was a looming figure in American philosophical history, despite residing in the became Colonies for only a few years. During that time, he wrote his influential treatise on the defense of Christianity, *Alciphron*, in which he clarified and refined his earlier *Essay toward a New Theory of Vision*. Both treatises remained key references throughout the mid-nineteenth century when Suydam would likely have encountered them, though they are not documented in his library. Berkeley arrived in Newport only as a brief stopping point on his way to Bermuda, where he intended to found a university with funds that he had secured from the British Parliament. He settled in Newport to await the money's arrival, but it never came, and he spent several years there as a result.

FIG. 3.4 John Smibert (1685–1753), *George Berkeley*, 1727, oil on canvas, 40¼ x 29¾ inches, National Portrait Gallery, Smithsonian Institution, gift of the Morris and Gwendolyn Cafritz Foundation (NPG.89.25).

FIG. 3.5 Whitehall, built 1729, photograph by the author.

Berkeley's legacy to the town stretched into the mid-nineteenth century when his influential theory of vision came into serious question for the first time. He had donated Whitehall (FIG. 3.5), the house he built for his family in Newport, to Yale University, which maintained the site. Such a relic of America's literary past would have exerted a considerable attraction upon Suydam. As Miner K. Kellogg recalled of their earlier travels together in Europe, "everything connected with the history of the olden Poets and Painters possessed a peculiar charm" for Suydam.[4] Together, they had traveled through Italy and visited Petrarch's historic home as part of Suydam's aesthetic education.

Berkeley's Whitehall is a modest building, with little ornament or other outward sign of its original owner's significance. The building, however, is a short distance from Sachuest, or Second Beach, the site of Paradise Rocks. The intimate association of Whitehall with Paradise Rocks was well known to artists of Suydam's generation, as his friend and companion Whittredge later completed a series of depictions of both subjects, including in *Whitehall—Bishop Berkeley's Farm at Middletown, Rhode Island* (FIG. 3.6).[5] Suydam's selection of Paradise Rocks as the subject of two paintings, including one that is by far his largest work, conveys a sense of the added significance he attributed to the subject.[6] In Suydam's depictions of Paradise Rocks and, indeed, in most of his later works, we find a visual correlate to Berkeley's theory.

Alciphron, or The Minute Philosopher, first published in 1732, is recognized among the first

major philosophical treatises written on the North American continent. It consists of seven Socratic dialogues in which the tenets of Christian faith and knowledge are defended against the skeptical position of freethinkers, who believed that knowledge of the world is learned only through observation rather than from church teaching. Berkeley pejoratively referred to free-thinkers as "minute philosophers" to separate them from the more positive connotations of their preferred identification.

Nineteenth-century tourist guidebooks and historical accounts of Newport proudly repeated legend that Berkeley had written the treatise itself in the space between the two strata shown in Suydam's works. "Here," according to one guide, "he would repair from his dwelling in the immediate neighborhood, and amid nature's fairest scenery, lift his thoughts to Nature's God."[7] That legend provided Paradise Rocks with another of its better known aliases, Berkeley's Seat. A somewhat smaller, though more characteristic, version of *Paradise Rocks*, entitled *Newport, Hanging Rock* (FIG. 3.13) shows the artist's concentration on that central motif, even as he adjusted the cloud formations and moved figures around the landscape between the two ver-

FIG. 3.6 Worthington Whittredge (1820–1910), *Whitehall—Bishop Berkeley's Farm at Middletown, Rhode Island*, ca. 1880, oil on canvas, 13 x 18 inches, Chateau-sur-Mer, Newport, Bequest of Alice Brayton. Courtesy of The Preservation Society of Newport County.

FIG. 3.7 James A. Suydam (1819–1865), *Paradise Rocks, Newport* (detail), 1860, oil on canvas, 25 x 45 inches, National Academy Museum, Bequest of James A. Suydam.

sions. The artist's lighter handling in *Newport, Hanging Rock* renders it more immediate in sensibility and provides a sense of the artist's changes of style as his compostitions grew larger. Both versions of his painting accentuate the upward thrust of the top layer of rock (FIG. 3.7), reaching toward a group of distant birds. Such an association of physical topography with an abstract idea is characteristic of the discrete, suggestive form of symbolism that much nineteenth-century philosophy derived from Berkeley's theories.[8] Berkeley's association with Paradise Rocks was so well-known during Suydam's day, in fact, that viewers of his painting would very likely have immediately associated the site with the theologian.

Suydam chose his vantage carefully. Moving even a few feet to either side dramatically diminishes the gap between upper and lower strata at the point of Paradise Rocks (FIGS. 3.8 and 3.9). Moreover, Suydam chose the time of day carefully as well in that regard. In either the early morning or late afternoon, Paradise Rocks is silhouetted and loses the planar flatness that Suydam illustrates in his work. Representing a moment of the late morning, he could emphasize not only the upward thrust of the top stratum of rock but also the projection toward the viewer within the lower stratum. The sun falls from the right directly onto the first segment of the lower tier of rock, but then turns to deep shadow at the corner of the slight projection. Although the rocks are the clearest examples of the artist's attention to geometry over realism, the same may be said of his repre-

FIG. 3.8 Paradise Rocks, photograph by the author.

FIG. 3.9 Paradise Rocks, photograph by the author.

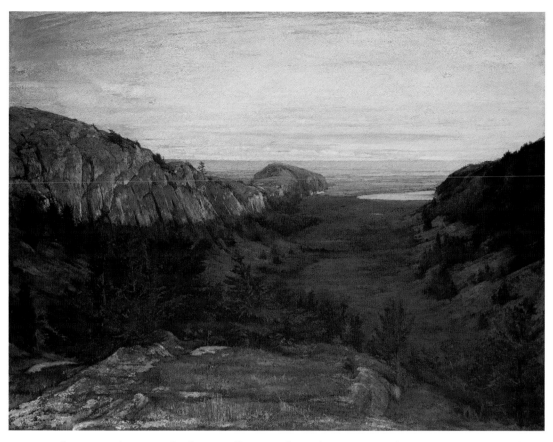

FIG. 3.10 John La Farge (1835–1910), *The Last Valley—Paradise Rocks*, 1867–1868, oil on canvas, 32¾ x 42⁵⁄₁₆ inches, National Gallery of Art, Washington, DC, Gaillard F. Ravenel and Frances P. Smyth-Ravenel Fund (2000.144.1). Image © 2006 Board of Trustees, National Gallery of Art, Washington, DC.

sentations of sea, sky, and beach. The basic forms of color and their values relative to one another bear overriding significance in Suydam's work, making his compositions distinctive among the artists of his circle.

Although *Alciphron*'s second dialogue is set in "a hollow glade, between two rocks" that has been consistently interpreted as the gap between strata shown in Suydam's two versions of *Paradise Rocks,* that description does not easily match the site.[9] Paradise, as the area around the rocks is known, does however consist of seven roughly parallel stone ridges (of which Paradise Rocks caps one) that were shaped by glacial erosion. The ridges create valleys and potential "glades," to which Berkeley might have referred in his passage.[10] John La Farge's slightly later painting, *The Last Valley—Paradise Rocks* (FIG. 3.10), shows one such area in its foreground.

The more likely relationship between Suydam's art and Berkeley's writings is in their interpretation of sight. The fourth dialogue of *Alciphron* revisits Berkeley's 1709 treatise entitled *Essay*

Towards a New Theory of Vision and suggests that the landscape around Newport had encouraged the author to develop his thinking on the matter further. In the *Essay*, which was also reprinted in the first editions of *Alciphron*, Berkeley characterized the nature of vision as immediate. To Berkeley, objects perceived by the eye at varying distances are seen collectively in the field of vision, rather than in any tangible interrelation or order. He asserted that the sense of touch operated differently from the sense of sight in experiencing depth and that the relationship between them depended upon learned use of the two in tandem, rather than by any innately similar properties. In artistic terms, Berkeley's theory relates to the priority placed on the illusions of depth and volume created in painting.

In the early twentieth century, the German scholar E. H. Gombrich responded to the powerful legacy of Berkeley's theory of vision: "I do not deny for a moment that the suggestion of space is an interesting achievement, but if we discard Berkeley's theory of vision, according to which we 'see' a flat field but 'construct' a tactile space, we can perhaps rid art history of its obsession with space and bring other achievements into focus, the suggestion of light and of texture, for instance, or the mastery of physiognomic expression."[11] To Gombrich, Berkeley's theory exerted an undue, even overpowering influence on the appreciation of the fine arts based upon their success at creating the illusion of space. Suydam's art, like that of the luminists generally, was deeply preoccupied with vision, but in a manner that directly engaged with Berkeley's concept of sight itself, rather than an artificial "construction" of space.

In both Europe and America, vision was a subject of considerable interest during the nineteenth century. New modes of seeing and reproducing images, including the invention of photography in 1839, offered viewers new tools to record and visually interpret the natural world. For the most part, those tools manipulated or emulated the human sense of sight, creating illusions of three-dimensionality through the use of a double camera lens, for example, in stereoscopy, the nineteenth-century equivalent of 3-D glasses.[12] As understanding of the human eye developed, artists and inventors created ever more complex ways of enhancing or tricking it. Suydam's work in Newport was informed both by the global culture of visual inquiry and by the local influence of Berkeley's legacy.

The relative simplicity with which Suydam's compositions such as *Paradise Rocks* recede into space adopts new significance at Newport because of Berkeley's long shadow there. Suydam's attention to color, shape, and balance in landscapes that are stripped to their most basic elements strongly suggests an engagement with Berkeley's concept of vision. In these, Suydam's most mature and accomplished works, his decisions to essentialize and flatten his compositions offer an alternative approach to illusionistic space. Rather than "constructing" recession in a conventional manner, leading the viewer's eye through space, Suydam's paintings confront the eye with a more reductive, abstracted compositional arrangement, balancing blocks of color and form against one another. Newport's deforested landscape, arcs of beach, open skies, expanses of water, and high cliffs collectively provided an exceptionally conducive environment to Suydam's landscape formula.

Berkeley's influence on Newport was manifold, both in his day and in later centuries. He instigated the sincere intellectualism for which Newport gained a reputation and that endured into and beyond the Civil War era. He did not conceal his own pleasure at the diversity and tolerance of Newport's community and he admitted African Americans to his own Episcopal congregation, offering an important model for change in attitudes toward slavery and human equality. For Suydam, Berkeley's influences on Newport would have been inspirational not only because of his own political beliefs and aesthetic practices but also because they suggested new directions. Whether through Kensett, Suydam, or both, Whittredge's writings reveal Berkeley's strong influence on luminist painters of Suydam's circle.

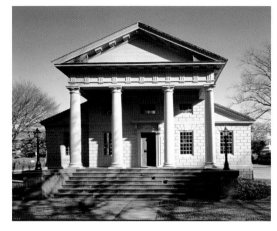

FIG. 3.11 Peter Harrison (1716–1775), architect, *Redwood Library*, 1748–1750, Redwood Library and Athenaeum, Newport, RI.

During the eighteenth century, Newport developed one of the country's most vibrant communities committed to education and study, evidenced by the founding in 1747 of the centerpiece of Newport's intellectual aspirations, the Redwood Library (FIG. 3.11), which remains in its historic home near the town's center. Members of a new Literary and Philosophical Society also regularly gathered to discuss philosophy, scientific discoveries, and other topics of the day beginning in 1730.[13] This conversation group brought together the already well-developed intellectual life of the region, including neighboring Narragansett.[14] One of the group's goals for Newport was to establish a major university, competitive with Harvard or Yale. To that end, Berkeley's arrival in 1729 was seen as a great opportunity to fulfill the community's potential and would set the tenor of later intellectual and artistic circles there in the nineteenth century.

Artists, however, were no better able to settle in Newport during the eighteenth century than in the nineteenth, and were forced to travel elsewhere once commissions in the area were exhausted. In eighteenth-century Newport, the primary art form remained portraiture. Arriving in Berkeley's entourage, John Smibert became the first prominent artist to work in Newport, where he painted local dignitaries and wealthy citizens. Smibert's arrival helped to establish a market for accomplished portraiture in the town, and later artists such as Robert Blackburn and Gilbert Stuart were indebted to his example both because of his skill and because his work became a benchmark of aesthetic taste. Kensett's arrival more than a century later would have a similar effect, establishing a style of painting the Newport landscape to which his peers responded.

Kensett's early visits to Newport were facilitated by the inveterate traveler and author George William Curtis, whom Kensett had first met in Rome in 1845 and who extended invitations to Kensett to visit him at picturesque sites, including Newport in July 1854.[15] Kensett returned the

following year, this time sharing a rented house with Henry Wadsworth Longfellow and his family, Longfellow's brother-in-law Tom Appleton, and Curtis from which they enjoyed a view of the sea, though at some distance.[16] Curtis was born in Providence and remembered visiting Newport during his childhood, when it was "the synonyme of repose."[17] By the 1850s, though, Curtis bemoaned the arrival of the "army of fashionable forces" each year. Despite the invasion, he nevertheless still found Newport, "the great watering-place of the country."[18] Kensett was a model for Suydam in many aspects of life, including his collecting of younger artists' works and his collegial service to various art organizations, but his art and travels were perhaps his strongest influences.

By 1858, Suydam became the second of his artistic fraternity to begin visiting Newport regularly. Over the ensuing years, a steadily rising number of artists would join them. Whittredge arrived in 1859, and by the later 1860s, Newport had become a veritable artists' colony, visited by Gifford, William Trost Richards, George Loring Brown, William Morris Hunt, John La Farge, Elihu Vedder, and many others. These artists all explored the topography near Paradise Rocks and the shoreline south of Newport, but few of them found the same appeal in the strict geometric rendering of the landscape in the manner of Kensett, Suydam, and Whittredge. The three worked together closely, and after Suydam's death in 1865, Whittredge even completed a final depiction of Paradise Rocks that Suydam had left unfinished and presented it to the Century Association in Suydam's memory.[19] The Newport coastline became a familiar sight at New York exhibitions during the 1860s.

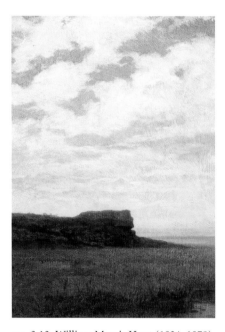

FIG. 3.12 William Morris Hunt (1824–1879), *Bishop Berkeley's Rock*, 1859, oil on panel, 12½ x 8½ inches, private collection, courtesy of William Vareika Fine Arts, Newport, RI.

The question of artistic leadership at Newport brings Suydam's two known versions of *Paradise Rocks* into the spotlight (figs. 3.1 and 3.13). Although Hunt painted a silhouetted profile view of the site in 1859 (FIG. 3.12), Suydam's composition is a far more iconic rendering. The painting is dated 1860, though it was not exhibited during the artist's lifetime, which is presumably the rationale behind the date of 1865 that has been assigned to the work since John I. H. Baur's 1950 article on Suydam. There remains the possibility that the signature was forged or inaccurately reinforced, either of which casts further doubt upon either date.[20] Although there is no way to be certain, the composition's complexity and scale suggest an unusual level of ambition for a painter of intimate scenes. Given Suydam's commitments during the last years of his life, during which time he often exhibited only one painting each year, it appears improbable that he would have undertaken such a large project. Although stylistic evidence is difficult to assemble, given the scarcity of Suydam's dated works, the likelihood remains that the work is inscribed accurately. No matter when it was

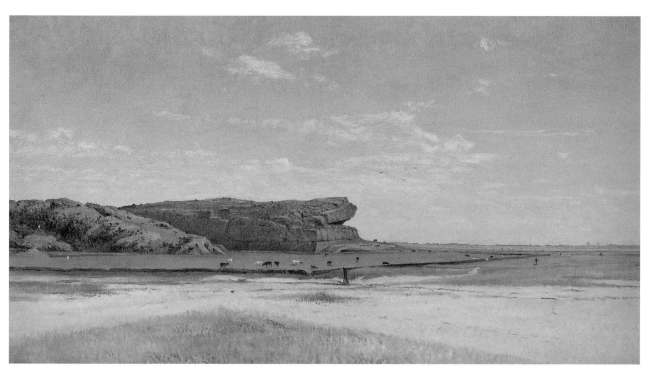

FIG. 3.13 James A. Suydam (1819–1865), *Newport, Hanging Rock*, ca. 1860, oil on canvas, 14 x 24 inches, private collection, New York.

FIG. 3.14 Worthington Whittredge (1820–1910), *Second Beach, Newport*, 1865, oil on canvas, 27⅝ x 38 inches, Philadelphia Museum of Art, promised gift of Robert L. McNeil.

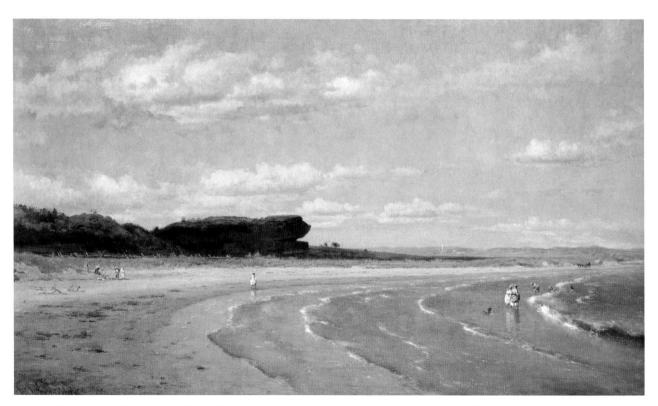

FIG. 3.15 Worthington Whittredge (1820–1910), *Second Beach, Newport*, ca. 1878–80, oil on canvas, 30¼ x 50¼ inches, National Gallery of Art, Washington, DC, Paul Mellon Fund and Gift of Juliana Terian in memory of Peter G. Terian (2004.58.1). Image © 2006 Board of Trustees, National Gallery of Art.

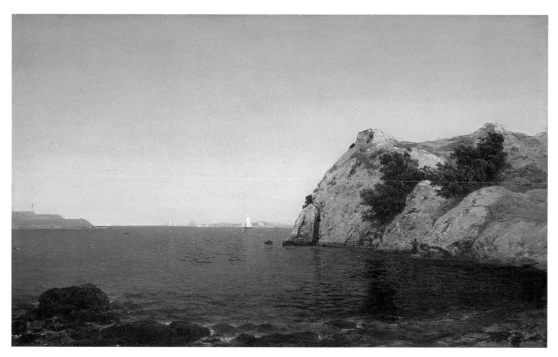

FIG. 3.16 John F. Kensett (1816–1872), *Beacon Rock, Newport Harbor*, 1857, oil on canvas, 22½ x 36 inches, National Gallery of Art, Washington, DC, Gift of Frederick Sturges, Jr. (1953.1.1).

painted, the work stands outside of his general production in both scale and style. If the painting was created in 1860, however, it would constitute a seminal example of the iconography of Newport, one that would inspire Whittredge (FIG. 3.14) to depict the view from a similar vantage. Whittredge also returned to the site several times thereafter as well, each time updating his approach. By the 1880s, he portrayed the site with impressionistic virtuosity and levity (FIG. 3.15), incorporating a group of fashionable waders at the water's edge. Even if Suydam's work was not the very first to treat Paradise Rocks in profile from Sachuest Beach, knowledge of his work appears to have had a lingering influence on Whittredge's vision. No views from this vantage by Kensett are known, making it possible that Suydam intended his various versions of *Paradise Rocks* to serve as his personal contribution to Newport's artistic tradition.

Kensett arrived at his own abstracted aesthetic during the mid-1850s, the very moment at which he began visiting Newport. His view of *Beacon Rock, Newport Harbor* (FIG. 3.16) was one of a number of depictions of a virtually identical view that he created over the course of the ensuing decade. Suydam's version of *Beacon Rock* (FIG. 3.17) shows the extent of his early debt to Kensett in both style and choice of subjects during the 1850s. As this comparison shows, however, Suydam never pursued the same degree of detail in his works that Kensett did. Like the similarities between the tabletop still lifes of John F. Peto and William Michael Harnett during this

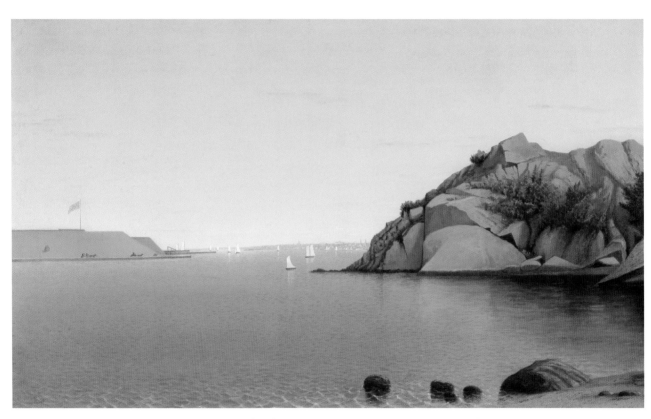

FIG. 3.17 James A. Suydam (1819–1865), *Beacon Rock and the Entrance to Newport Harbor*, ca. 1860, oil on canvas, 18 ½ x 30 inches, private collection, courtesy of William Vareika Fine Arts, Newport, RI.

same period, Suydam's aesthetic, while superficially similar to Kensett's, illustrates a different artistic sensibility that should be viewed independently. Although Suydam elected to portray the same basic scene as Kensett, his interest in formal abstraction considerably exceeds Kensett's and conveys a sense of the more independent aesthetic course he would steer during the 1860s, emphasizing personal expression over naturalistic detail.

Under Kensett's influence along the coast of Newport, Suydam found the basic formula that he would explore for the remainder of his career. In an area still little known to landscapists of their time, the two painters could explore the more peaceful states of nature without the encumbrance of a preexisting vocabulary. Newport offered a fresh start and a unique set of atmospheric and topographical conditions for the artists to master. With Kensett's guidance, Suydam helped to chart an aesthetic approach to Newport that would attract and influence later visitors, including his friends Whittredge and Gifford. Over time, the Newport coastline became Suydam's hallmark, and as tourism to the region grew, demand for depictions of the scenery expanded and further enhanced the breadth of his aesthetic influence.

A Tradition of Tolerance

Newport has two histories, one colonial and one modern. Those histories were separated by a decades-long interstice of recession during the early nineteenth century that left the town virtually unchanged. By the time the town's economy began to revive with the development of its tourist industry in the 1830s, Newport was a town set apart from the fabric of modernizing American society. Its historic structures had been preserved by the town's economic recession, never replaced because there were no resources to build anew. Today, the legacy of historic Newport (FIG. 3.18) remains intact, providing visitors with a similar sense of America's early history to that experienced by visitors such as Suydam during the mid-nineteenth century. Guidebooks and histories of the town recited the features of colonial Newport that distinguished it as a cultural and intellectual center. Honoring its traditions of tolerance and cultural distinc-

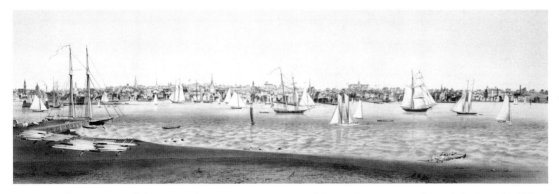

FIG. 3.18 John Perry Newell (1832–1909), *Newport, R.I.*, ca. 1860, lithograph on paper, 10⅞ x 33¾ inches, The Old Print Shop, New York.

81

tion, the town reemerged during the mid-nineteenth century with a related identity to which Suydam and his peers gravitated.

Tolerance was Newport's founding principle. Driven from Boston for their dissenting religious beliefs in 1636, the island's first colonists were sympathetic to differences of conscience and enshrined that sympathy in Newport's first statutes in 1641. The new government separated church from state, becoming a leading example of secular democracy that would inform the eventual founding principles of the American nation. The policy also made Newport a beacon of religious freedom that attracted displaced and persecuted religious minorities including not just the Baptists who had first fled Boston, but also Quakers, among others. The new arrivals brought business and affluence to Newport and, by the mid-eighteenth century, transformed the town into one of the British Colonies' leading centers of trade. At its height, the town had more than one hundred and fifty wharves and competed with or surpassed the British Colonies' other major ports, New York, Boston, Philadelphia, and Charleston, in every category. The very policy of tolerance that rendered Newport unique also made it successful, despite the underlying irony that its economy relied almost entirely upon the Triangle Trade and African slavery. Little conflict was perceived between the sponsorship of African slavery and religious and social toleration in eighteenth-century America, however, and Rhode Island was nevertheless among the first colonies to outlaw the importation of slaves.

As a leading American port during the eighteenth century, Newport established an early reputation for both its sincere intellectual life and the diversity of its population, much as early Dutch New Amsterdam had in the seventeenth century. Berkeley observed that his neighbors' embrace of religious and cultural diversity in their community should be appreciated as a model of tolerance. Even as sectional differences grew during the mid-nineteenth century, Newport remained a popular summer retreat for Southerners until the onset of the Civil War. For Suydam, Newport offered an escape both from the stress of New York City and from the vituperative political climate of the period. The community's history included a vibrant cultural life and was home of one of the earliest libraries and art collections in the Americas. The area offered a haven for study, reflection, and collegiality as well as a microcosm of the national landscape (both literally and figuratively, as James' observation in this chapter's epigraph suggests) and its potential to remain unified.

Given the town's contributions to the rise of American political thought, the Revolutionary War's effect on Newport was unfortunate. The town was occupied by the British during the early years of the war, targeted as a likely source of trouble because of its history of independent thought. Half the town's population fled, and the occupying forces almost entirely deforested the island's landscape for firewood and construction. The barren landscape around Newport depicted by Suydam and his colleagues during the 1850s and 1860s was the enduring result of the British occupation. Though no major battles were fought around Newport, the landscape was permanently altered by the conflict. New plantings were not made until the final decades of the nineteenth century, returning the landscape to a more bucolic form that visitors to the region see today.

Newport's economic engine restarted in earnest fifty years after independence, during the 1830s, with the construction of several major resort hotels that began drawing tourists to Newport by the hundreds from Boston, New York, Philadelphia, and points south. Although Newport had been something of a summertime refuge during its eighteenth-century heyday, the era of grand hotels soon developed a full-fledged season that provided all the comforts and conveniences of urban living in a restful landscape setting. Over the ensuing decades, regular visitors began to purchase lots from area developers and to build elegant summer "cottages" for themselves as early as the 1840s. Thus began a long tradition of friendly competition among wealthy neighbors (often the same neighbors both in New York and in Newport who competed in both places) that crested at the end of the century at the Vanderbilts' estate, The Breakers, in 1893.

During Suydam's day, however, summer life at Newport remained less structured and exclusive. An assortment of smaller hotels, houses for rent, and boardinghouses near the town's center and just east of the Redwood Library offered adequate quarters for the many visiting writers and artists. This seasonal intellectual community, in which Suydam participated, appears to have relied on more domestic arrangements than the mammoth hotels permitted, though they undoubtedly attended some of the public concerts and daily promenades through the town's fashionable areas that amused tourists. They appear to have kept close company and visited with one another in their rented lodgings rather than taking part in the increasingly regimented daily activities established by the resort hotels.[21]

Health and leisure were Newport's primary attractions. Offering a refreshing respite from the dirt, noise, and activity of urban life, the sunny Newport beaches, cliff walk, and shoreline roads provided an array of options for enjoying the area's healthful climate. William Ellery Channing recalled that Newport's daily fogs, depicted in Suydam's *Newport Beach* (see FIG. 3.2), acted as "brooms which keep the atmosphere clean."[22] The town's clean air, temperate atmosphere, and protected beaches were believed to reverse the negative effects of urban life on the mind and body. Easily accessed by boat, Newport became one of America's first resorts, a longstanding European tradition that had not previously taken hold in the United States. Health was also one of Suydam's primary reasons for visiting Newport. His struggle with depression and exhaustion in New York was widely reported by his friends and later recollected by his eulogists. At Newport, however, Suydam's spirits rose and his health improved as he spent time outdoors making studies for his paintings onsite until the last light of day. A diligent worker, Suydam garnered the admiration of his colleagues for the intensity of his work ethic.

Tourists in Newport mostly visited areas different from where Suydam worked. Easton's, or First Beach, was the closest and most accessible beach to the center of town (FIG. 3.19), and the hotels ran constant shuttles for the benefit of their guests. During bathing hours in the late morning, Easton's Beach was reportedly mobbed. Suydam's sites tended to be farther afield and rarely visited by tourists except in the later afternoon for picnics. Fashionably dressed figures appear in most of Suydam's Newport views, though not in the numbers that would have characterized the period. His scenes favor a sense of a new visual discovery rather than an overrun tourist destina-

FIG. 3.19 Frederick B. Schell (1838–1905) and J. Hogan (active later nineteenth century), *Newport, Rhode Island*, 1872–1874, engraving, 7 ¼ x 9 ½ inches, Picture Collection, The Branch Libraries, The New York Public Library, Astor, Lenox and Tilden Foundations.

tion. Suydam's rendering contrasts with Winslow Homer's similarly arranged 1869 view of *Long Branch, New Jersey* (FIG. 3.20), in which similarly well-dressed young women appear in the foreground. Suydam's depictions favor a less populated landscape, even reducing the figures below scale and thereby diminishing their effect on the scene. Never a figure painter, Suydam sought an aesthetic experience of modern Newport that avoided the more popular and frequented venues that most tourists would have associated with the area.

Landscapes of the Mind

Contemporary accounts suggest that Suydam's relationship with his art was more therapeutic than devotional. During the Civil War era, rapid urbanization was blamed for an array of social ills. An individual's relative proximity to nature was believed to correlate directly with happiness and fulfillment. Plagued by disease, poverty, and temptation, city dwellers, particularly those involved in business, often suffered from anxiety that was thought to be "one of the most frequent and important" causes of illness.[23] The field of moral philosophy, a forerunner of modern psychology, began in Europe during the early nineteenth century to study influences on the mind and understand the causes of social unrest that accompanied the Industrial Revolution. By Suydam's day, the field had grown substantially and established the foundations upon which modern psychology would develop after the war.

According to Gifford, Suydam enjoyed scenery that suited his temperment. Kellogg went even further, however, to stress: "No artist that I know more fully manifests his character in his works."[24] The coastline around Manchester and Beverly, Massachusetts was one such area. The region was "simple without being monotonous and vained without being rude or savage. Its quiet and retirement with the fine weather, the few agreeable people they met, and the interest he took in his studies all combined to soothe and benefit him mentally and physically."[25] Sensitivity to one's own emotions was increasingly recognized as a healthy quality, and when Suydam complained of fatigue, Gifford and his other friends "urged him to go at once into the country."[26] Understanding of the mind's operation remained at a rudimentary level during the 1860s, but it held out the potential to identify and take control of basic mental health. Suydam, whose depression was mentioned on several occasions by friends, sought out and depicted landscapes that improved his outlook.

The study of psychology in the United States largely began with Rev. Thomas C. Upham (1799–1872), professor of a newly created chair of Moral Philosophy and Metaphysics at

Bowdoin College. His pioneering *Elements of Intellectual Philosophy*, was first published in 1827 and regularly reprinted, revised, and elaborated upon until the author's retirement in 1869. Upham's work became the definitive textbook for college-level instruction of psychology, which was then known interchangeably as moral, mental, or intellectual philosophy.[27] Suydam may well have encountered Upham's work in his courses at the University of the City of New York during the later 1830s. Upham's book provided the paradigm for his contemporaries' appreciation of the mind. Inextricably bound to morality and aesthetics, Upham's work is remarkable for the often identical vocabulary that he applies to both science and art. In his words, objects of natural or artistic beauty

FIG. 3.20 Winslow Homer (1836–1910), *Long Branch, New Jersey*, 1869, oil on canvas, 16 x 21¾ inches, Museum of Fine Arts, Boston, The Hayden Collection—Charles Henry Hayden Fund, 41.631. Photograph © 2006 Museum of Fine Arts, Boston.

"may excite within us feelings of pleasure, and the mind, in its turn, may reflect back upon the objects the lustre of its own emotions, and thus increase the degree of their beauty."[28] Upham's words eloquently describe an emotive aspect of Suydam's luminist paintings and reflect critical opinion of both Suydam's works and those of his peers.

That amplification of emotion in the landscape echoes a signature luminist characteristic—intensification—that was first described by John I. H. Baur in his early definition of the aesthetic. He wrote that "the standard by which the early realists must be judged is neither the degree of their fidelity to nature nor their exploitation of formal values of composition and design . . . , [but] rather in evoking a poetic mood akin to the nature poetry of contemporary writers like Bryant and Street. Many of them, including Suydam, achieved this through an intensification of those aspects of nature that moved them personally."[29] In Suydam's work, virtually every tool is subject to intensification, from color to perspective. Far from Emerson's ideal of the artist as a "transparent eyeball," striving to eliminate any suggestion of his presence as an intermediary between the viewer and the landscape depicted, Suydam instead accentuated his role as an active interpreter of significance and poetic force. Baur's interest in the expressionistic aspect of Civil War–era marine painting finds resonance in Suydam's art and collection. The quietude of his landscapes was informed by the powerful subjectivity of works in his collection, such as Andreas Achenbach's *Off Ostend* (FIG. 2.15) and Jasper Cropsey's *Coast Scene* (FIG. 3.21), as much as by the more peaceful works that he owned.

The range of Suydam's collection of paintings conveys a sense of his admiration for the full spectrum of emotions, though he favored the serene in his own work. From his enormous

FIG. 3.21 Jasper Cropsey (1823–1900), *Coast Scene*, 1855, oil on canvas, 17 x 26¼ inches, National Academy Museum, Bequest of James A. Suydam.

Achenbach to his intimate Aaron Draper Shattuck *The Ford* (FIG. 5.2), Suydam apparently did not prefer one type of emotive content over another in his collection of landscapes any more than he exclusively acquired one type of book for his library, though his collection of figure paintings demonstrates a clear preference for the sentimental. The same encyclopedic principle that applied to his reading apparently extended to his art collecting and undoubtedly contributed to the nuance of feeling in his own painting. As Gifford remarked, Suydam "was always ready to recognize and acknowledge excellencies of whatever kind and whatever school."[30] Such a liberal, ecumenical taste was unusual in American collections of this period but lent great significance to his bequest to the National Academy. As a pedagogical tool, Suydam's broad collection was ideal for the purposes of the Academy's school and the encouragement of future generations of artists.

Suydam's collection, though it ranges from the peaceful to the violent, contains no representative works of the school of artists who worked in the sharply realistic aesthetic espoused by Ruskin in England, who came to be known as Pre-Raphaelites and flowered briefly, but brightly in the midst of the Civil War.[31] Ruskin's dictates bridged the conceptual gap between scientific examination and religious faith by insisting upon the discovery of Christian morality in the landscape. Given the scale of Suydam's collection, the absence of that competing aesthetic suggests a deliberate aversion. Suydam's position on the subject is further elucidated by the inclusion of a

controversial book by Robert Chambers, *Vestiges of the Natural History of Creation*, in his library (see Appendix 3). Chambers encountered such vehement opposition to his theory of evolution published in the book in 1844 that his experience caused Charles Darwin to delay the release of his own revolutionary volume, *On the Origin of Species*, until 1859.[32]

Art historian Joshua Taylor observed a distinction between the artists of Suydam's generation working in a "more serene" aesthetic than the earlier mode represented by Thomas Cole. The later artists "tended to prefer either the seemingly endless sweep of luminous space or the confounding complexity of a forest glade. In either instance, pictorial structure with its thrusts and balances gave way to infinite and apparently unstructured contemplation."[33] Taylor's observation concisely conveys a difference in kind between the luminist aesthetic and the Pre-Raphaelite. Whereas the Pre-Raphaelite approach expresses meaning through the "confounding complexity" of its detailed rendering of the landscape, Suydam's landscapes contain no such details to divert the eye from the scene's overall effect. Even more than Kensett, Suydam reduced the level of specificity in his compositions to minimize the distraction for the viewer.

Suydam contributed this further exaggerated sense of the distilled landscape to the development of the luminist aesthetic, going a step beyond the level of abstraction that his mentor Kensett practiced and making its significance to their aesthetic even more pronounced. Suydam's *Ocean Beach* (FIG. 3.22), for example, reduces the scene to only three basic components, sea, beach, and sky, eliminating even the high promontory that he customarily included in his larger compositions. In Upham's terms, Suydam explored the emotion of the sublime through "the attribute of mere horizontal amplitude," which Upham identified as the leading dimension of the sublime.[34] Describing the ocean's infinite distances, Upham could easily be describing Suydam's composition: "In regard to the ocean, one of the most sublime objects which the human mind can contemplate, it cannot be doubted that one element of its sublimity is the unlimited expanse which it presents."[35] Depth bore far less significance in this respect than horizontal reach, which Suydam exploited in several of his marine compositions by using extrawide canvases to accentuate their lateral movement.

Suydam's "tendency to melancholy" was a common enough trait among artists, not to mention the general public, during the Civil War. The origin of Suydam's depression is difficult to identify, however, unless it resulted from the war itself. His responsibilities to the National Academy's Fellowship Fund were certainly considerable, and were cited in his eulogies as a source of anxiety and fatigue, but those were not typically associated with depression during the period. The Fund was a breathtaking success, and he was recognized for his contributions to the venture. He certainly appears to have enjoyed his family life, or else his affluence would easily have permitted him to move out of his parents' home on Waverly Place. Similarly, he enjoyed the company of dedicated friends, including Kensett and their circle. He was popular enough to be nominated to membership in various social and professional clubs, and he had enough money to allow him to pursue virtually any ambition he desired. He had lost his father relatively early in life in 1841, but nothing is known of their relationship. When his mother died in 1864, he was

FIG. 3.22 James A. Suydam (1819–1865), *Ocean Beach*, undated, oil on canvas, 9 x 21 inches, National Academy Museum, Bequest of James A. Suydam.

not so distraught that he could not write to Thomas Hicks to deliver his treasurer's report for a meeting that he would miss because of the funeral.[36]

Whatever its origin, Suydam's depression led him to seek out sites that affected his health favorably and where he could expect to encounter congenial company. These gregarious venues were not terribly common during the Civil War period, however, and limited his options to major tourist destinations along the Hudson, at Newport, among the Catskill Mountains, at North Conway, or in neighboring Long Island. The scarcity of creative summer communities may explain why Suydam so often traveled in the company of other artists, bringing their society along with him to new sites. The fact that Suydam, Gifford, and Whittredge were unable to find a place to stay in Newport during their visit in the summer before Suydam died is also remarkable. Rejected from one his most beloved landscape, Suydam and Gifford sought other inspiration along the Massachusetts coast and then the White Mountains.

The manner of Suydam's death seems to have come as a considerable surprise to his friend Gifford. Certainly, dysentery was a dangerous illness during the period, killing more than forty-four thousand soldiers during the course of the Civil War, but it was primarily feared as a battle-field disease. In the temperate, early fall climate of northern New Hampshire, Suydam's case was not expected to be fatal, either by his doctor or by Gifford, who rushed to Suydam's bedside to care for his suddenly stricken friend. According to Huntington's memorial address, Gifford "clung to [Suydam's] bed-side till prostrated by sickness" even after the arrival of Suydam's relatives.[37] The depth of Gifford's friendship is difficult to gauge, but he was evidently seriously affected by Suydam's worsening health.

From the early stages of his illness, Suydam was convinced that he would die. That fatalistic outlook suggests a deeper state of depressive condition than was acknowledged in either the letters or memorials of his peers. They certainly urged him to leave New York when he felt worn-out by his responsibilities there. By the summer of 1865, however, the National Academy's new building was open, the funds raised, and the Civil War ended. Just as national fortunes picked up, Suydam was stricken. The last work he exhibited at the Academy's Annual in 1865 was a depiction of *Spouting Rock Beach*, likely the 1864 painting currently titled *On the Beach, Newport* (FIG. 3.23), one of his most accomplished compositions. How was it that he fell into such a fatalistic mindset and how would his condition have been interpreted?

In terms of the prevailing psychological theory of the day, Upham's, which are likely the terms in which Suydam understood his own situation, his condition was termed *hypochondriasis*, "a disordered state of the Sensibilities . . . nothing more nor less than a state of deep depression, gloom, or melancholy."[38] The sufferer's "imagination hovers over [some gloomy prospect], throwing a deeper shade on what is already dark." One of the cures that Upham proposed to alleviate the mental disease was travel.[39] Suydam's last dated work was likely painted nearly a year before his death, and offers no clues as to any deteriorating mental health. The question of *Paradise Rocks* still lingers, however. Is it conceivable that undertaking overwhelmed Suydam in the last year of his life and exacerbated his preexisting depression? The most probable explana-

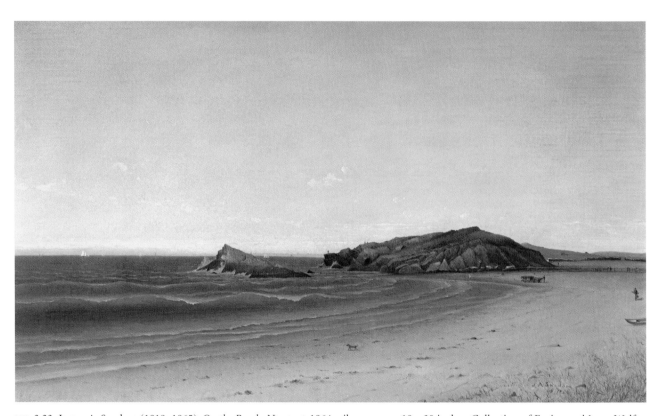

FIG. 3.23 James A. Suydam (1819–1865), *On the Beach, Newport*, 1864, oil on canvas, 18 x 30 inches, Collection of Erving and Joyce Wolf.

tion remains that exhaustion left Suydam vulnerable to disease and depression left him unwilling to fight it.

Suydam's later landscapes provide insight into the intellectual culture of his day. Admired by colleagues for the investment of his own personality into his art, Suydam's intimate involvement likely reflected his own sense of vulnerability. Reportedly a reserved, gentle person, he exposed himself to potential criticism by creating more ambitious compositions for the Academy's Annuals. Working in the midst of perhaps the most dramatic scientific revolution of the nineteenth century in the form of Darwin's *On the Origin of Species*, Suydam's selective appreciation and patronage, though expansive by nineteenth-century standards, separated him decisively from the strict dogma of the Pre-Raphaelites at the height of their influence in New York. Concentrating on his own uniquely personal, psychological form of luminism, Suydam was able to make notable contributions to the aesthetic practiced by his friends and colleagues.

In sum, Newport provided a unique landscape that was well suited to Kensett's and Suydam's aesthetic course. What James called "a grand landscape in miniature" suited their purposes and

encompassed the Colonial era's legacy of which Suydam was undoubtedly aware. The town provided Suydam with a haven from the intense political conflicts of the Civil War and offered a nurturing intellectual and creative community in which he could learn and develop his art during the later 1850s and 1860s.

Newport's long history also influenced both the landscape that Suydam discovered there and the manner in which he would approach it. Berkeley's theory of vision and his association with Newport established a strong philosophical dimension to the landscape, the same one that had inspired Berkeley more than a

FIG. 3.24 Spouting Rock Beach, Newport, photograph by the author.

century before. Although the town itself lay in fragile condition during the 1850s, its economic revival with the rising tourist industry led to new construction that breathed new life into the moribund town, suddenly more interesting for its historic quality. In Berkeley's theories, Suydam would have found a sympathetic foundation for his personal aesthetic that may partly explain his stylistic consistency during his later career, not to mention the frequency of his depictions of Paradise Rocks.

Paradise was an appropriate name for the area to which Suydam traveled to escape the fatigue and melancholy that bedeviled him during the Civil War years. For the artist who told his first mentor, Kellogg, that it was "dull work to plod alone" even among the celebrated collections of Europe, Newport offered the kind of "clever" community that he sought to ease his feelings of

isolation.[40] Suydam was certainly not alone among his colleagues to suffer depression. More than most of them, however, he appears to have used his art as a means of alleviating that condition. The landscape around Newport offered a virtually clean slate upon which to develop a more personally expressive mode of art.

NOTES

1. Henry James, "Art," *Atlantic Monthly* 38 (August 1876), 251; cited in James L. Yarnall, *John La Farge in Paradise: The Painter and his Muse* (Newport, RI: William Vareika Fine Arts, 1995), 8.

2. Suydam also exhibited a painting, now unlocated, entitled *Lily Pond* at the National Academy's Annual in 1857. Newport has a well-known site of that name, but without the painting itself to substantiate its location, it is inadequate evidence of an earlier visit to the area.

3. Daniel Huntington, Manuscript Memoir of James A. Suydam, typescript, National Academy Museum Archive, 2.

4. Miner K. Kellogg to Daniel Huntington, Baltimore, 1 May 1866, typescript, National Academy Museum Archive (hereafter cited as Kellogg to Huntington).

5. Sadayoshi Omoto, "Old and Modern Drawings: Berkeley and Whittredge at Newport," *Art Quarterly* 27, no. 1 (1964): 43–55.

6. Katherine E. Manthorne was the first to remark upon the correspondences between Suydam's depiction of Paradise Rocks and Berkeley's writings. Katherine E. Manthorne, "James Augustus Suydam," in Barbara Novak and Annette Blaugrund, eds., *Next to Nature: Landscape Paintings from the National Academy of Design*, exh. cat. (New York: National Academy of Design, 1980), 57–59.

7. J. R. Dix, *A Hand-Book of Newport, and Rhode Island* (Newport: C. E. Hammett, Jr., 1852), 80.

8. A critic for the *North American Review* observed in 1871 that "Berkeley's theory of vision was an important step in the development of the associationalist psychology." C. S. P., "The Works of George Berkeley," *The North American Review* 113, no. 233 (Oct. 1871): 449. For more on associationism, see Angela Miller, *The Empire of the Eye: Landscape Representation and American Cultural Politics, 1825–1875* (Ithaca, NY: Cornell University Press, 1993), 79–82.

9. David Berman, "Introduction," in George Berkeley, *Alciphron, or the Minute Philosopher*, ed. David Berman (New York: Routledge, 1993), 1.

10. Yarnall, *John La Farge in Paradise*, 4–5.

11. E. H. Gombrich, *Art and Illusion: A Study in the Psychology of Pictorial Representation*, 2nd ed. (Princeton, NJ: Princeton University Press, 1989), 330–31.

12 Jonathan Crary, *Techniques of the Observer: On Vision and Modernity in the Nineteenth Century* (Cambridge, MA: MIT Press, 1990), 70.

13. A. A. Luce, *The Life of George Berkeley, Bishop of Cloyne* (New York: Thomas Nelson and Sons, 1949), 120–21; Edwin S. Gausted, *George Berkeley in America* (New Haven, CT: Yale University Press, 1979), 17.

14. Benjamin Rand, *Berkeley's American Sojourn* (Cambridge, MA: Harvard University Press, 1932), 29–30.

15. Edward Cary, *George William Curtis* (New York: Houghton, Mifflin and Company, 1895), 87–88. Kensett may also have visited Newport earlier, as he illustrated Curtis's 1852 book *Lotus-Eating: A Summer Book* (New York: Harper & Brothers, 1852); Mark W. Sullivan, "John F. Kensett at Newport: The Making of a Luminist Painter," *Magazine Antiques* 140, no. 5 (November 1990): 1033.

16. George William Curtis to Bayard Taylor, 30 July 1855, Early American Fiction Collection, University of Virginia Library, Charlottesville.

17. Curtis, *Lotus-Eating*, 165.

18. Ibid., 166.

19. This is likely the 1865 version of *Paradise Rocks* that a reporter from the *New York Evening Post* observed in Suydam's studio in February, 1865, cited in Dearinger, *Paintings and Sculpture in the Collection of the National Academy of Design*, n. 523, as a reference to the larger version in the National Academy collection. Suydam's brother, David Lydig, and Whittredge

presented the version, entitled *Bishop Berkeley's Seat*, to the Century in 1866 as by both Suydam and Whittredge. It was inventoried in the Century collection in 1875 as no. 87.

20. Pre-conservation photographs taken in 1980 show significant paint loss around the upper area of the last digit of the date, but do not offer any evidence for a date other than 1860.

21. Charles H. Dow, *Newport: A City by the Sea* (Newport: John P. Sanborn, 1880), 117–18.

22. Cited in Dow, *Newport*, 80.

23. Charles Turner Thackrah, *The Effects of the Arts, Trades and Professions, and of Civic States and Habits of Living: With Suggestions for the Removal of Many of the Agents which Produce Disease, and Shorten the Duration of Life*, 2nd ed. (London: Longman, Rees, Orme, Brown, Green and Longman, 1832), cited in Taylor and Shuttleworth, eds., *Embodied Selves: An Anthology of Psychological Texts, 1830–1890* (Oxford: Clarenden, 1998), 293.

24. Kellogg to Huntington, 5.

25. Gifford cited in Huntington, Manuscript Memoir of James A. Suydam, typescript, 4.

26. Ibid.

27. A. A. Roback, *History of American Psychology* (New York: Library Publishers, 1952), 56. Suydam enrolled and earned honors in his class on moral philosophy at the University of the City of New York in 1838–1839. Student Records Archive, New York University.

28. Thomas C. Upham, *Elements of Mental Philosophy* (New York: Harper and Brothers, 1852), 299.

29. John I. H. Baur, "The U.S. Faces the Sea," *ArtNews* 47, no. 7 (1948/9): 23.

30. Gifford cited in Huntington, Manuscript Memoir of James A. Suydam, typescript, 7.

31. The collection does contain a small oil by William Trost Richards, who is better known as a Pre-Raphaelite, but Suydam's Richards seascape more closely approximates the luminist aesthetic than the Pre-Raphaelite.

32. Louis Menand, *The Metaphysical Club: A Story of Ideas in America* (New York: Farrar, Straus and Giroux, 2001), 122–25.

33. Joshua C. Taylor, *America as Art* (New York: Harper & Row, 1976), 111.

34. Upham, *Elements*, 302.

35. Ibid.

36. Suydam to Hicks, 17 April 1864, MSS, Fellowship Fund Papers, National Academy Museum Archive.

37. Huntington, typescript, Manuscript Memoir of James A. Suydam, 8.

38. Upham, *Elements*, 469.

39. Ibid., 470–72.

40. Kellogg to Huntington, Manuscript Memoir of James A. Suydam, 4.

FIG. 4.1 James A. Suydam (1819–1865), *Moonlit Scene*, undated, oil on canvas mounted on masonite, 6¼ x 10¼ inches, private collection, courtesy Betty Krulik Fine Art Limited, New York.

Chapter 4

A SHARED ARTISTIC LIFE

Katherine E. Manthorne

> The best things come . . . from the talents that are members
> of a group; every man works better when he has compan-
> ions working in the same line, and yielding to the stimulus
> of suggestion, comparison, emulation. Great things have of
> course been done by solitary workers, but they have usually
> been done with double the pains they would have cost if
> they had been produced in more genial circumstances.
> —Henry James, *Hawthorne*[1]

ARTISTS ARE INVETERATE COLLECTORS. Elihu Vedder, Thomas H. Hotchkiss, and Samuel Colman all amassed fascinating assortments of art objects.[2] The Brooklyn-based painter-etcher James Falconer was so proud of his holdings of prints and paintings that he commissioned Seymour Joseph Guy to paint a portrait of his mother surrounded by them, entitled *Evening* (1867; Worcester Art Museum). Many of the artists in James Suydam's circle were similarly engaged in collecting. Frederic Edwin Church assembled what he rather optimistically called his Old Masters at Olana. "Of Brooklyn artists who are the possessors of picture collections," it was reported, "the brothers William and James M. Hart, are blessed with extensive and excellent ones."[3] John F. Kensett, too, indulged in this habit, and often acquired works by the same artists as his friend Suydam.[4]

Just how did they assemble their collections? This was something a journalist for the *Brooklyn Eagle* pondered: "This end is accomplished by various means, often by friendly inter-change of works *quid pro quo*, a pleasant way, and one fruitful of many pleasant associations of one's fellow workers in the services of the divine mistress Art,—and again it not unfrequently [*sic*] happens that the painter plays the part of patron toward his fellows, 'just like other folks,' giving his 'commission' in the regular way."[5] At different times Suydam relied on these "various means," including purchases, exchanges, and commissions to round out his holdings. Often his

motivations were his altruistic, to provide economic assistance to a struggling fellow artist or to give visibility to work.

What was the place of Suydam's art collection in both his professional and personal life? What were his acquisition strategies? And how did the assembling of his collection relate to the formulation and expansion of his circle of friends? The collection in fact operated for him on multiple levels and evolved over time as his own agenda changed. As a gentleman of means, it provided a reflection and even an expansion of his status. As an amateur deeply committed to the cause of American art, he bequeathed the collection to the National Academy to benefit artists and the future of the field. It reflected his interests as well as promoted them. As an artist, he used the collection to aid his professional skills. In the beginning, he likely acquired works by Kensett and Asher B. Durand to instruct himself in the basic precepts of landscape painting. Later, a picture he bought might be useful to study to solve a particular artistic problem or to stimulate his own work. As he became surer of his own direction, he may have encouraged younger artists such as William Trost Richards or George Henry Boughton to go in that same direction, by commissioning works from them.

From a Personal to a Study Collection

The early stirrings of Suydam's vocation as a painter went hand in hand with his activities as a collector, which fall into a telling pattern. Alongside the American landscapes he bought from Durand and Kensett, he also purchased several of the minor European painters of forest interiors and coastal views then popular: Emile Charles Lambinet, Narcisse-Virgile Diaz de la Peña, Jules Achille Noël, and Alexandre Calame. These were all, as we shall see, pictures that had lessons to teach him: probably the raison d'être of his purchasing at the outset. Figure pieces were also of interest and fall into two groups: idealized women and sentimental genre scenes (Hicks's *Harriet Beecher Stowe* is the only portrait he was known to acquire). From Miner Kellogg, who had guided him on his European Grand Tour, he acquired several of his typical, vaguely Orientalist young women including *Greek Girl* and *Circassian Girl* (FIG. 1.4). It was probably Kellogg who awakened a taste in him for bust-length renderings of idealized female types, which are amply represented among his holdings. His purchase of genre scenes likely represents his move beyond the orbit of influence of his early mentors to branch out on his own. His interest in Edouard Frère and the Écouen School was part of a vogue they enjoyed in America, triggered by John Ruskin's exegesis and promoted and sold by art dealer and print publisher Ernest Gambart.[6] Suydam bought two pictures by Frère that were warmly praised by the critics and apparently emulated by a number of the younger American figure painters, whose works Suydam subsequently acquired as well. By the early 1860s he had assembled a small grouping of scenes of women and children including those by William Parson Winchester Dana and Eugene Benson, which demonstrate close affinities with the domestic subject and tenderness of mood identified with the French practitioners. This underscores a pattern in which Suydam was nudging the younger American artists along directions embodied in his collection.

For an artist, the impulse to acquire tends to be tied to that which inspires and aids the process of art making. The mystery lies in what aspect of the work he or she finds compelling—something that speaks to him or her—be it the bend of the arm in a portrait or the look of an apple in a still life. Think about Suydam by 1851 acquiring Durand's *Landscape*, the first of what turned out to be a long string of American landscape purchases. Where did his eye rest? What did he savor in the picture? For surely he must have favored some corner of the wooded scene more than others. Where did he keep them, how did he hang them? Given that we have frustratingly few descriptions of the collocation of the works, some of this remains conjecture.

Initially Suydam collected landscapes as tokens of friendships, aids to his own art making, and adornments to his studio and home. As he became more involved with the National Academy—especially after his election as an Academician and as facilitator in the realization of the new building that opened in 1865—he began to collect more broadly. He deliberately acquired works from a wider spectrum of painters and introduced more figural works into the mix. This strategy of compiling a representative sampling of the New York art world suggests that he did so with an eye to posterity. He aimed to assemble a permanent record of American artists and a study collection to train future practitioners. His plans for his ensemble evolved over time, culminating in that fateful day in North Conway just preceding his death when he made his will bequeathing his collection to the Academy.

Sir Joshua Reynolds provided an important precedent for Suydam, just as the Royal Academy of which he was President was a key model for the National Academy. Reynolds's collection of paintings, drawings, sculpture, and prints, in fact, was the largest assembled in eighteenth-century Britain. Intended partly as an investment and partly for study, he wanted it to benefit students—a "repository for great examples of art"—and offered it to the Royal Academy at a low price, on the condition that they provide an exhibition room. The offer was rejected.[7] Suydam was aware of his precedent, given that his library holdings included *The Work of Sir Joshua Reynolds*, *Literary Works of Sir Joshua Reynolds*, and an illustrated volume of Reynolds's *Discourses* (see Appendix 3). Wishing that his collection further the reputation of his fellow artists and serve their needs, Suydam bequeathed it to the National Academy. Many artists assembled collections, formally and informally. With few exceptions, however, these were sold or otherwise dispersed, and are often difficult to reconstruct. Suydam's collection offers a rare instance of an artist's collection maintained intact.

The Collaborative Circle

In Asher B. Durand's *Landscape* (FIG. 4.2), two men appear in the clearing among the trees at right, one reclining on the ground and the other close by, standing over him. They can be identified as artists by the portfolios they hold, and they are probably engaged in conversation about the vista before them (what looks like a view in the Catskills), and about the drawings and sketches contained in their portfolios. This was Suydam's first American landscape acquisition, from the leading figure in the field who had provided him with inspiration and guidance.

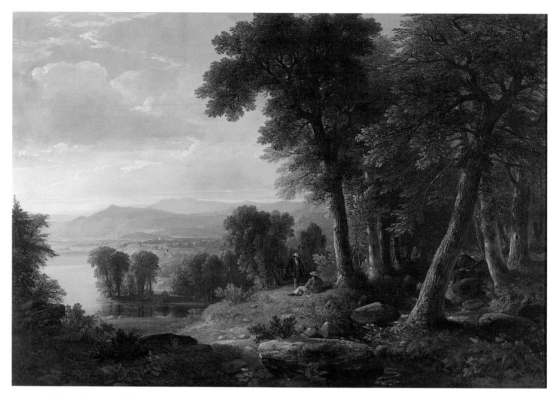

FIG. 4.2 Asher B. Durand (1796–1886), *Landscape*, 1850, oil on canvas, 27¼ x 38½ inches, National Academy Museum, Bequest of James A. Suydam.

Durand completed the work in 1850, immediately following his famous work *Kindred Spirits* (1849) where the artist Thomas Cole and the poet William Cullen Bryant commune with one another through the American scenery they loved. Given this precedent, it is tempting to read the figures in *Landscape* as master and pupil—perhaps Suydam and Durand—engaged in the study of art and terrain together.[8] This motif of two figures or more engaged in the joint contemplation of nature occurs with sufficient frequency in the landscapes in Suydam's collection to indicate a purposeful pattern. Paintings by Gifford, Aaron Draper Shattuck, Benjamin Champney, and others contain pairs or small groups of figures. The motif references the attitude they shared with Suydam that the enjoyment of natural world was not a solitary but rather a communal occupation.

The images that Suydam gathered around him usually showed the same quiet moments he painted himself where, as David Huntington aptly described, "nature has been hushed to attend a human mood."[9] Shattuck's *On the Saco, North Conway* (FIG. 4.3) possesses that same mood and features three figures locked in a circle on the water's edge. This painting in fact had been attributed by John I. H. Baur to Suydam, suggesting that he identified a close approximation in their sensibil-

ities.[10] Shattuck established a particular relationship between his picture and the observer that Henry T. Tuckerman neatly characterized: "There is a true pastoral vein in him; his best cattle and water scenes, with meadow and trees, are eloquent of repose and of nature to a degree and in a manner that often places the spectator in relation with what he unconsciously adopts as a personal reminiscence of the scenery."[11] That strategy of encouraging us to read his picture "as a personal reminiscence" implies a shared experience. The White Mountains where this was painted became the summer retreat for many of these painters, and the site of much joint sketching and relaxation.

This locale appears again in another work in Suydam's collection—*Conway Valley* (FIG. 5.3) by Benjamin Champney, who is sometimes dubbed the leader of the White Mountain School for his devotion to the subject. In this rendering, three figures take repose on the edge of the avenue of trees where they glimpse the vista to the hills beyond, again reinforcing the idea of shared community in nature. Thomas Starr King's popular guide to the area entitled *The White Hills. Their Legends, Landscape, and Poetry* (1859) identified the region as a place where "nature and conscious life are one. It seems just the spot where one—with fitting company—might realize a perfectly artistic life."[12] This need for suitable companions to realize art was central to Suydam and his fraternity of artists. The groupings of figures that appear in the foregrounds of the painted landscapes he acquired function as surrogate portraits of the members of their circle.

I have elaborated on this figural motif as a way of introducing the theme of the shared aesthetic via Suydam's art collection and the dynamics of what might be called a collaborative cir-

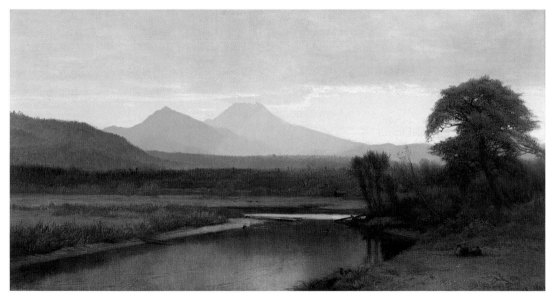

FIG. 4.3 Aaron Draper Shattuck (1832–1928), *On the Saco, North Conway*, 1857, oil on canvas, 14 x 26¼ inches, National Academy Museum, Bequest of James Suydam.

cle, which "combines the dynamics of a friendship group and a work group," as sociologist Michael P. Farrell explains.[13] Drawing on group theory, Farrell's examination of the life course of the French Impressionists has parallels with these Americans: "The core group consisted of four young men who met in an art teacher's studio in 1862 when they were all in their early twenties—Claude Monet, Pierre Auguste Renoir, Alfred Sisley, and Jean-Frédéric Bazille. Eventually the core group expanded to include others. This group is a prototypical case of a collaborative circle in which the members first became friends, then developed a shared style and built their careers within the context of a circle."[14] This chapter studies the circle of American painters around Suydam and elaborates on their interpersonal interactions, mutual borrowings, and the impact they ultimately had on one another. We begin to see a unified approach to painting as an outgrowth of those relations as we glimpse into this one artist's friendship and work group. Members shored each other up and acted as buffers between themselves and their detractors, be they critics, juries, or discontented patrons.

With the exception of approximately fifteen European pictures, Suydam acquired paintings by living American artists with whom he had some personal interaction. The collection provides a tangible record of the artists he found congenial, of pictorial solutions he identified as innovative or interesting. His assemblage of midcentury art functioned as a nexus for exchange within the circle, providing reference points for motifs, paint handling, and pictorial realization of shared ideas. It therefore provides the springboard for a discussion of the communal aesthetic that emerged out of his circle. In the following pages, I scrutinize two areas: first, I focus on individual personalities represented in the collection and determine their roles in the group dynamics. The contribution of well-known friends Gifford and Kensett are integrated here with those of sometimes-overlooked participants including William Hart, Richard William Hubbard, and Daniel Huntington. Second, I identify themes and motifs recurrent within Suydam's collection that contribute to a shared pictorial sensibility. In this way, we begin to see how a language of luminism was forged within this collaborative circle.

Suydam as Gatekeeper

Suydam occupies a position in the group, I would argue, parallel to Gustave Caillebotte, who worked within the Impressionist circle, creating highly personal images of Parisian life and buying works from his fellow painters that he donated to France upon his death. Farrell, in his analysis of collaborative circles, discusses Caillebotte in the "executive manager role," in which his financial support and organizational skills were paramount.[15] Similarities between Caillebotte's and Suydam's commitments to art are striking. Family money freed both from the constraints of the market to paint experimentally and to take risks in their own canvases, without the need to abide by particular stylistic norms or a circumscribed repertoire of nationally prescribed subjects. Second, it afforded time to think about the institutional side of art—museums and academies—in a way that few other artists could who were necessarily involved in the day-to-day struggle for survival. And finally, it allowed them to purchase works of art by other painters.

The Inner Circle: Kensett and Gifford

Dialogue between Suydam and Kensett was essential to the crystallization of a visual vocabulary as they worked and traveled together, venturing more and more frequently to the coast. In the early 1850s Kensett was still occupied with the earlier Hudson River School mode. He created traditional Hudson River salon compositions akin to those by Thomas Cole, with a central mountain, foreground body of water, and trees framing the view at right and left. This is exemplified by his major early work *The White Mountains—From North Conway* and in the smaller composition Suydam procured by his friend, *Glimpse Through the Wood* (FIG. 4.4). Kensett also did extraordinary pictures of woodland interiors such as *Bash Bish* that relate to Asher B. Durand's works. Suydam, too, practiced in these modes; several of his pictures echo those by Kensett he purchased including the sketch of the birch tree, rock, and mountain (FIG. 4.5) and *Bash Bish* (FIG. 4.6). Their pictures of this moment respect landscape conventions but at the same time strain against them. Their treatment of skies was not a product of the studio but reflects the study of outdoor light and atmosphere in which they were jointly engaged. Slowly, then, they were moving away from picturesque convention and toward a fresh personal expression. In the meantime, in September 1853 Kensett made an outing with George Curtis to the Navesink Highlands in New Jersey, where the Shrewsbury River empties into the Atlantic, which resulted in a series of five canvases pivotal in the forging of his mature style.[16] When *Shrewsbury River, New Jersey* (fig 5.6), and the smaller, related *Shrewsbury River* (1860; private collection) appeared, they must have startled audiences with their reductive design and hypercalm mood.

As in the case of other artists who create the lead picture of a new, breakaway style, this one, too, had to be nurtured in a circle of like-minded artists. I would posit that the dialogue Suydam had with Kensett reinforced his development in that direction. While preoccupied with the Shrewsbury River pictures in the mid-1850s he and

FIG. 4.4 John F. Kensett (1816–1872), *Glimpse through the Wood*, undated, oil on canvas, 12 x 10 inches, National Academy Museum, Bequest of James A. Suydam.

FIG. 4.5 John F. Kensett (1816–1872), *Study from Nature*, ca. 1852, oil on canvas, 19½ x 16⅛ inches, National Academy Museum, Bequest of James A. Suydam.

FIG. 4.6 John F. Kensett (1816–1872), *Bash Bish*, 1855, oil on canvas, 36 x 29 inches, National Academy Museum, Bequest of James A. Suydam.

Suydam were in Newport and took up the subject of Beacon Rock at the entrance to the harbor. This was the point of departure for another series of works from which Kensett's mature style would emerge.[17] From this point on, and often in the company of Suydam, he concentrated increasingly on the Atlantic coast. The shift in subject allowed a further shedding of the old conventions and a rethinking of design, light, and color: elements he continued to refine for the remainder of his career. Accounts of Kensett's work have thus far failed to take much notice of Suydam. But as we try to demonstrate here, he was a partner in fostering this shift in direction of American landscape art that led to luminism.

Sanford Gifford was another important figure in the group, close to the middle. Suydam and Gifford shared a similar family background and education. Gifford called the center of the Hudson River Valley home, the only one of the landscapists to be able to do so. Suydam was born and grew up in New York City, but his mother's family home in Wappingers Falls provided a second, country home for them, so he, too, would have felt a familial bond to the region. Both were college-educated (Gifford attended Brown University beginning in 1842) and intellectually refined. Gifford enjoyed the security of family money, "having placed himself in a position of pecuniary independence," as one contemporary put it, Gifford "was not obliged to paint what are commonly known as 'pot boilers'"[18]—another circumstance that precisely paralleled Suydam's. These common values must have facilitated their easy familiarity with one another and their tendency to forge similar visual solutions.

Gifford's *Mt. Mansfield, Vermont* (FIG. 4.7) of 1859 in the Suydam Collection manifests the bonds they shared. Gifford painted many versions of this subject, but in this—compared to almost all the others—he takes a more distant view of the mountain, thus diminishing and taming it in the manner Suydam favored. Then, too, there is the presence of two Native Americans on the ledge in the lower center, which carries connotations quite distinct from that of other versions. The white men who are usually seen admiring the scenery were meant to provide the viewer with someone with whom they can identify and thereby partake of the experience vicariously. The insertion of Native Americans here propels the image back in time, into the romanticized past. Such a flavor would have been in keeping with Suydam's interests as evidenced by his library, which included a number of volumes of romantic history. This small picture is related to the large *Mansfield Mountain* (1859; Manoogian Collection), regarded as "his first true mas-

FIG. 4.7 *Sanford R. Gifford (1823–1880), Mt. Mansfield, Vermont,* 1859, oil on canvas, 10½ x 20 inches, National Academy Museum, Bequest of James A. Suydam.

terpiece of American scenery."[19] In discussing the work, a critic hit upon the qualities Suydam must have found so admirable: "Among those [paintings] which are new, are several by Gifford, the most poetical of our American artists, whose pictures are like poet's dreams."[20] Here Gifford is already pursuing the aerial effects that were also occupying Suydam around the same time in works he did along the Hudson and at Lake George (FIG. 4.8).

Boundary Markers

"As group members interact together and attempt to clarify what it is they value and reject," Farrell explains, "the group boundary markers or deviants come to play important parts."[21] Cézanne played that role for the Impressionists, the peasant-dressing bad boy at one end of the scale. Having a common target of hostility held the group together, for it was easier to agree on what they did not like rather than what they liked. Frederic Edwin Church to a degree must have played that role; he was strong, aloof, successful, working in a style somewhat different from theirs. The fact that Suydam purchased one of his more forbidding South American scenes (FIG. 2.18) with its atypical crocodile lurking in the river, reinforces this idea that he was set up as a foil. Suydam also bought the most dramatic seascape by Andreas Achenbach (FIG. 2.15) he could find, the complete opposite of his own small, tranquil scenes. It is important to note that Suydam embraced the extremes within his collection, including not only Church and Achenbach, but also Louis Rémy Mignot (FIG. 4.9) and others who were rather removed from Suydam's developing luminist sensibility. He did not avoid the group's boundary marker, but took it into their midst

FIG. 4.8 James A. Suydam (1819–1865), *River Landscape*, undated, oil on canvas, 8½ x 20¹⁄₁₆ inches, Mr. and Mrs. William Berger and Mr. and Mrs. Richard Simmons.

FIG. 4.9 Louis Rémy Mignot (1831–1870), *Sources of the Susquehanna*, 1857, oil on canvas, 24¼ x 36½ inches, National Academy Museum, Bequest of James A. Suydam.

and struggled to come to terms with it. The circle adopted certain styles and postures not in a vacuum but rather in reaction to others that were inconsistent with their own.

Supporting Members of the Circle: Richard William Hubbard

In the formation and continuation of any collaborative effort, there are inner and outer circles. In the case of the artists around Suydam, those in the outer circle played supporting roles that need to be defined. Richard William Hubbard is one such figure who receives minimal attention in analyses of the American landscape school. Yet he was close friends not only with Gifford but also with Suydam, who purchased three pictures from him, indicating that he was highly regarded within their group. His personal characteristics and those of his art, as described by critics, reviewers, and friends, were entirely sympathetic to those of Gifford, Kensett, and Suydam. Responding to Hubbard's work, Tuckerman suggested, was like meeting a person "whose manners, dress, and physiognomy are subdued and unemphatic." At first we tend to "pass by or overlook" the individual, only to recognize slowly or accidentally their "more quiet yet universal and significant charms."[22] These observations are applicable to his *Twilight*, *Brook Scene*, and *The Ravine* in Suydam's collection. His vocabulary and rationale undergird this notion of an aesthetic Hubbard shared with those Tuckerman himself calls "of kindred spirit":

The repose of Hubbard's landscapes and those of kindred spirit, appeal mainly to the contemplative and patient, we had almost said pensive, observer. Their tone is usually subdued, their beauty poetic; occasionally the effects are exquisite; they may lack boldness and vigor, but rarely meaning and grace . . . and are related to the gentler, more thoughtful and dreamy impressions we derive from nature, whose agency Wordsworth so delighted to advocate and illustrate.[23]

The critic analyzed the means by which these unobtrusive pictures seem to lay such little claim on the attention of the observer: "The method by which this latent interest is developed in landscape is in a great degree scientific, but not infrequently it may be traced to a certain refinement of sentiment or special artistic sympathy. It implies rectitude and feeling rather than great power."[24] Hubbard "works slowly," "paints few pictures," and prefers to work on a small scale: all dimensions paralleled in the work of his circle of friends.

Daniel Huntington

Daniel Huntington also contributed to the group, not because he could in any sense be defined as a luminist, but rather because he provided Suydam and company with needed institutional and emotional support. For all his standing in the art world from the 1850s on—including his

FIG. 4.10 Daniel Huntington (1816–1906), *The Fair Student*, 1858, oil on canvas, 30 x 25 inches, National Academy Museum, Bequest of James A. Suydam.

FIG. 4.11 Daniel Huntington (1816–1906), *Juliet*, 1862, oil on canvas, 12 x 10 inches, National Academy Museum, Bequest of James A. Suydam.

remarkably long run as president of the National Academy (from 1862 to 1870 and from 1877 to 1890) and his position as vice President of the Metropolitan Museum of Art for thirty-three years—he sadly still remains a vague presence in studies of this period. The Suydam Collection includes four works by him that show the range of his talents. Huntington recalled fondly the hours he spent in Suydam's presence as he painted his fine likeness of him (FIG. 2.1), which displays his ability in this line.[25] Portraying fellow painter Durand, Huntington set him among the White Mountains.[26] In the Suydam portrait, too, the setting indicates a favorite milieu: the coastal scenery he was best-known for delineating. Like many American painters, Huntington had ambitions beyond portraiture, as indicated in the collection by

FIG. 4.12 Daniel Huntington (1816–1906), *Glimpses from the Forest*, 1856, oil on canvas, 17¼ x 21 inches, National Academy Museum, Bequest of James A. Suydam.

two historically flavored figure pieces entitled *The Fair Student* (FIG. 4.10) and *Juliet* (FIG. 4.11). What is more relevant here, however, is the fact that he also had landscape leanings, a fine sample of which Suydam acquired: *Glimpses from the Forest* (FIG. 4.12). Adeptly painted, it possesses a feeling for nature and an appreciation of the varieties of rock and trees that he shared with the dedicated landscapists. While critics sometimes scolded Huntington for refusing to stick to a single genre, Suydam's acquisition of this small landscape suggests his encouragement of his work in this vein, which is perhaps a souvenir of a joint sketching expedition.

Like Suydam, Huntington was born in New York City and college-educated, having studied at Yale for a year before he transferred to Hamilton College in Clinton, New York. He was a skillful and successful artist who was well-connected and willing to take on positions of leadership.[27] At the same time, he refused to take himself too seriously, as indicated by his humorous letters to the *Crayon*, and was sensitive to the plight of the less fortunate: all characteristics that made him a positive presence in the fledgling art world of the 1850s. He portrayed or knew almost everyone worth knowing in New York business and culture and therefore carried with him the cachet of the establishment. His interaction with Suydam and his circle would have provided access to his counsel and further legitimated their activities, including his promotion of the White Mountains as a subject for art via the letters he published in the *Crayon* and his presence as "the center of North Conway's 'artistic coterie.'"[28] *Glimpses from the Forest* may represent the White Mountains, since the rocky outcropping and vista to the distance recall that region. Interestingly, Huntington purchased Suydam's *Mount Washington near the Intervale. North Conway, N.H.* in the 1870s out of the Kensett collection, another memento of this shared artistic life.[29]

FIG. 4.13 William Hart (1823–1894), *Twilight*, undated, 12 x 22 inches, National Academy Museum, Bequest of James A. Suydam.

William Hart, Expositor of the Group

This group also included William Hart, who was another strong—if now overlooked—presence in the midcentury art world. He took on the role of expositor of the group via a series of lectures on landscape he delivered upon his election as first president of the Brooklyn Academy of Design in 1865. Entitled *The Field and the Easel*, the lecture provided what Tuckerman called a "just exposition" of "the spirit and method" not only of William Hart and of his brother James, but also of "the leading members of the American school." Hart's lecture codified the tenets of the Suydam circle, reinforcing their sense of balance between direct observation of scenery and the artist's need to infuse it with his own poetic feeling.[30] The canvases by Hart in the Suydam Collection—*Twilight* (FIG. 4.13) and *Landscape* (see Appendix 2)—exemplify that synthesis of empirical and personal pervaded by a sense of calm and repose that was shared by the entire circle.

Lambinet and French Landscape Precedents

Suydam's collection also provides important clues into the kinds of transatlantic artistic dialogues that fed his own artistic sensibilities and those of his circle. Aside from the prints by the British master Turner (discussed in Chapter 1), the most important European works for him were the modest tonalist pictures by the French Barbizon painters. In 1856 Christopher P. Cranch, in a letter to the *Crayon*, complained: "In America we know less of the landscape school of France, than of any other."[31] Works by the French landscapist Emile Charles Lambinet and French painter and printmaker Diaz de la Peña along with the Swiss Alexandre

Calame in Suydam's collection began to fill this gap in knowledge.

Lambinet was by 1860 "a well-known and much admired landscape painter in the United States." In 1858 Suydam had bought two works from Lambinet's easel: *Landscape* (FIG. 4.14) and *The Village of Datchet*. These were, as one reviewer recommended, the best examples of his ability to be seen in New York. Consider the responses to him by fellow American artists. Writing of a *View Near Amsterdam* he had seen in the fall of 1859, William Sidney Mount noted in his diary that Lambinet "exhibits a fine quality of green in shadow, as well as in light— his pictures are fresh and spunky, and he

FIG. 4.14 Emile Charles Lambinet (1815–1877), *Landscape*, 1856, oil on canvas, 15½ x 24 inches, National Academy Museum, Bequest of James A. Suydam.

understands the value of cool tints."[32] Although he refused the opportunity of European travel, Mount was a faithful follower of European art through books and exhibitions he was able to see in New York. His comment that these French pictures were "fresh and spunky" suggests that in the late 1850s there was something distinctive about them, and the Americans set about studying how they, too, could achieve those effects.

As Suydam cast about for the formal means to express himself—something he was never completely able to do in the Hudson River Salon mode—his eyes must have glanced with interest toward the modest contours of his Lambinets, with their "cool tints" and limited tonal range he was beginning to develop. Already gravitating toward the low-lying meadows and riversides as his preferred scenery, Suydam not surprisingly would have been drawn to these cabinet pictures. Lambinet's favorite subjects were the fields of the upper Seine, rendered in a palette of middle grays and blues combined with green tints. This led critic Philip Gilbert Hamerton to call him "the best lowland landscape painter in France" and to compare him favorably with Barbizon artists: "His execution is perfect of its kind, and he is sensitive to colour. . . . Lambinet's knowledge of nature, so far as it goes, is nearly unerring, sounder than Rousseau's, more delicate than Daubigny's."[33] The vogue in landscape art at the time was toward highly finished pictures with detailed handling of rocks and vegetation preached by Ruskin and evident in works by Church and Durand. Here again Lambinet—with his economy of means—provided Suydam with an alternate mode of execution, as Hamerton explained: "There is in all Lambinet's work a complete harmony of execution, everything being finished just so far as to take its own place in the subject, and no farther."[34]

Eschewing the offerings at the Sale of British Art that was being conducted simultaneously with the French sale, Suydam found the canvases not only of Lambinet but also of Diaz de la Peña worthy of study as he struggled to find his own mode of expression. His enthusiasm was shared by oth-

FIG. 4.15 Edouard Frère (1819–1886), *Dressing the Doll*, 1857, oil on panel, 13¼ x 9¼ inches, National Academy Museum, Bequest of James A. Suydam.

FIG. 4.16 Alexandre-Marie Guillemin (1817–1880), *The Bird Cage*, 1855, oil on panel, 11¼ x 8⅝ inches, National Academy Museum, Bequest of James A. Suydam.

ers in his circle, especially Kensett and Gifford. Among foreign artists represented in Kensett's collection were Lambinet, Théophile Victor Emile Lemmens, Constant Troyon, and Théodore Rousseau.[35] In 1855 Gifford was so impressed with the work of Troyon and Rousseau that he confided to his journal, "The subjects are mostly of the simplest and most meager description; but by the remarkable truth of color and tone, joined by a poetic perception of the beauty of common things, they are made beautiful."[36]

Figure Painting Parallels

Just as Lambinet provided a French counterpart to the circle's efforts in landscape, so Edouard Frère was seminal to their figure painting. Not well known currently in the United States, in the late 1850s and early 1860s his popularity constituted something of a minor craze, with Suydam in the forefront of artists and collectors who gravitated toward his modest pictures of French peasant children. To understand something of their appeal, it is helpful to read the commentary of Ruskin reprinted in the *Crayon* "in order to convey" as the editor phrased it, "an idea of the poetic spirit of the artist through the exquisite poetry of the critic": "I cannot tell how I am ever to say what I want to say about Frère's pictures; I can find no words tender enough or reverent enough. They have all beauty, without consciousness; dignity without pride; lowliness without sorrow; and religion without fear. Severe in fidelity; yet, as if by an angel's presence, banishing all evil and pain; perfect in power, yet seeming to reach his purpose in a sweet feebleness, his had failing him for fullness of heart."[37] At the sale of French art in New York held shortly after the publication of that review, Suydam acquired two of Frère's pictures. Entitled *Dressing the Doll* (FIG. 4.15) and *Finishing the Meal*, they bear close resemblance to works praised by Ruskin as among "the most touching poems that were ever yet written, and, I believe, by far the most lovely ever yet painted of lowly life."[38]

We should, of course, tie Suydam's receptiveness to this pictorial mode with the forces of the commercial art world. In fact, Frère was being vigorously promoted outside France by Ernest Gambart, who had apparently encouraged Ruskin to write about him in his Academy notes of the mid-1850s; so there is a definite market strategy to which he is succumbing. This also involved

the American dealer Samuel Avery, who visited Écouen and enthusiastically pushed this type of work. Their active promotion ensured that Frère and his associates remained a presence on the art scene at the time, a minor strain but one that was apparently popularly received by broad audiences.

Frère was dubbed "the Columbus of country children." He discovered in them ideal models, and he gave them a rank in art as Jean-François Millet gave to the peasant, and Constant Troyon to the ploughman. Thus we can consider, as his progeny, a number of painters whose works made their way into Suydam's holdings. Among them were French painters who included Théophile Emmanuel Duverger, Alexandre-Marie Guillemin, and Paul Seignac, all members of the Écouen School of artists over which Frère presided. Guillemin's painting *The Bird Cage* (FIG. 4.16), like his watercolor *The Pet Child*, were two additional humble peasant scenes of this ilk Suydam acquired.[39]

Suydam's taste demonstrates fluidity between genres, but continuity in mood or effect, which pervaded equally scenes from nature or those from human life. Writers consistently emphasized his love of his fellow man, his kindness, and his empathy, attitudes that would find their extension both in the scenes he painted and in the like-spirited figure and landscape pictures by others he owned.

When William Sidney Mount singled out one of Frère's domestic scenes for study, his analysis provides some clues into this possible linkage: "*The Family Dinner* by Frère—all eating out of one dish—good color, cool tints well managed. His pictures are full of color, and tells his story well."[40] One genre painter of rural subjects is looking at another, analyzing his narrative technique. Above and beyond the content, however, the pictures also contained lessons about the application of color and tint, for which he was also prized. Mount, in fact, pursued the matter further and four years later reported on his conversation with George H. Yewell about Frère's methods: "Geo. H. Yewell says that E. Frère . . . paints loosely, commences in an indistinct manner at first painting, and repeats the colors as the work progresses. Frère takes up his paint box etc to a collage and makes up his pictures according to the interior arrangements."[41]

There is something touching about Mount, who had been painting genre since the 1830s, still studying the works of a French counterpart. Frère had something to offer the American not only about the pathetic subject matter but also about color and touch. Several of the American works in Suydam's collection relate to this trend, including works by Boughton, who went in 1859 to study at Écouen with Frère. The fact that Suydam subsequently acquired his *Wandering Thoughts* (FIG. 4.17) suggests a degree of influence, which he probably also exerted on George Cochran Lambdin and William Parsons Winchester Dana.

FIG. 4.17 George Henry Boughton (1833–1905), *Wandering Thoughts*, 1865, oil on canvas, 16 ¼ x 13 ¼ inches, National Academy Museum, Bequest of James A. Suydam.

FIG. 4.18 George Cochran Lambdin (1830–1896), *Drawing the Elephant*, 1859, oil on canvas, 24 x 20 inches, National Academy Museum, Bequest of James A. Suydam.

Dana, Lambdin, Tassaert, and the Sense of the Pathetic

Dana's background was not unlike Suydam's in that his family was in mercantile and banking business, for which he was destined, before his love of art changed the course of his life. From 1852 to 1862 he was in Europe, where he spent time especially in Paris at the École des Beaux-Arts. Tuckerman, for one, saw this as a prime shaper of his work: "His method and manner, his coloring and ideas of art, are remarkably loyal to the French school." The critic detected "an absence of crudity and a refinement of taste in his works," underscoring once again the unifying *refinement* discernible in most of the work of the group.[42] *Admirals in Embryo* (FIG. 2.10) combines his proclivity toward marine subjects with his sweet renderings of children. Like Eastman Johnson's *The Art Lover* (FIG. 2.11) also in Suydam's collection, it depicts children in training for future roles, in the process of becoming adults.

Of the two works by George Lambdin that reside in Suydam's collection, his finely painted *Drawing the Elephant* (FIG. 4.18) developed this same theme of nurturing art talent in the young. The other, entitled, *The Sweetest Songs Are Those That Tell of Saddest Thoughts*, depicts two young ladies seated in an interior—one in tears while the other plays the piano—with an hourglass measuring the passage of time. It embodies what Tuckerman called his possession of "a true sense of the pathetic," which is another significant undercurrent in the Suydam Collection:

> *Within a few years, several of our artists have devoted themselves, with more or less success, to that kind of* genre *painting in which the modern French school has become so eminent; comparatively few, however, boast the thorough equipment of color and drawing which gives to those gems, even when destitute of much invention, a certain artistic value. . . . Lambdin, though crude in execution, has a true sense of the pathetic . . .* [43]

Pathetic sentiment was expressed even more forcefully in Nicolas Francois Octave Tassaert's *Poverty* (FIG. 2.8) in the Suydam Collection, in which we are meant to empathize with the impoverished young woman who has paused in her labors collecting faggots on a cold winter day to rest on a doorstep. Tassaert's placement of the figure low in the field and close to the picture plane makes it impossible for us to avoid the pale face of the woman succumbing to death from cold and exposure, an emotional effect further heightened in other versions of the subject in which a young child clings helplessly to her dying mother. These figures may have been emblematic of artistic life, which Tassaert himself experienced as harsh and painful, a condition which eventually led him to take his own life. In Suydam's collection the painting took its place beside a number of other genre

pictures of young women and children that ran the gamut from sweet and sentimental to this one, where the female victim evokes pathos and grief.

Looking back on the taste for this particular mode of French art from the perspective of the 1890s, John Durand believed that Ruskin "developed more interest in art in the United States than all other agencies put together." In studies of American art Ruskin's name has become linked with the truth-to-nature doctrine of the Pre-Raphaelites with which Suydam himself had little affinity. But "Ruskin himself, in his extreme admiration of the works of Edouard Frère," Durand reminded us, "gave an impetus to the popularity of the French School."[44] Suydam was sufficiently interested in Ruskin to purchase his *Modern Painters*, *Stones of Venice*, and *Seven Lamps of Architecture* from Cropsey.[45] His own travel and education, however, contributed to a personal aesthetic that derived from a variety of sources, rather than relying on the precepts of one single writer or influence. Suydam's purchase of Octave Tassaert's *Poverty* and Frère's pictures point to a significant dimension in his evolving aesthetic, integral to both painting and collecting.

Many of these figural studies could be described as reveries, depictions of attractive females lost in thought. George Cochran Lambdin was one of several painters represented in the collection who specialized in paintings of children and young women sit-

FIG. 4.19 Thomas Hicks (1823–1890), *The Home Guard*, 1863, oil on canvas, 18 x 24 inches, National Academy Museum, Bequest of James A. Suydam.

ting quietly and concentrating intently. The static quality of these works led some critics to call them "human still lifes." Certainly such imagery partook of a Victorian sentimentality that was highly regarded in its day, but the preponderance of this figural typology over other equally popular ones indicates a single hand and vision guiding the collection toward these pictures of quiet contemplation delineated not only by Lambdin but also by Lang, Boughton, and others. They embodied an underlying continuity of mood, often verbalized as "tranquil," "quiet," or "sweet." This meditative dimension finds parallels in the landscape pictures he acquired. What had been expressed subtly in the abstract language of landscape is given concrete expression in contemporary figuration.

A canvas in the Suydam Collection dated 1863 entitled *The Home Guard* (FIG. 4.19) by Thomas Hicks is important to examine in this context. Hicks has painted a rustic domestic interior in which a male figure dressed in Civil War uniform is seated in the lower left corner, facing an attractive young woman whose skein of yarn he holds while she knits, under the watchful eye of her mother and faithful dog. The title *Home Guard* refers to a precursor of the National Guard,

FIG. 4.20 *Portrait of James A. Suydam*, undated, carte-de-visite, Photograph Album, Worthington Whittredge Papers, Archives of American Art, Smithsonian Institution, Washington, DC. Courtesy Archives of American Art.

FIG. 4.21 Launt Thompson (1833–1894), *Relief Portrait of James Augustus Suydam*, 1870, painted plaster, 11 x 9⅝ inches, National Academy Museum.

an unofficial unit of the regular army assigned to protect the home front rather than engage in active combat. When the painting was exhibited at the Academy in the winter of 1869–70, commentary was critical of the soldier who appears to be shirking his duties:

> *Thomas Hicks has a pleasant little picture called* The Home Guard, *a satire on the handsome soldiers who looked after the pretty women when they should have been at the front. This warrior, in full costume, is holding a skein of worsted, which a sweet girl in winding off a spool. Everything in the canvas is in sympathy with the artist's scorn of the youth's conduct. The girl is looking away from the cavalier's eager gaze; her mother directs disapproving eyes over her spectacles into space; the furniture is awry; the very perspective of the room betrays its sense of the obliquity of the proceedings by being perversely askew. It is an old picture, done in war times, when things were out of joint.*[46]

But the atmosphere in the country in 1869 when the picture was shown and the Radical Republicans held power was very different from the midwar moment of 1863 when the picture was painted. So we must ask, was the interpretation offered by the reviewer in 1869 consistent with what Hicks and his patron/purchaser Suydam intended?

This picture is a key work in the artist's collection; a close look at the profile of the soldier, carefully backlit by the light from the window for easy inspection reveals that it may well be a portrait of Suydam himself. Comparison with a carte-de-visite photograph (FIG. 4.20) and Launt Thompson's relief sculptural portrait of him (FIG. 4.21) confirms the nearly identical muttonchop sideburns, distinctive hairline and profile of the nose that identify the artist. We can suggest, then, that this painting represents a collaboration between Hicks and Suydam, in which a likeness of Suydam has been inserted into this storytelling scene, but to what end? Is it, as the later reviewer suggests, the image of a soldier shirking his duties to remain in the company of the ladies, or at least to serve as the protector of the domestic sphere? It hardly seems likely that the picture would be commissioned on the basis of so slight and unpatriotic a message.

Hicks, sadly, remains a figure about whom we know too little, either of his personality or of his politics. Some evidence, however, is at hand among other works in the collection, for Suydam, in fact, acquired two other works by him: a rare effort in landscape entitled *Italian Study* (FIG. 4.22) and the portrait *Harriet Beecher Stowe* (FIG. 2.7). The presence of Stowe's likeness among Suydam's holdings is especially significant, for it was the only portrait he chose to include among his artworks. Rather than being an indictment

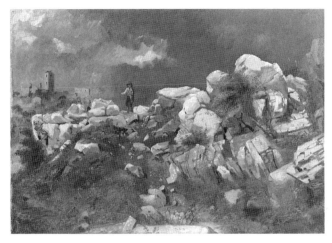

of the individual soldier, therefore, the picture may aim to question the Union Army which made such poor use of human resources that it ordered soldiers to guard the home front rather than suppressing the rebellion more aggressively on the fields. A look out the window of the picture shows that it is springtime, prior to the soon-to-come carnage of July 1863 at Gettysburg and Vicksburg. Criticism of President Lincoln at that moment was tricky and had to be couched in veiled terms. But it may very well be that these strongly pro-Union, pro-abolitionist painters meant to do just that. Certainly Suydam's close friends held strong opinions. In 1863 Kensett joined the Union League Club of New York, which was

FIG. 4.22 Thomas Hicks (1823–1890), *Italian Study*, 1847–48, oil on paper mounted on composition board, 15 x 21 inches, National Academy Museum, Bequest of James A. Suydam.

formed in reaction to the election of anti-abolitionist Horatio Seymour as governor of New York in 1862.[47] And Gifford was sufficiently stirred that he signed up for military service. The presence of Hicks's hybrid genre-portrait painting alongside Stowe's portrait reminds us of the violent times in which these artists created some of their most tranquil and repose-filled scenes.

Artistic Meeting Places and Salons

If as we are claiming here these artists formed a circle of friends with tight bonds and working relations, then we must consider when and how they met and exchanged ideas. Informal groups with regular meetings like the Sketch Club offered one such forum, and there were friendly gatherings in the studios. Sanford Gifford hosted a number of social get-togethers in his quarters at Tenth Street. During his extended bachelor days (he did not marry until 1877), once he was established, he enlisted the services of Mrs. Winters—a housekeeper who worked in the building—to help out with the hospitality. Whittredge recalled that they were usually limited to six people, invited in person or by "a friendly letter."[48] Such gatherings also would have provided the opportunity for deepening friendship bonds and, since they were held in his studio, for viewing and discussing works in progress that must have been lying about his workroom. On these occasions that went unrecorded because they were so ordinary, this fraternity of artists must have conversed at length over issues

about which they cared deeply. What kind of subjects, we should ask, were the points of contention? Sketching outdoors versus working in the studio? The pros and cons of particular treatments of color, light, and atmosphere? What were the recommended places to paint? The validity of particular writers, including Ruskin and Bryant? Joint discussions would have contributed to the consolidation of an artistic vision, facilitated by reference to works in their own collections.

Along with artist-artist interactions, it was also important to bring others from the community into their conversations, to nurture a taste for their work and to foster relations with potential patrons. Whittredge credited Louis Lang with establishing a forum for discussing art that widened the circle of participants to nonartists, for he was "the first to introduce in any of the clubs monthly collections of pictures to be lighted up on the occasions of monthly evening meetings. This gave the artists an opportunity of hearing what members of all sorts had to say about their work, and as artists' works are not done to be criticized by artists alone, much advantage was gained by hearing the opinion of others who were not artists."[49]

Louis Lang, Kensett's Suitemate

Louis Lang is one of those art world figures whose name is known less for the paintings they produced than for their presence and the social functions they performed. As we round out this circle, therefore, we want to define Lang's place within it. Lang was Kensett's best friend.[50] He shared living and working quarters for almost twenty-five years in their sprawling accommodations in the Waverly House (built by Thomas Rossiter), and yet he is rarely mentioned in discussions of Kensett. His work as an interior decorator ensured the fashion and comfort of their quarters, which served as a frequent meeting place for their fellow artists and patrons. A contemporary description provides rare insight into the living arrangements and therefore the relationship between Kensett and Lang:

> *I trust it will not be invidious to speak of here—the triune studios of Kensett, [George] Baker, and Louis Lang; together they occupy a suite of fifteen spacious rooms, having separate entrances, they may all be thrown open together. They are the finest rooms for the purpose in our city. They were arranged, finished, and furnished under the direction of Mr. Lang, whose good taste in all such matters is well known and appreciated in art circles.*
>
> *Messrs. Kensett and Lang are bachelors, and have in common their home department . . . Each has his private room, fitted up as daintily as "my ladies chamber," together with parlor and dining room, fine pianos, choice books, and all the appointments of an elegant home. All three have their private studios and reception room, which contain many fine pictures of other well known artists as well as their own, in all an interesting and valuable gallery. In the largest of these rooms Mr. Lang has his School of Design.*[51]

His favorite subjects were Madonna-like women and babies, including, for instance, *The Fair Penitent* and *The Fainting Spell* (FIG. 4.23) in Suydam's collection are consistent with that descrip-

tion. The critic James Jackson Jarves found such works by Lang "illustrations of lackadaisical sentimentalism of the most hollow kind."[52] Yet they find echoes in other pictures in Suydam's collection. From the title of Eugene Benson's *Ennui* (unlocated), we might imagine another bored female figure, and other works in the collection present women in interiors doing little or nothing, displaying themselves as weak and docile. Lang's *The Fainting Spell* in fact typifies this trope of Victorian female frailty, which oddly seems to personify the character of the artists of this circle.

So what does this knowledge of the tight friendship between Kensett and Lang mean for our understanding of the bond between Kensett and Suydam, and of the circle generally? There is an unavoidable sense of a triangle in which Suydam at times must have felt like the odd man out. In a letter to Kensett dated Cold Spring, August 7, 1861, these feelings surface, when Suydam writes that Lang thinks of going to Europe and hopes Kensett will not go with him.[53] Kensett, in fact, went.

FIG. 4.23 Louis Lang (1814–1893), *The Fainting Spell*, 1860, oil on canvas, 10 x 8 inches, National Academy Museum, Bequest of James A. Suydam (731-P).

About 1861, the bonds between Kensett and Suydam loosened, and Gifford seems to have replaced Kensett as a close friend and colleague. It was the loyal Gifford who accompanied Suydam on his last trek in the White Mountains and who was there at his deathbed. When David Johnson wanted to create a memorial to Kensett, he painted a landscape of Beacon Rock, Newport, and thus underscored the association of artist and place, via a series of many canvases Kensett had created of Beacon Rock over his lifetime.[54] Gifford similarly revisited the Hook Mountain area in September 1866, around the first anniversary of Suydam's death (he died on September 15, 1865) and created a work that could be considered an homage to him. As Ila Weiss explains, "After his return from the Adirondacks in September 1866, Gifford sketched that subject in pencil, viewed from Haverstraw Bay, in the series that transformed the horizontal view into an enclosed composition."[55] And Gifford continued to meditate on the place and his friend and created additional works the following year: "The two versions of the vignetted composition that followed, dated 1867, in effect enclose Suydam's subject in a frame of sentimentality, propelling it into a separate realm of remembrance and ideality."[56] Just as Johnson's homage to Kensett took the shape of a much-delineated favorite subject, Gifford's private remembrance of Suydam drew upon a subject they had visited together. Here again we might draw analogies to the artistic relations of Picasso, who reportedly declared to Matisse: "When one of us dies, there will be some things the other will never be able to talk of with anyone else."[57] Kensett, Gifford, and the other artists in Suydam's circle must have felt a similar lacuna when he was gone, a gap in their conversation that would never be filled. To judge from the testimony of his friends and contemporaries, Suydam's influence was strongly felt, and much treasured. The gift of his collection to the National Academy ensured that the artistic dialogue—however much it was transformed—could always continue in some form.

NOTES

1. Henry James, *Hawthorne* (London: Macmillan, 1909), 31.

2. Barbara Novak, *Dreams and Shadows: Thomas H. Hotchkiss in Nineteenth-Century Italy* (New York: New-York Historical Society in association with Universe Books, 1993), 16–17; *The Art Collection of the Late Samuel Colman, N.A.*, auction catalogue (New York: Anderson Galleries, 1927).

3. "James M. Hart's Collection of Paintings," *Brooklyn Eagle*, July 7, 1870, 2.

4. *The Collection of Over Five Hundred Paintings and Studies by the Late John F. Kensett*, (New York: s.n., March 1873[?]), auction catalogue, n.p. It included two works by Suydam: "no. 590. *Study at North Conway, Mass* [*sic*] by J.A. Suydam, 19 x 13"; and "no. 625. *Scene Near Fort Hamilton, NY*, by J.A. Suydam 10 x 9."

5. "James M. Hart's Collection of Paintings," 2.

6. On Gambart's relation to Ruskin and promotion of Frère see Jeremy Maas, *Gambart: Prince of the Victorian Art World* (London: Barrie & Jenkins, 1975).

7. Jane Turner, ed. *The Grove Dictionary of Art* (New York and London: Oxford University Press, 1996), 26:279.

8. When Asher B. Durand exhibited his *Landscape* (see FIG. 4.2) at the National Academy in spring 1851 it had already been acquired by Suydam, making it the first landscape on record in the collection.

9. David C. Huntington, "Church and Luminism: Light for America's Elect," in John Wilmerding, *American Light, The Luminist Movement, 1850–1875.* (Washington, DC: National Gallery of Art, 1980), 184.

10. Baur, "A Tonal Realist," 224. When the frame was removed during the preparation for the exhibition "Next to Nature" (1980), his signature was revealed.

11. Henry T. Tuckerman, *Book of the Artists* (New York: G.P. Putnam, 1867), 560.

12. Quotation from Boston *Journal of Music* (n.d.) appeared in Thomas Starr King, *The White Hills. Their Legends, Landscape, and Poetry* (1st ed. 1859; Boston: Estes and Lauriat, 1887), 154–55.

13. Michael P. Farrell, *Collaborative Circles. Friendship Dynamics & Creative Work* (Chicago: University of Chicago Press, 2001), 7, 5.

14. Ibid.

15. Ibid., 61–63.

16. The earliest dated picture bears the inscription "1856," although it is possible that the undated small canvas (12 x 20 in.) now at Rutgers was done on that first visit. But the two finest renderings of the group—those larger in scale and therefore more likely intended for public exhibition—required a longer gestation period.

17. John Paul Driscoll and John K. Howat, *John Frederick Kensett. An American Master* (Worcester, MA: Worcester Art Museum, in association with WW Norton Co., 1985), 135.

18. Unidentified clipping, Library, Smithsonian American Art Museum, Washington, DC; quoted in Kevin Avery and Frank Kelly, eds. *Hudson River School Visions: The Landscapes of Sanford R. Gifford* (New York: Metropolitan Museum of Art, 2003), 5.

19. Avery and Kelly, eds., *Hudson River School Visions*, 12.

20. Ibid.

21. Farrell, *Collaborative Circles*, 51.

22. Tuckerman, *Book of the Artists*, 522–23.

23. Ibid.

24. Ibid.

25. "At this time the portrait of him was painted now belonging to the Academy, and the calm and cheerful hours spent in his society while it was in progress will be ever fresh and mournfully sweet in the memory"; see Huntington, "Church and Luminism," in Wilmerding, *American Light*, 189 n. 67.

26. On Huntington's *Portrait of Asher B. Durand* (1857; Century Association), see Eleanor Jones Harvey, *The Painted Sketch: American Impressions from Nature, 1830–1880*, exh. cat. (Dallas, TX: Dallas Museum of Art, 1998), 142–43.

27. For background on Huntington see *Next to Nature*, 42–43.

28. Wendy Greenhouse, "The Crayon's *Flake White* Identified," *American Art Journal* 18 (Winter 1986): 77–78, discussed Huntington's correspondence, which appeared there in 1855, 1856, and 1860; quotation from Mummy (Alvin Fisher), which appeared in the November 1859 issue.

29. "no. 89, Suydam. *Mount Washington Near the Intervale. North Conway, N.H.* 14 x 20 in. Bought at the Kensett sale, $155.00 (no. 590)." *The Daniel Huntington Collection of Paintings*, auction catalogue (New York: Keeler Art Galleries, 1916). At the same sale, he purchased thirty of Kensett's pictures.

30. In the absence of a transcript we have to rely on the summary by Tuckerman, *Book of the Artists*, 510–14; Hart is usefully discussed by Lisa Andrus in Wilmerding, *American Light,* 39. See also Chapter 5, below.

31. C. P. Cranch, "Letter," *Crayon* 3 (1856): 183–84.

32. Alfred Frankenstein, *William Sidney Mount* (New York: Abrams, 1975), 344.

33. Philip Gilbert Hamerton, "Painting in France: The Salon of 1863," *Fine Arts Quarterly* 1 (October 1863): 253.

34. Ibid., 253–54.

35. *The collection of over five hundred paintings and studies by the late John F. Kensett*, auction catalogue, n.p.

36. Weiss, *Poetic Landscape*, 107.

37. *Crayon* 4 (1857): 287.

38. Ibid., In the next volume of the *Crayon*, in fact, it was reported that Suydam "was so fortunate as to secure a number of the gems of the late French exhibit. *The New Doll* by Edward Frère, is among these, two landscape subjects by Lambinet, and a very touching picture by Tassaert called *Distress [Poverty]*." *Crayon* 5 (March 1858): 88.

39. Duverger's *Music Lesson* was shown at Goupil's in 1857, no. 65, where perhaps Suydam purchased it; this work depicts young ladies, not poor peasant children, in a work that is related but distinct.

40. 28 October 1859; quoted in Alfred Victor Frankenstein, *William Sidney Mount* (New York: Abrams, ca. 1975), 344.

41. 8 May 1863; quoted in Frankenstein, *William Sidney Mount*, 365.

42. Tuckerman, *Book of the Artists*, 484.

43. Ibid., 447.

44. John Durand, *The Life and Times of A. B. Durand* (1894; repr. New York: Kennedy Graphics, 1970), 193, 194.

45. Jasper Francis Cropsey's Account Book, Receipts for 1856: "April 25, 1856. Mr. Suydam for set of Ruskin Books, Stones of Venice, etc. $57." Newington-Cropsey Foundation, Hastings-on-Hudson, New York.

46. Dearinger, *Paintings and Sculpture in the Collection of the National Academy of Design*, 271.

47. Andrew Wilton and Tim Barringer, *American Sublime: Landscape Painting in the United States, 1820–1880* (London: Tate, 2002), 205.

48. Weiss, *Poetic Landscape*, 81.

49. John I. H. Baur, ed. "The Autobiography of Worthington Whittredge, 1820–1910," *Brooklyn Museum Journal* 1 (1942): 589.

50. Jervis McEntee, recounting the details of Kensett's death, confirmed their close relationship when he reported: "Some thoughtful hand sent flowers from Lang to his best friend and also from his old friend Baker both of whom are in Europe." See Jervis McEntee, Diary, entry for Thursday, 19 December 1872, Jervis McEntee Papers, Archives of American Art, Smithsonian Institution, Washington, DC.

51. Rita Moza, "Our Artists," *Art Journal* 1 (January 1868): 22. From 1856 to 1866 Kensett listed his address as 697 Broadway, a building known as Waverly House where several other artists had studios. For a short period from 1867 to 1869 Kensett was at 1193 Broadway, and from 1870 to his death he maintained a studio at the YMCA building on the corner of Twenty-third Street and Fourth Avenue. Since this article is dated 1867, the year Kensett moved from one spot to another, it is not entirely clear to which building the author refers, but it seems most likely that it was the Waverly House.

52. James Jackson Jarves, *The Art-Idea,* (1864; repr. ed., Cambridge, MA: The Belknap Press of Harvard University Press, 1960), 192–93.

53. John F. Kensett Correspondence, Archives of American Art, reel N68-85.

54. *The Artistic Heritage of Newport and the Narragansett Bay*, exh. cat. (Newport, RI: William Vareika Fine Arts, 1990), pl. 22.

55. Weiss, *Poetic Landscape,* 122–23.

56. Ibid., 260–61.

57. Yves-Alain Bois, *Matisse and Picasso,* exh. cat. (Paris: Flammarion, 1998), 16.

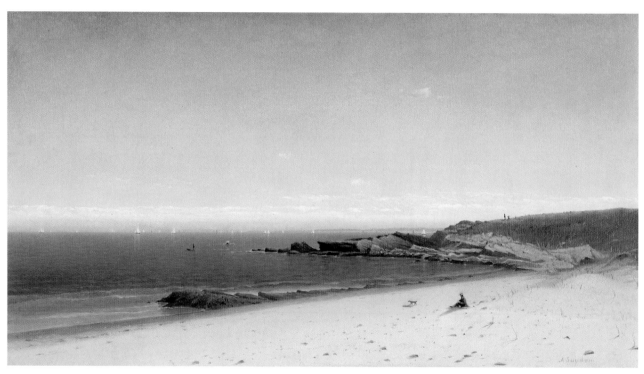

FIG. 5.1 James A. Suydam (1819–1865), *Beach at Newport, Rhode Island*, ca. 1860–65, oil on canvas, 13 x 23 inches, Collection of Henry and Sharon Martin.

Chapter 5

LUMINISM REVISITED, TWO POINTS OF VIEW

Mark D. Mitchell and Katherine E. Manthorne

. . . meditation and the sea are wedded forever.
—Herman Melville, *Moby Dick*[1]

THE USE OF THE TERM "LUMINISM" has a long and varied history and requires clarification as it applies to this discussion. Easily one of the most debated rubrics in American art, luminism has become a red herring in recent decades. The term has been so frequently invoked and abused that its evolution offers an encapsulated summary of the emerging discipline of American art history during the twentieth century. James Suydam's work provides a fresh opportunity to reexamine the origins of the term during the 1940s, to describe the art historical period in which Suydam figured prominently, and to refocus attention on the term's meaning and its application to his work and the work of his immediate colleagues. By rehabilitating luminism, the field regains a productive tool in the differentiation of nineteenth-century landscape aesthetics.

Suydam's art was integral to the first definition of luminism. In a November 1948 article for *ArtNews*, John I. H. Baur, who was then a curator at The Brooklyn Museum of Art and later coined the term "luminism," reproduced Suydam's *Paradise Rocks, Newport* as the lead image for an article on American marine painting with the caption, "the first of his pictures ever to be reproduced."[2] Between 1947 and 1954, Baur studied the artists whose works he found to share a similar interest in light and atmosphere, culminating in the 1954 publication of his influential essay entitled "American Luminism, a Neglected Aspect of the Realist Movement in Nineteenth-Century American Painting" in the journal *Perspectives USA*. In the interim, he tried out a number of other terms, including tonal realism and pantheistic realism, the latter relating to the literary expression of Ralph Waldo Emerson, and complained "labels are the dickens." Between Suydam's first appearance in 1948 and "American Luminism" in 1954, Baur also wrote the only monographic study to appear on the artist before this one. Entitled "A Tonal Realist: James Suydam," the article appeared in *Art Quarterly* in the summer of 1950, and

offered "a fragmentary introduction" to the artist's career "in the hope that, as his name becomes better known, more information may be brought to light."[3] More than half a century later, we are at last able to offer a concentrated assessment of Suydam's contributions to American art.

During the 1960s, luminism reached its apotheosis. Moving from an "aspect" of American realism in Baur's terms to become the culminating paradigm of American nationalist aesthetics during the mid-nineteenth century, luminism took center stage in the history of American art. The subject received three full chapters in scholar Barbara Novak's pioneering study, *American Painting of the Nineteenth Century: Realism, Idealism, and the American Experience* (1969). Fitz Henry Lane and Martin Johnson Heade were asserted as the aesthetic's two leading exponents, and their lack of affiliation with one another was considered proof that luminism was a spontaneously generated "indigenous mode of seeing that characterized much pre-Civil War art without however, taking on the communal aspects of an acknowledged school or movement."[4]

Novak subsequently contrasted the "grand opera" of the Hudson River School Salon style with the "still small voice" of luminism, suggesting that while Frederic Edwin Church and Albert Bierstadt awe and astound with Wagnerian bombast, Lane and Suydam soothe and calm in the manner of a hushed psalm.[5] The artists' rudimentary uses of perspective and carefully concealed brushwork were considered artistic correlates of Ralph Waldo Emerson's ideal of "a transparent eyeball" in which the self dissolves into the presence of God in nature. This was despite the fact that there was "no direct proof that Lane knew Emerson's essays or that he ever heard him on any of the frequent occasions when Emerson visited Boston, and even Gloucester," where Lane lived.[6] That insistence upon an intuitive sympathy between artists working hundreds of miles apart as proof of a national aesthetic consensus left the increasingly popular concept of luminism vulnerable to refutation.

In 1980, a blockbuster exhibition at the National Gallery of Art in Washington irrevocably broke the luminist monolith. Organized by John Wilmerding, who was then curator at the National Gallery, the exhibition had a sharply divided legacy: for the public, it sealed luminism's reputation as the apogee of early American landscape painting, but for students of American art, the exhibition's catalogue essays revealed fault lines in scholarly opinion about luminism's validity both as a movement and as a uniquely American art form. In his essay for the catalogue, Theodore Stebbins observed, "Luminism, or something very like it, can be found everywhere in Europe," including in England, Germany, Denmark, and even Russia, and Novak, one of luminism's strongest proponents, reiterated that luminism should more accurately be characterized as a "mode," rather than a "movement."[7] Thus, according to two of its leading advocates, luminism was neither American nor a movement; ensuing scholarship has concentrated upon the underpinnings of the term and further eroded its validity among academics.

Luminism, however, has not gone quietly into the sunset. Even recent scholarship must contend with the term, because it has become a fixture in the lexicon of American art history.

Overcompensation has also been endemic and led British scholar Andrew Wilton to declare categorically, not to mention erroneously, that "it is a distortion to suggest that they [painters working in a luminist aesthetic] worked together or that the output of any of them demonstrates any clear intention to produce landscape painting according to a set of rules perceived as unique to the group."[8] Even more virulent criticism has emerged, with one writer accusing John I. H. Baur, for example, of market collusion in his first inception of the term.[9] Far from consigning luminism to the confines of outdated literature on American art, however, recent studies have kept the term in the academic eye. In the popular estimation, however, luminism's aesthetic basis has never been questioned and remains as compelling as it was in 1980.

The most productive revision of luminism in recent decades came in Angela Miller's 1993 *The Empire of the Eye: Landscape Representation and American Cultural Politics, 1825–1875*. Miller used the term "luminism" freely but distinguished between the "atmospheric luminism" of the 1850s and 1860s, which she described, and an earlier, "transcendental" variety.[10] Within a few sentences of saying that she would use the term only "in a purely descriptive sense," however, she added that the development of atmospheric luminism marked "not only a stylistic and aesthetic shift but also a basic transformation in the ideological content of landscape art."[11]

Aside from that ambivalence, Miller effectively summarized how John F. Kensett's art reflected a new, "instantaneous apprehension of the image as a whole, picking out random details here and there but in no particular order."[12] In Miller's reading, gendered vocabulary applied to aesthetics during the 1850s and 1860s paralleled new scientific understanding of the gradual, underlying forces of nature that shaped the landscape. Those gradual forces were often characterized in feminine terms, "domesticating" the grander, more sublime, and more masculine effects of cataclysmic events and monumental forms. Her study offered helpful tools to reconsider the characteristics of luminism, even if her emphasis upon depictions of the White Mountains overlooked the artists' signature marine subjects almost entirely.

The term "luminism" is resonant because it is accurate. It succinctly identifies the overriding interest in light that captivated a number of American artists working during the mid-nineteenth century. Any such broad term calls for greater precision in its definition, however, so that its meaning becomes finer over time, rather than more generalized. As Stebbins observed, there were many artists all around the world who shared an interest in light and atmosphere before, during, and after the ostensible rise of luminism in America. The term's fluid definition has not helped matters, as the adjective luminist has been applied to the earliest landscapes made in Colonial America all the way up to and beyond the abstractions of Mark Rothko and the fluorescent tubes of Dan Flavin in the twentieth century.

While there were any number of artists whose interest in light might qualify their works as luminous or atmospheric, the term "luminism" is more appropriately and meaningfully applied to the group of artists working in Suydam's circle during the 1850s and 1860s. These artists, led by Kensett and inspired by Asher B. Durand, developed specific compositional conventions that

they applied in their works to exaggerate the abstractly expressive qualities of light in the landscape. Luminism, strictly constructed, identifies the artists of Suydam's circle, whom he referred to in a letter to Kensett as their "fraternity." Theirs was a distinctly modernist approach to landscape, accentuating formal qualities such as color, texture, and balance over naturalism. This was luminism at its most coherent.

The prevailing definition of luminism has long required more solid footing and need not rely upon speculative relationships made solely upon the basis of visual comparison. The fact that artists including Suydam, Kensett, Sanford R. Gifford, and Worthington Whittredge all worked, lived, and traveled in close proximity to one another during the 1850s and 1860s is helpful. In their association, particularly as seen through the lens of Suydam's collection, we better appreciate luminism's resonance during the Civil War era. In 1987, Oswaldo Rodriguez Roque first identified this development of the later 1850s as a "great transformation" that "made a virtue of small size, simple composition, and subtle color effects."[13] By no means a grand nationalist movement, these artists instead found meaning in a shared visual mode emphasizing introspection and private experience. The following two sections provide the authors' individual perspectives on defining lumnism.

Luminism as a Modern Form
Mark D. Mitchell

Artistic modernism is defined here as a consciousness of and engagement with the modern world and its changing social and intellectual contexts. Luminism's practitioners, particularly Suydam, looked forward to the concerns and preoccupations of the post-Civil War era, more than back to the ideals of Emerson. Developed in the midst of the rapidly industrializing city of New York as the nation was riven by sectional conflict during the 1850s and 1860s, Suydam and his colleagues framed an aesthetic that engaged both with the intellectual transformations of their age and with the challenges to national identity posed by industrialization and secession. The style is characterized by small-scale works, as Roque described, that order the natural landscape with flattened planes of color, strict geometries of form, miniaturized figures, and truncations of scale and perspective. Luminist paintings of this period form an introspective poetic form that emphasizes personal emotional engagement over historical narrative.

As the foregoing chapters have described, the artists of Suydam's immediate circle, including Kensett, Gifford, and Whittredge, were an intimate group. They both worked and socialized with one another; they traveled together to study the landscapes that interested them; they paid attention to one another's professional accomplishments and setbacks; and they cared for each other and their families when one of their group became ill or died. Their admiration for one another's works and input led to a strong degree of influence. During the 1850s and 1860s in New York, Suydam's circle formed a coherent aesthetic movement, mutually aware, that sought a distinctive approach to landscape representation. Though their paths diverged and rejoined at various

times, the artists were committed to their work and to the development of a style of landscape painting that reflected the concerns of their time.

The artists' response to the Civil War was to turn inward, a move from which the conviction of their works derives. They employed the aesthetic language of early psychology formulated in America by moral philosophers such as Thomas Upham, as described in the foregoing discussion of Suydam's experience at Newport. Escaping the constant pressures of New York City in search of artistic inspiration, artists such as Gifford in the Catskills and Suydam and Kensett at Newport found reassuring subjects to which they returned time and again to explore and experiment with strikingly similar compositions. Distanced from the ongoing violence in the border states and the simmering class-based and ethnic violence in New York during the war years, these artists restored order to the landscape in the "cultivated" scenery of the Northeast.

Luminism was, in Suydam's experience, neither a scientific experiment nor a religious doctrine. It appears more consistently to have been a poetic structure or framework for contemplative expression. Asked why he never painted the more dramatic aspects of nature, Suydam replied, "I must paint what I feel." [14] Although Suydam's library demonstrates that he read widely on scientific and religious subjects across the spectrum, his omnivorous interests also invalidate any single scientific or theological approach to his work. Moreover, Gifford recalled that Suydam "rarely ever made any reference to his religious faith either while in health or during his illness" before his death. [15] This was not an artist to pontificate or proselytize through his art. Observations and even references to Suydam's Episcopal faith were limited to eulogists whose comments reflected more upon themselves than upon their subject. His work was primarily a reflection of his own experiences and personality.

The luminist landscapists of Suydam's circle responded to industry and warfare by further distilling Durand's conception of landscape tourism as a restorative, therapeutic experience. They were all competent technicians who were aware of the tools at their disposal and made aesthetic decisions based upon their objectives. A lingering sense that luminism, at least as practiced by this group of artists, originated in their ignorance of more advanced practice of perspective and modeling overlooks the artists' backgrounds and experience. To become poets of nature, Suydam, Kensett, and their colleagues utilized the poet's tools, including hyperbole, metonymy, metaphor, and allusion. The bright blue of Suydam's water in *Beach at Newport, Rhode Island* (FIG. 5.1), the perfect arc of sand in his *Ocean Beach* (FIG. 3.22), and the exaggerated size of Spouting Rock in *On the Beach, Newport* (FIG. 3.23) illustrate his considered manipulation of the grammar of landscape. The artists' shared move toward non-narrative compositions with heightened color sensibilities in smaller scale created an evocative body of work that differed strikingly from other contemporary aesthetics. Converting the painting itself into an absorptive experience fostered a different form of vision from the quick, fragmentary glimpses and constant motion of the urban environment, encouraging instead a continuous, meditative stare. Unhurried, Suydam's compositions provided viewers with a tourism of per-

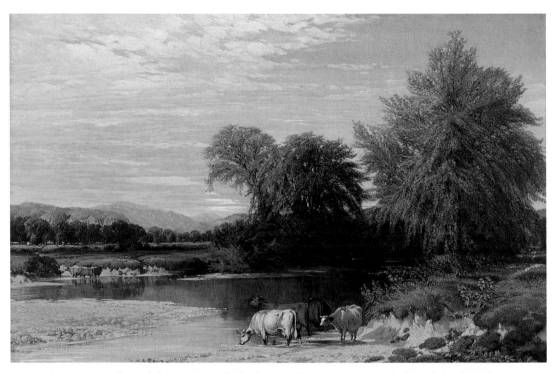

FIG. 5.2 Aaron Draper Shattuck (1832–1928), *The Ford*, 1856, oil on canvas, 16 x 24 inches, National Academy Museum, Bequest of James A. Suydam.

ception as much as of place. These restful scenes offered an intimate escape from the rhythms and realities of everyday urban experience.

Suydam's own collection offers an interesting counterpoint in this regard, because a number of the works he owned also visit tourist venues, such Kensett's view of Bash Bish Falls (FIG. 4.6) in the Berkshire Mountains of Massachusetts and Aaron Draper Shattuck's *The Ford* (FIG. 5.2), set among the White Mountains of New Hampshire. These compositions position the viewer as a lone tourist in the landscape of the Northeast, though in different modes of tourism. In his study of tourism as a modern form of vision and experience, scholar Dean MacCannell distinguished between *landmark* tourism and *scenery* tourism, of which Kensett's and Shattuck's compositions are examples, respectively.[16] In Kensett's work, we visit a renowned site and appreciate its unique, awe-inspiring qualities, whereas in Shattuck's scene we experience a more general view of various elements within the landscape. Benjamin Champney's view of *Conway Valley* (FIG. 5.3) operates similarly, even screening off the distant mountains with the shading branches of trees above the picnickers' heads.

In Suydam's own work, the distinction between landmark and scenery tourism is less evident and favors the latter. Although he interspersed depictions of identifiable landmarks in his scenes,

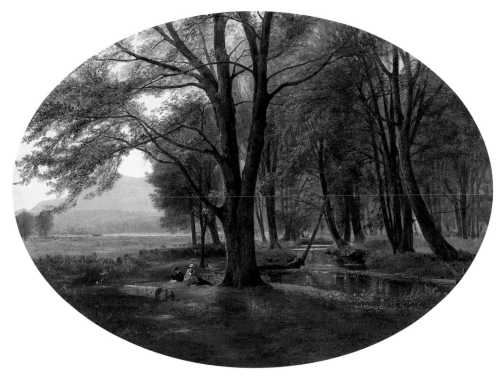

FIG. 5.3 Benjamin Champney (1817–1907), *Conway Valley*, 1855–57, oil on canvas, 23¾ x 30¼ inches, National Academy Museum, Bequest of James A. Suydam.

the iconic sites are only barely distinguishable in approach from his more generic scenes of a particular region. This was the direction of the luminist artists generally during the 1860s, and Suydam's work is typical of the move toward scenery tourism in their compositions, favoring immersion in a more generalized experience of nature, rather than fixating on the significance of a particular attraction. Newport's gently rolling topography is certainly conducive to that form of experience.

Most often, the figures in Suydam's compositions relax and gaze toward the horizon, absorbed in reflection. As metaphors for contemplative leisure, they provide excellent instruction on our suggested behavior as we appreciate the scenes ourselves. Lose yourself, they suggest, in abstract thought and soothing ideas of balance and order. These figures portray a mode of aesthetic experience in the landscape that differs from the admiration expressed by the artists in conversation in Durand's 1850 *Landscape* (FIG. 4.2), which Suydam owned. Durand's figures converse and explore the topography, as one figure points out particular features with his walking stick. Even when Suydam depicted a major attraction, such as Paradise or Spouting Rock in Newport or even Mount Washington in the White Mountains, the abstraction of his geometric approach balances the feature's relative significance within the overall composition. When Suydam's figures

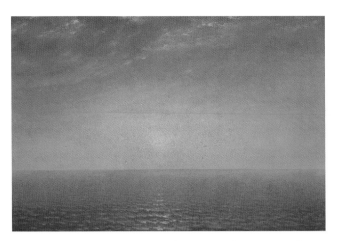

FIG. 5.4 John F. Kensett (1816–1872), *Sunset on the Sea*, 1872, oil on canvas, 28 x 41 ⅛ inches, The Metropolitan Museum of Art, New York, Gift of Thomas Kensett, 1874 (74.3). Photograph © 1984 The Metropolitan Museum of Art.

do work, they are generally harvesting a crop, fishing, or gathering seaweed, all of which rely upon the cycles of nature, syncopated with nature's rhythms, rather than disrupting them.

Our vantage is always indirect in Suydam's own compositions, however, looking along the beach instead of out to sea, as his figures often do and as in some of Kensett's later works, such as his *Sunset on the Sea* (FIG. 5.4) of 1872. Suydam's compositions of the 1860s are anchored to the shoreline and a rocky promontory, a solid, block that organizes the composition and extends a protective, embracing arm along the horizon line. The foreground thereby becomes a safe enclosure, protected from the intensity of the open sea. The latter effect is apparent in Jasper Cropsey's *Coast Scene* (FIG. 3.21) and Andreas Achenbach's *Off Ostend* (Fig. 2.15) in Suydam's collection. Believed to depict Newport, Suydam's own favored landscape, Cropsey's composition is a striking, stormy contrast to the enclosed serenity of Suydam's and Kensett's works.[17]

Suydam's collection of works by both American and European artists directly contradicts the notion that luminism was a uniquely native aesthetic developed from naïve readings of drawing instruction books. The collection documents his awareness and appreciation of contemporary European aesthetics, just as the prints in his library convey his awareness of art history. His travels through Europe and Middle East exposed him to as much (if not more) original art than any aspiring European artist. As a luminist painter, Suydam is a fascinating and challenging case study, because his life and intellect so readily defy stereotypes of Americans during the nineteenth century. Here was a young man of considerable wealth, highly educated, descended from the earliest Dutch New Yorkers, and well traveled—hardly the ignorant "American cousin" who was the stereotypical American of that time. Suydam's art, life, and collection invite more careful, reflective, and intensive scrutiny of our assumptions regarding American art of the period. Suydam was an exception, but his art and experience offer an important perspective both on luminism and on the assumptions of art history.

During the Civil War era, knowledge was increasingly perceived to be social in nature. The writings of intellectual Charles Sanders Peirce, in particular, most notably distinguish social knowledge as a critical element in the development of culture during the period. Peirce identified collaborative experimentation and debate as essential to the appreciation of underlying structures and to self-realization. As Louis Menand has summarized Peirce's conclusions: "knowing cannot be a matter of an individual mind 'mirroring' reality. Each mind reflects differently—even the same mind reflects differently at different moments—and in any case real-

ity doesn't stand still long enough to be accurately mirrored. Peirce's conclusion was that knowledge must therefore be social."[18] In Suydam's case, his intimate associations with other artists and intellectuals in New York and regional travels provided a shared vocabulary of visual forms in which to explore the landscape. Together, they found and conveyed meaning along the beaches of Newport and beyond that could be understood in the galleries and drawing rooms of New York.

The impact of Suydam's most intensely illuminated scenes is absorptive. Bathed in brilliant light, elevated effects of color density seem reasonable, as in *Beach at Newport, Rhode Island* (FIG. 5.1). The glare simplifies the composition, erasing details and flattening forms into planes of color. Suydam's light is not colored, but partially blinding. There is little space in these compositions for the viewer's eye to wander; instead, they compel the kind of immediate appreciation that Kensett's compositions were admired for as well. The sunlight renders the scenes hermetic, closed, isolated spaces into which the eye can travel only with difficulty. As art historian Michael Fried has argued of such absorptive styles, the effect is to create a space that does not make reference to the presence of the viewer.[19] In other words, the landscape is not a stage set on which a performance is being given for our entertainment, but rather a scene for which we feel empathy but are in no way acknowledged as an audience.

Suydam's compositional contrivances only amplify the absorptive effect of his painting. He consistently depicted low tide, providing a wide, flat, near-white expanse to reflect the light and complement the colors of sea, sky, and rocks. Spatial recession in Suydam's art is also never direct. Instead, he depicts whiplash beaches that sweep back almost all the way to one margin of the composition before swinging back out along a promontory to an almost imperceptible point. Suydam plays very effectively with the idea of a horizon line and single-point perspective (in which all parallel receding lines meet), but his parabolic beaches submerge rather than converge on the vanishing point. The effect is a dynamic, layered composition of saturated colors that heightens the landscape's abstract geometry above its sense of realism.

The rounded, interpenetrating forms and balances of Suydam's compositions along with their heightened colors convey a dynamic interplay that may be characterized as mannerist. Like the early Baroque incarnation of Mannerism in sixteenth-century Italy, Suydam's luminist form suggests a willful manipulation of naturalism for dramatic effect. Suydam's repetition of similar coastal views, manipulating color and light, rather than his basic compositional structure, suggests that the structure itself accurately reflected his artistic objectives. Within that similar basic structure, however, he adjusted virtually every other facet of his painting. In poetic terms, it seems as if the basics of the beach resembled the strict iambic pentameter of a sonnet into which he could introduce whatever meaning he chose. The varied brilliance of light and palette that Suydam used to convey sentiment set the tenor and meaning of the painting itself.

Suydam's mannerist coastal views are an integral form of luminism. He explored the Newport landscape with Kensett, Gifford, and Whittredge, and likely others as well, and they

shared common subjects and approaches there. In Suydam's work, like theirs, the scenery of Newport provided a resonant source of inspiration that integrated "civilized" landscape with ideas of visual poetry. Their formal experimentation with space and structure to create more expressive scenes than naturalism permitted responded to the world that they lived in by enhancing its emotive aspects and ordering the landscape at a time of national upheaval. The enduring validity of the term "luminism" derives from this singular project that Suydam's circle shared.

Luminism is a term worth preserving, though with a new emphasis. Single artists such as Lane, who worked in isolation, provide useful comparisons but little in the way of evidence of a shared, intellectually consistent approach to art, which is not to say that his work cannot be productively examined in relation to the luminists of Suydam's circle. Even Heade, however, worked in the group's immediate proximity at Tenth Street, though mostly after the war years, and enters into discussion of luminism in New York. Although the artists living during this tumultuous period in American history undoubtedly shared sentiments of the collective unconscious, binding disparate artistic spirits together proves unwieldy and strains the credulity upon more intensive study. In refocusing the term "luminism," therefore, emphasis should be placed upon the collegial group of artists whose works best illustrate the term. This group of artists has a more complex history than has been previously been observed, and this book provides the opportunity to explore several dynamics of their art and relationships with their time.

SUYDAM'S CONTRIBUTION TO LUMINISM
Katherine E. Manthorne

Suydam's finesse in capturing atmospheric effects distinguished him from his contemporaries. Writing of a work entitled *On the Sea-Shore* (unlocated), which hung at the Artists' Reception at Dodworth Hall, New York, in March 1859, one reviewer described it as having nothing as subject, yet wonderfully fine in interpretation. In fact, he praised the work as the best expression of humidity and density of fog he had ever seen.[20] This ability to take "nothing as a subject" was all the more remarkable given the prevailing taste in landscape art. The year that these comments were made, 1859, witnessed the great popularity of Church's *Heart of the Andes* (1859; The Metropolitan Museum of Art), the departure of Bierstadt in search of novel subjects in the American West and Louis Rémy Mignot and Thomas Pritchard Rossiter's giant history painting *Washington and Lafayette at Mount Vernon, 1784* (1859; The Metropolitan Museum of Art) all signaling the "triumph" of spectacular, large-scale painting. That Suydam's modest pictures of light and air could be created and—perhaps what is more interesting—appreciated alongside their more exotic, large-scale peers is yet another demonstration of the complexity of the age and of this artist's mastery.

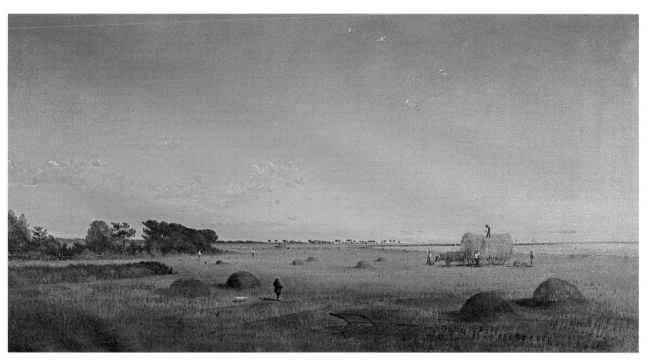

FIG. 5.5 James A. Suydam (1819–1865), *View on Long Island*, 1862, oil on canvas, 28 x 40⅜ inches, Museum, Manor of Saint George, Brookhaven, New York.

Suydam's *View on Long Island* (FIG. 5.5) of 1862, identified by Clara Erskine Clement and Laurence Hutton as "one of his most important works," represents a further evolution of his signature style.[21] "If asked what artistic quality and what truth of nature he best illustrated with his art," one reviewer remarked, "I should say that of *gradation*. In this he rivaled, if he did not surpass, his friend, Mr. John F. Kensett."[22] Here he characterized the beautiful blue, cloud-streaked sky over the coastal marshes in late summer/early fall in the vicinity of Brookhaven, Long Island.[23] These subtle tonal nuances provided the backdrop for the hayrick, livestock, figures, and stacks of hay, all depicted in a stiff, almost primitive hand. This particular pairing of material and immaterial, of primitive and sophisticated, is a common trait of luminism. Suydam, the most rarefied of the luminists, intensified the contrast between the stony-edged hardness and atmospheric gradation.

In this picture's emphasis on the precise linear geometries that provide the underpinning for the softly rounded forms of the hay piles, it seems closest to works by Fitz Henry Lane such as *Riverdale* (1865; Cape Ann Historical Association). The method of placing the row of hedges parallel to the tracks of the hay wagon, which are in turn parallel to the spots where the stacks sit, is strikingly similar to Lane's picture-making habits. This combination of crystalline light with a marked stiffness of drawing suggests further affinities between them.[24]

In my opinion, these correspondences remind us that we need to reconcile the activities of the New York–based artists with figures who operated largely outside the city, such as the peripatetic Heade and Lane in Massachusetts. Are we in a sense talking about a New York variation of luminism, by college-educated, refined artists in the Suydam-Kensett circle? Is this another example of what we might term the pirate mentality of New Yorkers blatantly co-opting a style from New England and adopting it to their own uses? Influences, as we shall see, went both ways. Considered "the paradigm of Luminism" by Barbara Novak, Fitz Henry Lane had worked in Boston for a time but lived his artistic life in the major fishing port of Gloucester, Massachusetts. His coastal views were shown in New York, where they might have been of more than passing interest to artists just beginning to turn their attention to the shoreline. John Wilmerding has pointed out the importance of Lane's *Twilight on the Kennebec*, on view at the American Art-Union in 1849. In fact, Lane's work could have provided other New York–based landscapists with inspiration during that transitional year when their leader Thomas Cole had just died and they were casting about for new directions. Suydam, too, may have been impressed by it or by others of his work to which he had access throughout the critical decade of the 1850s. The Art-Union sale of 1852, from which he purchased a painting by Kensett, included a Lane with the listed title *Marine View–Coast of Maine* that was described in the catalogue as a "sunset scene," of which Suydam must certainly have taken notice. At the first of the Artists' Receptions held in January 1858 a Lane was included, while his *Gloucester Fishing-Schooner on Georges Bank* hung in the National Academy Annual exhibition of 1859. And in 1858 and 1859 both Lane and Suydam exhibited at the Boston Athenaeum. In 1858 Lane was represented by a view of Boston Harbor while Suydam showed *Conway Meadows*

(FIG. 1.5). The following year Lane showed *Sunset in the Bay, Sunset after a Storm*, and *Hazy Sunrise*, while Suydam sent *Twilight* and *Narragansett Shore*. By 1860 Suydam exhibited a painting of Manchester Beach, which indicates that he could well have crossed paths with Heade and Lane, also sketching there about that time.[25] It is evident, then, that opportunities existed for mutual contacts between the two painters, who may very well also have crossed paths as they roamed the shores of northern Massachusetts.

Marshes as Meeting Ground

Suydam's *View on Long Island* and Lane's *Riverdale* both depict the harvesting of salt grass, a characteristic activity of the marshy areas along the northeastern seaboard. Heade is often credited with "discovering" the marshes as a subject for landscape art, and he certainly developed the theme and its formal implications to their greatest potential; but Suydam and Lane both turned to the same subject at precisely the same time. If they had not both died in 1865, then they would likely have continued to investigate their flat, open expanses. For as artists grappled with the challenge presented by the marsh, they were forced to abandon the conventions of the picturesque landscape and to develop alternative, nontraditional schema for their work. It is critical to recognize that this tendency arose one after the other in the work of these related artists, with Suydam in the thick of it.

Haying was a seasonal activity in the coastal regions of Long Island, New York; Newburyport, Massachusetts; and Newport, Rhode Island, areas favored by Suydam, Kensett, Heade, and Lane. Wherever the painters found them, they sought them out for the same reasons. Such agricultural spaces were defined by the fact that the farming done there was nonintrusive, in harmony with the rhythms of nature. At the same time, a salt marsh is a topographical nether land; with restless tides, it was a space with fluid boundaries, impossible for mapmakers to pinpoint. They were spaces where imagination was allowed free rein, perfect for these more poetic souls. While several of these painters gravitated toward the marsh right about the same time, and Suydam may actually have done smaller versions sooner, it is Heade who pushed his expression the furthest. This he did in part by adopting a canvas whose ratio of height to length was 1:2, which suggested a limitless horizon in its extension beyond the canvas. *Sunset on the Newbury Marshes* (1862; Walters Art Gallery) embodies what one critic calls "is one of the earliest examples of Heade's manifest interest in space, light, and the silence of the sublime."[26] Heade followed it with *Lynn Meadows* (1863; Yale University Art Gallery), and continued to develop the theme over many decades of his career.

Salt marshes and details of its harvest are also featured in *Paradise Rocks*. Here the monumental rock formation, also known as "Bishop's Seat," presides over the quiet spaces of the marsh, where a man pauses with his empty hay wagon drawn by oxen. Comparison between works indicates that where Heade's marsh scenes are soft, warm, undulating, images of Mother Earth in her compliant sensuality, Suydam's are more hard-edged and unyielding, while Lane's are contours bathed in yellowish-pink light. The convergence by multiple artists on this previ-

ously untapped subject matter at just about the same moment, however, suggests a continuity of interest and shared artistic vision that is impossible to ignore. It also reminds us that Suydam held his own in this company, creating out of this same subject matter masterful and original pictorial solutions.

Reconciling Pantheistic Realism and Poetic Imagination

Discussions of luminism have perhaps been stalled by a holdover from the early attempts to label it "pantheistic realism," which cast it in terms that emphasized the artists' direct observation of nature and struggled to reconcile the subjects rendered with fidelity to original motif. Present-day terms "luminism" versus "Hudson River School" are used to distinguish these modes of painting; in their own day these same artists tended to be assigned according to a poetic versus scientific dichotomy, underscoring the linkage they detected between the luminist/poetic mode and the personal and moral character of the artist. Decades of study of Martin Johnson Heade and his oeuvre has eventually led Theodore Stebbins to a similar conclusion: "In all the work of his artistic maturity, Heade was a romantic masquerading as a realist. He studied the humming-birds, the orchids, and the passion flowers with the eye of a naturalist, just as he sketched the landscapes of the Northeast, Florida, and Brazil using the *methods* of a topographical painter. Yet in each genre, the paintings have more to do with memory than with fact; they speak less to the keenness of observation than to the richness of the painter's imagination."[27] The working assumption here is that to grasp something of the imagination and psychology of the artists is to comprehend better the art.

William Hart's 1867 "The Field and Easel" lecture, discussed in Chapter 1, is known primarily through a synopsis provided by Henry T. Tuckerman. A notice in the *Brooklyn Eagle* informed audiences that the lecture was to be profusely illustrated and reminded them to bring their opera glasses, tantalizing hints at how this material was presented. His lecture could be said to codify the practice of these poet-painters in much the same way that Durand's "Letters on Landscape Painting," did for the Hudson River painters a decade earlier. There is a perceptible shift in emphasis from direct observation to attitudes and feelings about nature. The artist must go out into the landscape and set up his easel, but in the final analysis it is how he feels about the place or motif that is most important. This is more about poetic feeling than naturalism, more about emotion than intellect. He emphasized the interplay between field and studio work, emphasizing that empirical observation had to filtered through the artist's personal temperament. His dictum "above all, let your pictures tell something that you feel" echoed closely descriptions of Suydam's aesthetic and that of the entire group.[28]

There is, of course, nothing revolutionary in this approach; Émile Zola's famous dictum that a landscape painting represents a corner of nature seen through a temperament has long guided historians of European art. The novelty here lies in its application to the luminist landscape. In this approach we may follow the lead of Tuckerman who always linked the character of the art with that of the artist. The accepted wisdom is that luminism was not recog-

nized in its own time, and that Tuckerman failed to discuss most of the artists we now consider under that rubric.[29] I would argue, however, that while he may not have called them luminists, he definitely recognized that there was something different about Suydam, Kensett, and their associates that gave rise to a form of artistic expression distinct from mainstream American landscape art.

Finding a Language for Luminism

Tuckerman in his *Book of the Artists* (1867) attempted to provide a representative cross section of the New York art world he knew firsthand from his residence in the Tenth Street Studio Building. The sentence that opens his sixteen-page essay on Church (the longest in the book devoted to a single artist) is revealing: "The indomitable explorative enterprise of the New England mind Church has carried into landscape art, the infinite possibilities whereof, as accessory to and illustrative of natural science, were long ago foreseen by Humboldt, into whose views the young American painter entered with ardor and intelligence."[30] His choice of vocabulary— indomitable, explorative, ardor, intelligence—underscores his appreciation for a muscular art, born of action or—as the nineteenth century would have it—of "enterprise." Nor was this confined to Church, it equally applied to Bierstadt, Bradford, and other artist-explorers.

Kensett's work represented the opposite pole of landscape art from Church's. One "able critic," quoted by Tuckerman, called him "the most unaggressive and loved of the leaders of the American school of painting," and went on to characterize his achievement:

> *Mr. Kensett has long been accepted as a most consummate master in the treatment of subjects full of repose and sweetness, and been honored by critics and painters for the simple and unpretending character of his works—works remarkable for tenderness and refinement of feeling, exquisite quality of color, and a free and individual method of painting certain facts of nature . . . and if at times devoid of strength, in his best estate he fairly won for himself the honor of being called the lyrical poet of American landscape art.*[31]

Confronted with his pictures of the New England coast, or views along the Hudson, critics instinctively drew upon language of a different ilk to convey some sense of their distinctive quality. This same inclination can be detected in Tuckerman's entry on Suydam, which he opened with a work that was illustrated as a line engraving in the deluxe edition of *Book of the Artists* (FIG. 1.16): "A characteristic landscape, by this artist, is *Long Island Shore*. It possesses that coolness of tone and tenderness of expression which formed the principal charms of his picture. . . . The quiet, thoughtful character of this picture is eminently pleasing and suggestive."[32] Tuckerman unquestionably saw the scientific naturalism of Church and Bierstadt as quite distinct from the quiet, poetic landscapes of Kensett, Suydam, and their circle. And he strived to find a vocabulary to convey the unique spirit of the two distinct means of expression. The shift here to "tenderness," "suggestive," and "quiet, thoughtful character" all clue the reader to a pictorial mode that

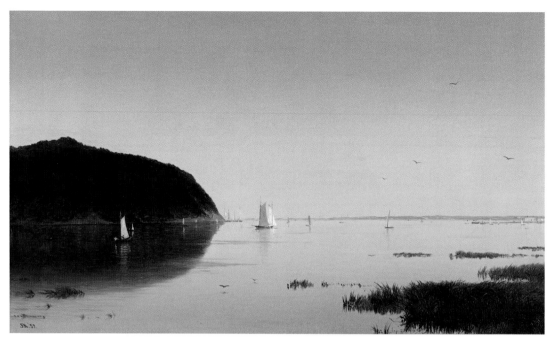

FIG. 5.6 John F. Kensett (1816–1872), *Shrewsbury River, New Jersey*, 1859, oil on canvas, 18½ x 30½ inches, on permanent loan to The New-York Historical Society from the New York Public Library, Stuart Collection, acc. no. S-229.

is the polar opposite of Church's. Although Tuckerman did not use the terms "Hudson River School" or "luminism" to distinguish them, there is no question that he continually underscored a bifurcation within American landscape painting, as did every other observer of the art scene at that time. What follows is an analysis of the critical language drawn upon as fellow artists, supporters, and detractors all attempted to discern what was distinctive if not unique about these works we call "luminist."

Let us focus first on the ample body of writings on Kensett, who played a far more public role than did his friend Suydam. Simultaneous with Bierstadt's departure for the Rocky Mountains or Church's exhibition of *Heart of the Andes*, Kensett was painting such works as *Shrewsbury River, New Jersey* (FIG. 5.6). In contrast to their canvases, Kensett's appears flat and empty; the rounded hump of land at the left is the only form to pierce the horizon. Compared with the minute detail of Church's vegetation or Bierstadt's painterly skies, Kensett's handling of paint is utterly self-effacing. While today we consider Kensett's minimalism the bolder and more daring style, to the nineteenth-century eye this connoted a lack of assertion, of confidence—in short, a lack of manliness.

Kensett's obituary observed that his style "reflected the purity, peacefulness and serenity of his soul." The elaboration of this point by a *New York Times* critic stands in here for a larger body of similar commentary:

He delighted to render with a skillful hand nature in her ordinary smiling mood. He was neither a deep nor a subtle analyzer of her rarer and higher aspect, nor did he venture upon the grand and gigantic features of her tempests. What delighted him was the jutting rock that formed some tranquil bay, where the placid waters were bathed in floods of sunshine. The silvery sheen of the sea shore in its profoundest calm was also a favorite subject of his pencil. His boldest flights never rose above the brawling of a trout stream, the foaming of vexed waters among the rocks, and the deep pool where the big fish love to lie.[33]

What sounds to our twenty-first century ears like a scathing indictment of artistic timidity is clarified in the closing sentence: "But though his aims were humble, his execution and coloring were of the very highest, and his fidelity to nature and perfection of detail entitle him to rank among the great landscape painters of the world."[34]

James Jackson Jarves, who arguably possessed the best-trained eye of the period, evoked Kensett's achievement in these words: "Kensett is more refined in sentiment, and has an exquisite delicacy of pencil. He is the Bryant of our painters,—a little sad and monotonous, but sweet, artistic, and unaffected. In his late pictures there is a phantom-like lightness and coldness of touch and tint, which gives them a somewhat unreal aspect. But they take all the more hold on the fancy for their lyrical qualities."[35] Jarves's attention to what he elsewhere called the artist's "labor trail"—Kensett's "phantom-like lightness" of touch—is a brilliant articulation of that critical element in an artist's personal expression.

Suydam's character and pictures are discussed in parallel language: "Artists will not think of him as a great light gone out, but as a sweet influence no more active. They will not think of him as a mighty river, enriching a country and bearing the future on its strong current, suddenly checked; but they will think of him as a spring lost under the earth—as a sweet voice no more heard."[36] For critics and public alike Gifford's more painterly but related work posed an analogous challenge to verbal description. His art was similarly viewed as an alternative to the Church/scientific mode. Their art was reflective of feelings, of personality and poetry, rather than of the objective observations of science. Regardless of the precise terms employed, however, observers recognized a definite division in landscape modes.

Kensett, Suydam, Gifford, Lane, and Heade never formed a movement, it is true, and never called themselves luminists. Nor did Church, Bierstadt, and Durand conceive of themselves as members of a Hudson River School. The often-invoked complaint that the terms were not used in the artist's day can be made against many of the useful but misconceived labels we formulate when trying to explain the history of art. Even this brief overview of the critical commentary reveals, however, a reliance on gendered language: the former (we call luminists) were sweet, tranquil, and feminine; the latter (our Hudson River School) were forceful, dynamic, and manly. The terms are nothing new; the gendering of art goes back at least as far as the Renaissance. In America this division continued to have distinct episodes in the twentieth century: the Stieglitz circle of European-inspired "aesthetes" versus the Ashcan painters; the citified Abstractionists

versus the country-loving, rough and ready Regionalists; the Beat poets versus Hopper and the Abstract Expressionists.[37] It reminds us of the patterns that have repeated themselves over the centuries and together constitute an enduring American tradition.

Art and Identity

Scholarship in American art of the last twenty years has increasingly attended to issues surrounding gender and sexuality. This, in turn, has led to new awareness about codes for homosexuality in the nineteenth century, as the figural works of John Singer Sargent and especially Thomas Eakins have been analyzed with increasing intensity for what they reveal of the artist's own identity and changing ideas of manhood in the Victorian era. Landscapists who worked in the years that bracket the Civil War have been slower to receive this kind of attention. Rumors and innuendo about Kensett's possible homosexuality have become accepted wisdom in art circles, but scholars have been reluctant to take up the subject. This study of Suydam and his artistic relationship with Kensett and their associates can help shed needed light on some of these issues, which I hope will be taken up by future scholars. For my purposes here, I would like to offer a few points for the reader to consider.

Arguing that Thomas Eakins "failed to achieve a number of the era's principal markers of manhood," Martin Berger explained how Eakins bought his way out of Civil War service, was long unmarried, lived and worked in his parents' home, was engaged in a profession that had consistently held effeminate associations, and was unable to earn his own living."[38] Similar arguments could be made for the luminists. Their response to the war was complex, many of them avoiding the service but at the same time holding strong opinions about chattel slavery and about the Union. These conflicted attitudes contributed to Hicks's picture *The Home Guard*, the pictorial fiction in which Suydam is cast as the uniformed figure protecting the domestic front. After the war the guard was interpreted as cowardly, dallying at home while his compatriots fought at the front. As we have seen, it was not likely that Suydam would have sat for such an anti-patriotic scenario, but the ambiguity surrounding the picture underscores an ambiguity over the artist/guard's manhood, which the war put to the test. The majority of the Hudson River School painters followed the conventional Victorian pattern of the family man, including early marriage and fatherhood. The luminists, by contrast, deviated from these societal expectations and either remained lifelong bachelors or married late in life. We are left with an unmistakable sense, then, that contemporaries associated them not with the masculine but with the feminine sphere.

Suydam's situation was further complicated by being labeled an "amateur." Since nineteenth-century men "took their social identity from their success or failure at work," he must have suffered from attendant anxieties that were tied to identity construction.[39] Then, too, amateur status carried feminine overtones, for the term was most often used with a gender qualifier, *lady* amateur.[40] Amateur artists, especially in the Anglo-American art world, were frequently assumed to be women. Removed from the rough-and-tumble workaday world, they were seen as figures of diminished masculinity. Struggling to characterize Suydam's peculiar sensibility, Tuckerman

made the following revealing statement: "Compared with other painters of vigorous, or impassioned, or purely intellectual genius, his was as sweet and gentle as the south wind over blowing [blossoming] roses, and it had something of the seductive sadness of an evening of June."[41]

What are we to make of this description, or of George Templeton Strong's reference to "poor Jem Suydam"?[42] Or his close friendship with Kensett, who in turn, lived with Louis Lang for twenty-five years in quarters described by one visitor as "fitted up as daintily as 'my ladies chamber.'"[43] Even in the homosocial world of mid-nineteenth-century New York, this artist and the members of his immediate circle stood out.

Collecting Images of Women and Children

In the absence of photographs or descriptions of the display of Suydam's collection, we are left to ponder the situation of a man in the midst of at least eighty paintings by other artists, almost evenly divided between landscapes and figure paintings. Almost all of these figural pieces represent women (in the form of idealized female heads and half-lengths of wan, lethargic women) and children engaged in play, sweet and sentimental. There are at least six or seven religious or modern Madonnas, including those by Kellogg and Diaz de la Peña. Also present are another seven idealized female types ranging from Karl Ludwig Friedrich Becker's *Neapolitan Girl* (FIG. 5.7) to William Oliver Stone's *Widow* (FIG. 5.8). Another group represents

FIG. 5.7 Karl Ludwig Friedrich Becker (1820–1900), *Neapolitan Girl*, ca. 1864, oil on canvas, 20 x 16 inches, National Academy Museum, Bequest of James A. Suydam.

FIG. 5.8 William Oliver Stone (1830–1875), *The Widow*, 1856, oil on panel, 12½ x 10 inches, National Academy Museum, Bequest of James A. Suydam.

women in interiors, sometimes engaged in making music—as in Theophile Emmanuel Duverger's *Music Lesson* or George Cochran Lambdin's *The Sweetest Song*—but more often simply lounging about or—as in Lang's painting—recovering from a fainting spell. The predominance of this type of work—when we know that genre and figure painting of the period offered other subjects and sentiment—cannot therefore be ascribed to the desire to assemble a representative sampling of artists and motifs. Choices have been made, from which a distinct aesthetic emerges. There is a lack of active or masculine subject matter. These images of women lost in personal reverie or reclining on fainting couches seem to mirror a placid, sweet, fragile nature of these artists themselves. They provide a metaphor for the less manly, even feminine sensibility. These artists functioned in a homosocial world, to be sure, but even within that context they stood out from their contemporaries.

Images of children constitute the second division within the figure painting. In his selections Suydam eschewed active, rural, or outdoor subjects and preferred homey scenes in which the figures are located in a protected domestic environment. John George Brown's scene of young boys involved in a snowball fight is one of the few images of young males engaged in action, and yet here the title *The Victim* (FIG. 2.9) invokes images of a bully preying upon his weaker comrades that may itself have autobiographical overtones. Eastman Johnson's *The Art Lover* (FIG. 2.11), in its depiction of a young child poring over an art album, is one of several that deals with the shy, bookish child retreating from the world.[44] This is not a simplistic case of equating sweet, sentimental pictures of women and children with homosexuality. Taken together, the refined quality of the work, the selections made, the language used to describe them, the interrelations of the artists themselves, all seem to warrant further investigation into their sexual identities and the relation between that and the style of luminism.

Suydam, Lynchpin of Luminism

How different would landscape art of the time have been if Suydam had not been on the scene, painting and collecting? My conviction is that he played a critical role, but that his mild manner and self-effacing nature ensured that he functioned largely behind the scenes, deflecting praise or attention of any sort. He functioned as the gatekeeper of his artistic circle, who provided financial and emotional support, and instruction and counsel via his collection and library. He was, in my view, the lynchpin of the New York luminists, the key element holding together the dynamic members of the group.

First, his unconditional encouragement of Kensett contributed to the latter's early breakaway work. His own experimentation with the prototypes Kensett floated ensured ongoing development of the ideas; Kensett, left on his own, might have lacked the boldness to pursue his intuitions or the conviction to realize their value without Suydam as his alter ego. The process they underwent possibly parallels Farrell's explanation of the crystallization of the Impressionists vision: "They arrived at the vision as they worked alongside one another, commenting on each other's work, experimenting, making mistakes, deciding to include some mistakes, eventually

discovering the effects they preferred. It is not likely that either would have arrived at the new style alone, but together they had the courage to go beyond the limits. . . ."[45]

Second, Suydam's collection—both landscapes and figures—provided a repository of their shared motifs and sensibility. The works collectively reinforced qualities of refinement and gentility that served as an artistic anchor for the group. Here was tangible evidence of their shared aesthetic, expressed in single figures, landscapes, and genre scenes.

Even the work of artists in the collection not classified as luminist demonstrated formal affinities. Tuckerman's choice of Suydam's *Long Island Sound* to illustrate a deluxe edition his book and its circulation as an independent print further ensured that its compositional structure became linked with his name. The presence of an oil-spattered engraving of it among Church's possessions at Olana indicates that he kept it close at hand while he was painting. David Huntington noted: "The balance of sun and lighthouse in *Long Island Sound* is quite parallel to the balance of sun and volcano in *Cotopaxi*. The peacefulness of the Suydam print might have been on Church's mind when he painted a serene twilight scene (paired with an equally serene moonlit scene) in 1865 as a memorial to his two infant children who died that year."[46]

Significant also is the use of the central sun and columnar fall of light on the water in Church's *Scene on the Magdalene* (FIG. 2.18), an early product of Church's South American travels, purchased by Suydam. William Trost Richards, as Linda Ferber has observed, was another beneficiary of Suydam's encouragement and counsel; the *Coastal Scene* (FIG. 5.9) by Richards among Suydam's holdings indicates the patron's influence, both in its early inclination toward coastal subject matter and in the central tension of the composition produced by the prominent central orange sun and trail of its reflection in the water below.[47]

FIG. 5.9 William Trost Richards (1833–1905), *Coastal Scene*, 1862, oil on cardboard, 8 x 12 inches, National Academy Museum, Bequest of James A. Suydam.

Suydam was not the sole source for any of these impulses; but it is likely, given Suydam's holdings of Turner's relevant imagery and his own successful utilization of this visual motif, that he discussed it with Church, Richards, and others. We can even imagine them in his library poring over a passage from one of the rare volumes with texts by Ruskin and illustrations after Turner.

Third, his own pictures stood at the end of the landscape spectrum, the most rarefied of an already refined expression. The precise sources of his art remain mysterious, but it is possible to speculate here on one last inspiration. His artistic yearnings were born on his formative trip to Europe and the Near East, which he continued to ponder via the many related volumes in his library.[48] None of the sketches Suydam was reported to have made on that trip survives but a

small picture by his early mentor Kellogg entitled *Top of Mount Sinai* (1844; Smithsonian American Art Museum, Washington, DC), painted in a subtle, muted palette, in which the progression of dark to light from bottom to top adumbrates Suydam's later treatment. It seems possible that some impression of the distinctive light and atmosphere of the Holy Land may have been retained, to conflate with the secluded spots along the Long Island or along the Massachusetts coast. He could make a painting out of very little, from a golden stretch of sand contrasted with steel-blue water to the effect of fog along a modest curve of beach (FIG. 1.10). It was in fact a complicated affair to make something out of so little, and he rightly deserves to be identified, as David Huntington did, as "one of the most rarified spirits of the luminist school."

NOTES

1. Herman Melville, *Moby-Dick; or The Whale. An Authoritative Text.* Harrison Hayford and Herschel Parker, eds. (New York: Norton, 1967), 2.

2. John I. H. Baur, "The U.S. Faces the Sea," *ArtNews* 47, no. 7 (November 1948): 21.

3. John I. H. Baur, "A Tonal Realist: James Suydam," *Art Quarterly* 13, no. 3 (Summer 1950): 221.

4. Barbara Novak, *American Painting of the Nineteenth-Century: Realism, Idealism, and the American Experience* (1969; 2nd ed., New York: Harper & Row, 1979), 125.

5. Barbara Novak, "On Defining Luminism," in John Wilmerding, ed., *American Light: The Luminist Movement, 1850–1875,* (New York: Harper & Row; Washington, DC: National Gallery of Art, 1980), 23–30.

6. Barbara Novak, *American Painting,* 110.

7. Theodore E. Stebbins, Jr., "Luminism in Context: A New View," in Wilmerding, *American Light,* 227; Novak, "On Defining Luminism," 29.

8. Andrew Wilton, "The Sublime in the Old World and the New," in Andre Wilton and Tim Barringer, *American Sublime: Landscape Painting in the United States, 1820–1880,* exh. cat. (Princeton, NJ: Princeton University Press, 2002), 25.

9. J. G. Sweeney, "Inventing Luminism: Labels are the Dickens," *Oxford Art Journal* 26, no. 2 (2003): 93–120.

10. Miller credits Oswaldo Rodriguez Roque and Ila Weiss with first identifying "atmospheric luminism," but Miller's elaboration of the term is the clearest in distinguishing it from the "transcendental" form.

11. Angela Miller, *The Empire of the Eye: Landscape Representation and American Cultural Politics, 1825–1875* (Ithaca, NY: Cornell University Press, 1993), 244, 245, n. 4.

12. Ibid., 244.

13. Oswaldo Rodriguez Roque, "The Exaltation of American Landscape Painting," in John K. Howat, ed., *American Paradise: The World of the Hudson River School,* exh. cat. (New York: The Metropolitan Museum of Art, 1987), 46.

14. Huntington, Manuscript Memoir of James A. Suydam, National Academy Museum Archive, typescript, 6.

15. Gifford cited in Huntington, Manuscript Memoir of James A. Suydam, typescript, 6.

16. Dean MacCannell, *The Tourist: A New Theory of the Leisure Class* (1976; 3rd ed., Berkeley and Los Angeles: University of California Press, 1999), 80.

17. I am grateful to Kenneth Maddox for sharing his insights into this painting and for identifying its location at Newport.

18. Louis Menand, *The Metaphysical Club: A Story of Ideas in America* (New York: Farrar, Straus and Giroux, 2001), 200.

19. Michael Fried, *Absorption and Theatricality: Painting and Beholder in the Age of Diderot* (Berkeley: University of California Press, 1980), 76–79.

20. Unconfirmed source.

21. Clement and Hutton, *Artists of the Nineteenth Century and their Works,* 2:280.

22. Unidentified reviewer quoted in Tuckerman, *Book of the Artists,* 541.

23. The painting is currently owned by the Manor of St. George Museum, in Brookhaven; the view offshore there is that depicted in the picture. I believe he must have intentionally taken that perspective for a canvas that was always intended

for that site. Suydam's sister Jane married Charles Jeffrey Smith, who possibly had some connection to the Smiths of the Manor of St. George, although ongoing research has yet to confirm this point.

24. Eleanor H. Gustafson, ed., "Collectors' Notes: Fitz who Lane?" *Antiques* (2005): 48.

25. Sarah Cash, "Singing Beach, Manchester: Four Newly-Identified Paintings of the North Shore of Massachusetts by Martin Johnson Heade," *American Art Journal* 27 (1995–96): 84–98; Suydam's *Manchester Beach*, no. 461 in the 1860 National Academy exhibition, cannot be convincingly identified with any known work.

26. Earl A. Powell, "Luminism and the American Sublime," in Wilmerding, *American Light*, 83.

27. Theodore E. Stebbins, *Martin Johnson Heade*, exh. cat. (Boston: Museum of Fine Arts, 1999), 9.

28. Lisa Fellows Andrus, in her essay (in Wilmerding, *American Light*, 39), discussed the lecture, quoted from Tuckerman; "Brooklyn Academy of Design," *Brooklyn Eagle* (March 30, 1867), 3.

29. Stebbins is among those who say this; he overlooked the fact that Tuckerman devoted three full pages to Suydam, to cite just one exception. Stebbins, "Luminism in Context: A New View," in Wilmerding, *American Light*, 211.

30. Tuckerman, *Book of the Artists*, 499.

31. Ibid., 512.

32. Ibid., 540.

33. Obituary of John F. Kensett, *New York Times*, 16 December 1872.

34. "The Late John F. Kensett, N.A.," *Watson's Art Journal* 28 (December 1872): 98.

35. Jarves, *The Art-Idea*, 199.

36. Tuckerman, *Book of the Artists*, 541.

37. Brian O'Doherty, *American Masters. The Voice and the Myth* (New York: Random house, 1973), 42–43 and elsewhere provides a provocative discussion of these ideas.

38. Martin Berger, *Man Made: Thomas Eakins and the Construction of Gilded Age Manhood* (Berkeley: University of California Press, 2000), 3, 11.

39. Ibid., 11.

40. Griselda Pollock, for example, asks, "Why did Cassatt become a professional artist and not a lady amateur?" in *Mary Cassatt: Painter of Modern Women*, (London: Thames and Hudson, 1998), 6.

41. Tuckerman, *Book of the Artists*, 540–41.

42. Allan Nevins and Milton Halsey Thomas, eds., *The Diary of George Templeton Strong* (New York: Macmillian, 1952), 4:99.

43. Rita Moza, "Our Artists," *Art Journal* 1, no. 3 (January 1868): 22.

44. See Mark Mitchell, entry on Johnson's related charcoal on paper entitled *The Album* in *Marks of Distinction: Two Hundred Years of American Drawings and Watercolors from the Hood Museum of Art*, exh. cat. (New York and Manchester, VT: Hudson Hills Press, 2005), 86–87.

45. Farrell, *Collaborative Circles*, 41.

46. David C. Huntington, "Church and Luminism: Light for America's Elect," in Wilmerding, *American Light*, 189, n. 67.

47. Linda S. Ferber, *William Trost Richards (1833–1905): American Landscape and Marine Painter* (PhD diss., 1980, Columbia University; Garland Publishing, 1979), 340.

48. Books in Suydam's library (see Appendix 3), including those by Thomas Allom, Layard, and others, would have informed this interest.

Portrait of James A. Suydam, undated, carte-de-visite,
Photograph Album, Worthington Whittredge Papers, Archives
of American Art, Smithsonian Institution, Washington, DC.
Courtesy Archives of American Art.

Appendix 1

James A. Suydam: Known and Recorded works

The following inventory reflects current and ongoing research on Suydam's art. Because historic exhibition and collection records rarely include adequate information to identify a work with confidence, only a cautious effort has been made to combine similarly titled entries. Suydam often depicted sites more than once, particularly in Newport, so works with related subjects may appear deceptively similar in their titles. Future research will likely permit further consolidation of some of the entries in this inventory.

The listing is divided into two parts: dated and undated works. When approximate dates are available, those works are included in the dated section of the inventory. Aliases, variants, and former titles, when known, follow the accepted title of the work in parenthesis. Entry numbers have been assigned to provide a clear reference for future study and consist of the year followed by a sequential number assigned to the works in alphabetical order by title. Undated works are given an "ND" (not dated) prefix.

ABBREVIATED CITATIONS

Cowdrey Mary Bartlett Cowdrey. *National Academy of Design Exhibition Record: 1826–1860.* 2 vols. New York: The New-York Historical Society, 1943.

Dearinger David B. Dearinger, ed. *Paintings and Sculpture in the Collection of the National Academy of Design, Volume I, 1826–1925.* New York and Manchester, VT: Hudson Hills, 2004.

Naylor Maria Naylor, comp. and ed. *The National Academy of Design Exhibition Record: 1861–1900.* 2 vols. New York: Kennedy Galleries, 1973.

1848.1

Going Fishing, 1848

Graphite, pen and ink, and watercolor on paper,
4¾ x 5¹⁵⁄₁₆ inches

Inscribed, l.c., "A hearty man a fishing went / And on
a chub his looks he bent"; signed, dated, and
inscribed, on reverse, "October 1848 / Miss [illeg.]
Griffin from / James Suydam"

PROVENANCE

Collection of Mr. and Mrs. Stuart P. Field, NY
(current)

1855.1

At River's Bend (*River Scene*), ca. 1855

Oil on canvas laid down on artist's board,
5¾ x 10 inches

Initialed, l.l.

PROVENANCE

Private collection, NY (current)

Phillips de Pury & Luxembourg, NY (2002)

Sotheby Parke Bernet, NY (1979)

Estate of John J. Gordon, FL (1979)

1856.1

From North Conway, ca. 1856

PROVENANCE

Unlocated

LITERATURE

Cowdrey, 2:146.

EXHIBITED

National Academy of Design Annual Exhibition,
New York, 1856.

1857.1

Conway Meadows, ca. 1857

Oil on canvas, 11 x 20 inches

Signed, l.l.

PROVENANCE

Private collection (current)

Phillips de Pury & Luxembourg, NY (2003)

Private collection (1960–2003)

R. Sanford, Esq. (1859)

LITERATURE

Cowdrey, 2:146

*Catalogue of the Third Annual Exhibition of the
Washington Art Association* (Washington: William
H. Moore, 1859), no. 112.

EXHIBITED

Washington Art Association 3rd Annual Exhibition,
Washington, DC, 1859.

Boston Athenaeum Annual Exhibition, 1858.

National Academy of Design Annual Exhibition,
New York, 1858.

1857.2

Lily Pond, ca. 1857

PROVENANCE

Unlocated

LITERATURE

Cowdrey, 2:146.

EXHIBITED

National Academy of Design Annual Exhibition,
New York, 1857.

1858.1

Corn Field, ca. 1858

PROVENANCE

Bradley Collection (1858)

LITERATURE

*Catalogue of Paintings to be Sold for the Benefit of the
Ranney Fund* (New York, 1858), no. 29.

1858.2

Moat Mountain—Conway, ca. 1858

PROVENANCE

Unlocated

LITERATURE

Cowdrey, 2:146.

EXHIBITED

National Academy of Design Annual Exhibition,
New York, 1858.

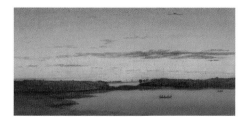

1858.3

Twilight, Salt Lake, Narragansett, ca. 1858

Oil on canvas, 7 x 14⅛ inches

Signed and dated, l.r.

PROVENANCE

Century Association, New York, Edward Slosson
Bequest, 1871 (current)

LITERATURE

Mayor, A. Hyatt, and Mark Davis, *American Art at the
Century* (New York: The Century Association,
1977), 133.

1859.1

Fog at Narragansett, ca. 1859

PROVENANCE

George Whitney Collection (1867)

LITERATURE

Cowdrey, 2:146.

*Artists' Fund Society of Philadelphia, Catalogue of the
Exhibition of February, 1867, at the New Galleries*
(Philadelphia: Henry B. Ashmead, 1867), no. 48.

EXHIBITED

Artists' Fund Society, Philadelphia, Pennsylvania, 1867.

National Academy of Design Annual Exhibition,
New York, 1859.

1859.2

Narragansett Shore, ca. 1859

PROVENANCE

Unlocated

LITERATURE

Cowdrey, 2:146.

1859.3

Twilight on the Lake, ca. 1859

PROVENANCE

Unlocated

LITERATURE

Cowdrey, 2:146.

EXHIBITED

National Academy of Design Annual Exhibition,
New York, 1859.

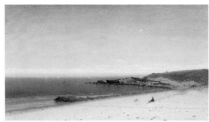

1860.1

Beach at Newport, Rhode Island, ca. 1860–65

Oil on canvas, 13 x 23 inches

Signed, l.r., "JA Suydam"

PROVENANCE

Henry and Sharon Martin Collection (current)

Berry-Hill Galleries, NY (1994)

LITERATURE

Sharp, Kevin. *For Spacious Skies: Hudson River School Paintings from the Henry and Sharon Martin Collection*, exh. cat. (New Britain, CT: New Britain Museum of American Art, 2005), 70–73, cat. no. 14.

Weber, Bruce. *American Paintings, VII* (New York: Berry Hill Galleries, 1994), 76–77.

EXHIBITED

"For Spacious Skies: Hudson River School Paintings from the Henry and Sharon Martin Collection," New Britain Museum of American Art, CT, 2005 and National Academy Museum, New York, 2006.

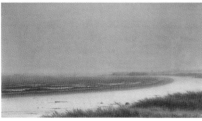

1860.2

Beach Scene, Newport (Fog at Narragansett), 1860

Oil on canvas, 9 ½ x 16 ¼ inches

PROVENANCE

Private collection (current)

Lano Collection, NY (1980)

LITERATURE

Wilmerding, John. *American Light: The Luminist Movement, 1850–1875.* exh. cat. (Washington, DC: National Gallery of Art, 1980), 309, FIG. 341.

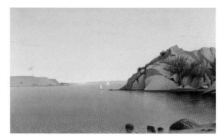

1860.3

Beacon Rock and the Entrance to Newport Harbor, ca. 1860

Oil on canvas, 18 x 30 inches

PROVENANCE

Private collection, (current)

William Vareika Fine Arts, RI (1991)

Childs Gallery, MA (1990)

Sotheby's, NY (1990)

LITERATURE

William Vareika Fine Arts, Newport, RI, *The Artistic Heritage of Newport and the Narragansett Bay*, exh. cat. (Newport, RI: William Vareika Fine Arts, 1990), pl. 21.

1860.4

Beverly Beach, ca. 1860

PROVENANCE

Unlocated

LITERATURE

Cowdrey, 2:146.

EXHIBITED

National Academy of Design Annual Exhibition, New York, 1860.

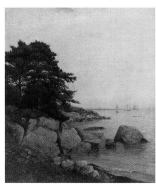

1860.5

Beverly Rocks, ca. 1860

Oil on canvas, 11 ³/₁₆ x 9 ½ inches

PROVENANCE

National Academy Museum, New York, NA Diploma
 Presentation, 1862 (current)

The artist

LITERATURE

Baur, John I. H. "A Tonal Realist: James Suydam,"
 Art Quarterly 13, no. 3 (Summer 1950): 226.

Czestochowski, Joseph S. *The American Landscape
 Tradition: A Study and Gallery of Paintings*
 (New York: E. P. Dutton, 1982), 96–97, FIG. 97.

Dearinger, 523.

EXHIBITED

"An American Collection: Paintings and Drawings
 and Sculpture from the National Academy of
 Design," Cheekwood Fine Arts Center, Nashville,
 TN, 1889–1990, North Carolina Museum of Art,
 Raleigh, NC, 1990, Emory University Museum,
 Atlanta, GA, 1990, Triton Museum of Art, Santa
 Clara, CA, 1990, Terra Museum of American Art,
 Chicago, IL, 1991, Washington University Gallery of
 Art, St. Louis, MO, 1991, and Denver Art Museum,
 CO, 1991–1992.

"A Mirror of Creation," Collezione d'Arte Reliogiosa
 Moderna, Vatican, 1980 and Terra Museum of
 American Art, Evanston, IL, 1980–1981.

"Scenic Beauty: Junius R. Sloan and the Hudson
 River School of Painting," Valparaiso University,
 IN, 1976.

1860.6

Chocorua, White Mountains, ca. 1860

PROVENANCE

Unlocated

LITERATURE

Cowdrey, 2:146.

EXHIBITED

National Academy of Design Annual Exhibition,
 New York, 1860.

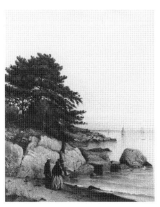

1860.7

James A. Suydam and William John Hennessy
 (1839–1917)

*Foggy Morning, L.I. (Foggy Morning, Massachusetts
 Coast)*, ca. 1860

Oil on canvas, 12 x 10 inches

PROVENANCE

Private collection, NY (1980)

Louis Lang (1866)

Samuel P. Avery (1865)

LITERATURE

Naylor, 2:907.

*Catalogue of Works of Art contributed by Members of
 the Artists' Fund Society,to Be Sold at Auction, for the
 Benefit of the Fund, at the National Academy of
 Design* (New York: G. A. Whitehorne, 1865), no. 215.

EXHIBITED

Artists' Fund Society Annual Exhibition, New York,
 1865.

1860.8

Manchester Beach, ca. 1860

PROVENANCE

Unlocated

LITERATURE

Cowdrey, 2:146.

EXHIBITED

National Academy of Design Annual Exhibition, New York, 1860.

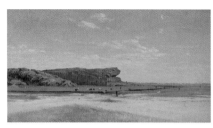

1860.9

Newport, Hanging Rock, ca. 1860

Oil on canvas, 14 x 24 inches

PROVENANCE

Private collection, NY (current)

1860.10

Old Mill at North Conway, ca. 1860

Oil on composition board, 10⅛ x 17 inches

Inscribed, on reverse, "Old Mill at / North Conway / J. A Suydam"

PROVENANCE

Hood Museum of Art, Dartmouth College, NH, Gift of Mr. and Mrs. Peter A. Vogt, Class of 1947 (current)

1860.11

On Long Island, ca. 1860

PROVENANCE

Richards collection (1860)

LITERATURE

Artists' Fund Society of N.Y., Catalogue of the First Annual Exhibition (New York: G. A. Whitehorne, 1860), no. 110.

EXHIBITED

Artists' Fund Society, Annual Exhibition, New York, 1860.

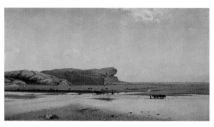

1860.12

Paradise Rocks, Newport (Berkeley's Seat, Newport), 1860

Oil on canvas, 25½ x 45⅛ inches

Signed and dated, l.r., "Suydam 1860"

PROVENANCE

National Academy Museum, New York, Bequest of James A. Suydam (current)

The artist

LITERATURE

Dearinger, 523.

Wilmerding, John. *American Views: Essays on American Art* (Princeton, NJ: Princeton University Press, 1991), 91, FIG. 65.

Workman, Robert G. *The Eden of America: Rhode Island Landscapes, 1820–1920*, exh. cat. (Providence, RI: Museum of Art, Rhode Island School of Design, 1986), 40–41, FIG. 20.

Novak, Barbara, and Annette Blaugrund, eds., *Next to Nature: Landscape Paintings from the National Academy of Design*, exh. cat. (New York: Harper & Row, 1980), 58.

Stein, Roger B. *Seascape and the American Imagination* (New York: Clarkson N. Potter, Inc. Publisher, 1975), 104–105, FIG. 113.

Naylor, 2:907.

Shepard, Paul, Jr. "Paintings of the New England Landscape: A Scientist Looks at Their Geomorphology," *College Art Journal* 17, no. 1 (Autumn 1957), 32–33, FIG. 1.

Baur, John I. H. "A Tonal Realist: James Suydam," *Art Quarterly* 13, no. (Summer 1950), 226, FIG. 2.

Richardson, Leslie. "Paradise Rocks, Newport," *The Christian Science Monitor* (10 January 1950), 6.

Baur, John I. H. "The U. S. Faces the Sea," *ArtNews* 47, no. 7 (November 1948), 21.

Baur, John I. H. *The Coast and the Sea*, exh. cat. (New York: Brooklyn Museum, 1948), 18, 33, cat. no. 113.

United States Centennial Commission, International Exhibition, 1876, Official Catalogue, Part II, Art Gallery, Annexes, and Out-Door Works of Art (Philadelphia: John R. Nagle and Company, 1876), no. 197.

Artists' Fund Society, *Catalogue of the Sixth Annual Exhibition at the National Academy of Design* (New York: G. A. Whitehorne, 1865), no. 2.

EXHIBITED

"The Eden of America: Rhode Island Landscapes, 1820–1920," Museum of Art, Rhode Island School of Design, Providence, 1986.

"American Light: The Luminist Movement, 1850–1875," National Gallery of Art, Washington, DC, 1980.

"Seascape and the American Imagination," Whitney Museum of American Art, NY, 1975.

"The American Scene, 1820–1900," Indiana University Art Museum, Bloomington, IN, 1970.

"Luminism in Nineteenth Century American Painting," The Katonah Gallery, NY, 1972.

Parrish Art Museum, Southampton, NY, 1955.

"The Coast and the Sea: A Survey of American Marine Painting," Brooklyn Museum, NY, 1948–1949.

"International Exhibition," United States Centennial Commission, Philadelphia, PA, 1876.

National Academy of Design Annual Exhibition, New York, 1866.

Artists' Fund Society Annual Exhibition, NY, 1865

1860.13

Twilight, ca. 1860

PROVENANCE

Richards Collection (1860)

LITERATURE

Artists' Fund Society of N.Y., Catalogue of the First Annual Exhibition (New York: G. A. Whitehorne, 1860), no. 24.

EXHIBITED

Artists' Fund Society First Annual Exhibition, New York, 1860.

1860.14

Twilight on the Lake, ca. 1860

PROVENANCE

Unlocated

LITERATURE

Catalogue of the Third Annual Art Exhibition at the Rooms of the Young Men's Association in the Athenaeum (New York: D. H. Jones, 1860), no. 64.

EXHIBITED

Young Men's Association, Troy, NY, 1860.

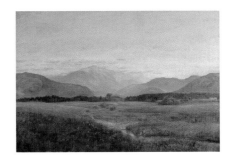

1860.15

View of Mt. Washington from the Conway Meadows (Mount Washington near the Intervale. North Conway, N.H.), ca. 1860

Oil on canvas, 14 x 20 inches

Signed, l.l.

PROVENANCE

Dr. Michel Hersen and Victoria Hersen (current)

Questroyal Fine Art, NY (2004)

Hamilton Auction Galleries, CT (2004)

Daniel Huntington (1873–1906)

John F. Kensett (by 1872)

1861.1

Landscape, ca. 1861
PROVENANCE
Unlocated
LITERATURE
*Catalogue of Pictures, the Second Exhibition of the
 Brooklyn Art Association in the Academy of Music,
 Brooklyn* (New York: G. A. Whitehorne, 1861),
 no. 51.
EXHIBITED
Brooklyn Art Association Second Exhibition, NY, 1861.

1861.2

Noon-day Fog, ca. 1861
PROVENANCE
Unlocated
LITERATURE
Naylor, 2:907.
Artists' Fund Society, *Catalogue of the Third Annual
 Exhibition at the Gallery of the Fine Art Institute*
 (New York: G. A. Whitehorne, 1862), no. 60.
EXHIBITED
Artists' Fund Society Annual Exhibition, New York,
 1862.
National Academy of Design Annual Exhibition,
 New York, 1861.

1861.3

Twilight on the Beverly Shore, ca. 1861
PROVENANCE
Unlocated
LITERATURE
Naylor, 2:907.
EXHIBITED
National Academy of Design Annual Exhibition,
 New York, 1861.

1862.1

Coast Scene, ca. 1862
PROVENANCE
Unlocated
LITERATURE
Artists' Fund Society, *Catalogue of the Third Annual
 Exhibition at the Gallery of the Fine Art Institute*
 (New York: G. A. Whitehorne, 1862), no. 146.

EXHIBITED
Artists' Fund Society Annual Exhibition,
 New York, 1862.

1862.2

Lake George, ca. 1862
PROVENANCE
Unlocated
LITERATURE
Naylor, 2:907.
EXHIBITED
National Academy of Design Annual Exhibition,
 New York, 1862.

1862.3

Landscape with Figures, ca. 1862
PROVENANCE
Unlocated
LITERATURE
Artists' Fund Society, *Catalogue of the Third Annual
 Exhibition at the Gallery of the Fine Art Institute*
 (New York: G. A. Whitehorne, 1862), no. 164.
EXHIBITED
Artists' Fund Society Annual Exhibition, New
 York, 1862.

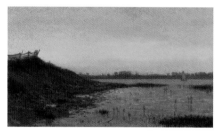

1862.4

Long Island, 1862
Oil on canvas, 18 x 30 inches
Signed, dated, and inscribed, on reverse; signed again
 on stretcher
PROVENANCE
Collection of Mary Ann and Jack Hollihan (current)
D. Wigmore Fine Art, NY (2004)

1862.5

Salt Meadows, L.I., ca. 1862

PROVENANCE

C. J. Smith collection (1862)

LITERATURE

Naylor, 2:907.

EXHIBITED

National Academy of Design Annual Exhibition,
New York, 1862.

1862.6

Spouting Rock Beach, Newport, Rhode Island, ca. 1862

PROVENANCE

Unlocated

LITERATURE

Naylor, 2:907.

Artists' Fund Society, *Catalogue of the Third Annual
Exhibition at the Gallery of the Fine Art Institute*
(New York: G. A. Whitehorne, 1862), no. 50.

EXHIBITED

Artists' Fund Society Annual Exhibition, New York,
1862.

National Academy of Design Annual Exhibition,
New York, 1862.

1862.7

Twilight, Beverly Creek, ca. 1862

PROVENANCE

Buffalo Fine Arts Academy, Buffalo, NY (1862)

LITERATURE

*The Buffalo Fine Arts Academy, Catalogue of American
and Foreign Paintings and Sculpture* (Buffalo:
Wheeler, Matthews & Warren, 1862), no. 84.

EXHIBITED

Buffalo Fine Arts Academy, Buffalo, New York, 1862.

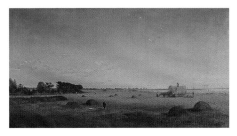

1862.8

View on Long Island, 1862

Oil on canvas, 28 x 40⅜ inches

Signed and dated, l.r.

PROVENANCE

Museum, Manor of St. George, Brookhaven, NY
(current)

George A. Crocker, NY (1950)

William A. Reese (1879)

LITERATURE

Baur, John I. H. "A Tonal Realist: James Suydam," *Art
Quarterly* 13, no. 3 (Summer 1950), 223, 225, FIG. 1.

Baur, John I. H. *The Coast and the Sea*, exh. cat. (New
York: Brooklyn Museum, 1948), 33, cat. no. 112.

Champlin, John Denison, ed. *Cyclopedia of Painters
and Paintings*, 4 vols. (New York: Charles
Scribner's Sons, 1886–1887), 4:247.

Clement, Clara Erskine and Laurence Hutton. *Artists
of the Nineteenth Century and their Works,* 2 vols.
(1879; Boston: Houghton, Mifflin and Company,
1896), 2:280.

EXHIBITED

"The Coast and the Sea: A Survey of American
Marine Painting," Brooklyn Museum, NY,
1948–1949.

1862.9

The Weedy Brook, ca. 1862

PROVENANCE

Unlocated

LITERATURE

Artists' Fund Society, *Catalogue of the Third Annual
Exhibition at the Gallery of the Fine Art Institute*
(New York: G. A. Whitehorne, 1862), no. 137.

EXHIBITED

Artists' Fund Society Annual Exhibition, New
York, 1862

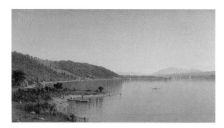

1863.1

Hook Mountain, Hudson River (*View of Lake George*;
 Hudson River), 1863

Oil on canvas, 12 ½ x 21 ¾ inches

Initialed and dated, l.l., "J.A.S. 1863"

PROVENANCE

Ann and Lee Higdon Collection (current)

Private collection, NY (ca. 1995)

John J. Hall

Smith Cliff (1863)

LITERATURE

Naylor, 2:907.

Champlin, John Denison, ed. *Cyclopedia of Painters
 and Paintings*, 4 vols. (New York: Charles
 Scribner's Sons, 1886–1887), 4:247.

Clement, Clara Erskine and Laurence Hutton. *Artists
 of the Nineteenth Century and their Works*, 2 vols.
 (1879; Boston: Houghton, Mifflin and Company,
 1896), 2:280.

*Catalogue of Paintings exhibited in the Ladies'
 Reception, Union League Club* (New York, 1875),
 no. 11.

*United States Centennial Commission, International
 Exhibition, Official Catalogue, Part II* (Philadelphia:
 John R. Nagle and Company, 1876), no. 183.

EXHIBITED

"International Exhibition," United States
 Centennial Commission, Philadelphia, PA, 1876.

Union League Club, New York, 1875

National Academy of Design Annual Exhibition,
 New York, 1866.

National Academy of Design Annual Exhibition,
 New York, 1863.

1863.2

The Hudson, ca. 1863

PROVENANCE

Unlocated

LITERATURE

Artists' Fund Society, *Catalogue of the Fourth Annual
 Exhibition at the Gallery of the Fine Art Institute*
 (New York: G. A. Whitehorne, 1863), no. 42.

EXHIBITED

Artists' Fund Society Annual Exhibition, New York,
 1863

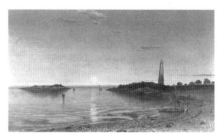

1863.3

Long Island Sound, ca. 1863

PROVENANCE

Unlocated

Note: Known through engraved reproduction by
 Samuel Valentine Hunt (1803–1893), 5 ⅜ x 9
 inches, Collection of Olana State Historic Site,
 New York State Office of Parks, Recreation and
 Historic Preservation.

1863.4

Newport Beach (*Coastal View*), 1863

Oil on canvas, 18 x 30 inches

PROVENANCE

Private collection (current)

Doyle, NY (2000)

Sotheby's, NY (1989)

1863.5

On the Beach, ca. 1863

PROVENANCE

Weehawken Gallery, NJ (ca. 1863)

LITERATURE

Catalogue, Gallery of Paintings at Weehawken, exh. cat.
(Weehawken, NJ: Weehawken Gallery, 1863), no.
134.

EXHIBITED

Weehawken Gallery, NJ, 1863.

1863.6

Twilight at New London, ca. 1863

PROVENANCE

Unlocated

LITERATURE

Naylor, 2:907.

EXHIBITED

National Academy of Design Annual Exhibition,
New York, 1863.

1864.1

Noontide on the South Side, ca. 1864

PROVENANCE

Unlocated

LITERATURE

Naylor, 2:907.

EXHIBITED

National Academy of Design Annual Exhibition,
New York, 1864.

1864.2

On the Beach, Newport (*Spouting Rock, Bailey's
Beach*), 1864

Oil on canvas, 18 x 30 inches

Signed and dated, l.r., "J A Suydam / 1864"

PROVENANCE

Collection of Erving and Joyce Wolf (current)

Washburn Gallery, NY (1977)

John Burrows, NY

Marshall O. Roberts (1867)

Vernon Collection (1865)

LITERATURE

Naylor, 2:907.

*Catalogue of Paintings and Other Works of Art,
Presented to the Metropolitan Fair in Aid of the U.S.
Sanitary Commission* (New York: George F. Nesbitt
& Co., 1864), no. 163.

*Catalogue of the Art Exhibition at the Metropolitan
Fair, in aid of the U.S. Sanitary Commission* (New
York: 1864), no. 278.

EXHIBITED

"Country Places," Washburn Gallery, New York, July
1977, no. 27.

National Academy of Design Annual Exhibition,
New York, 1865.

Metropolitan Sanitary Fair, New York,1864.

1864.3

View on the Hudson, ca. 1864

PROVENANCE

B. F. Gardner (1864)

LITERATURE

Catalogue, Art Exhibition, Maryland State Fair
(Baltimore: J. B. Rose & Co., 1864), no. 3.

EXHIBITED

Maryland State Fair, Baltimore, 1864.

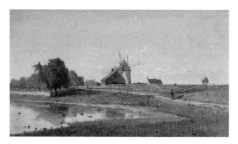

1864.4

The Windmill (Easthampton, Long Island), ca. 1864

Oil on canvas, 6¼ x 10¼ inches

Initialed, l.r., "J.A.S."; inscribed, on reverse, "Jas. A.
　　Suydam The Windmill (Easthampton, L.I. / N.Y.)"

PROVENANCE

Century Association, New York, William Cullen
　　Bryant Collection (current)

LITERATURE

Mayor, A. Hyatt and Mark Davis, *American Art at the
　　Century* (New York: Century Association, 1977), 133.

"The Bryant Album," *New York Evening Post*, 16
　　January, 1865, 2.

EXHIBITED

Rochester Memorial Art Gallery and tour, 1976–77.

Century Association, New York, 1865.

1865.1

Brant Rock, Marshfield, Massachusetts Bay, ca. 1865

Drawing

PROVENANCE

Unlocated

LITERATURE

*Catalogue of Paintings, Statuary, etc. in the Art
　　Department of the Great North-western Fair,
　　Chicago, Ill., held for the Benefit of the U.S. Sanitary
　　Commission and Soldiers' Home*, 2nd ed. (Chicago:
　　Published for the Benefit of the Fair, 1865), no. 236.

EXHIBITED

Northwestern Fair, Chicago, 1865.

1865.2

Haying on the Flats, ca. 1865

PROVENANCE

Unlocated

LITERATURE

*Catalogue of Works of Art on Exhibition at the Gallery
of the Buffalo Fine Arts Academy* (Buffalo, NY:
　　Wheeler, Matthews & Warren, 1865), no. 80.

EXHIBITED

Buffalo Fine Arts Academy, Buffalo, 1865.

1865.3

New London Harbor by Twilight, ca. 1865

PROVENANCE

Unlocated

LITERATURE

*The Utica Art Exhibition Catalogue of American and
　　Foreign Paintings and Sculpture* (Utica, NY:
　　Roberts, 1865), no. 85.

EXHIBITED

Utica Mechanics' Association, Utica, NY, 1865.

1865.4

Quiet Seas, ca. 1865

PROVENANCE

Unlocated

Note: Known through an engraving in Frederick
　　Saunders, *Festival of Song: a Series of Evenings with
　　the Poets* (New York: Bunce and Huntington, 1866).

1865.5

Salt Meadows, L.I., ca. 1865

PROVENANCE

Butler collection (1865)

LITERATURE

*Catalogue of Works of Art contributed by Members of
　　the Artists' Fund Society, to Be Sold at Auction, for
　　the Benefit of the Fund, at the National Academy of
　　Design* (New York: G. A. Whitehorne, 1865), no. 47.

EXHIBITED

Artists' Fund Society Annual Exhibition, New York,
　　1865

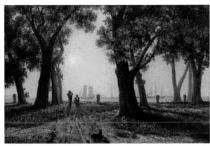

ND.1

Battery Park, New York, undated

Oil on canvas, 7¼ x 10 inches

PROVENANCE

Mr. and Mrs. Howard Godel, Bedford, NY (current)

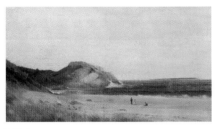

ND.2

Beach Scene, undated

oil on canvas, 12 x 20¾ inches

PROVENANCE

National Academy Museum, New York (current)

LITERATURE

Dearinger, 524.

ND.3

Beach Scene, undated

PROVENANCE

Private collection, NY (1967)

ND.4

Beacon Rock and the Entrance to Newport Harbor, undated

Oil on canvas, 14¼ x 25 inches

Signed, l.r.

PROVENANCE

Harry Schaten, NJ (current)

Schutz & Co. Fine Art, CT (2001)

ND.5

Casting the Nets, undated

Oil on canvas on board, 6 x 11 inches

Initialed, l.l.

PROVENANCE

Shannon's, CT (2004)

Private collection, MA (2004)

ND.6

Conway Valley, undated

PROVENANCE

National Academy of Design, New York, Suydam Collection (1865; unlocated)

LITERATURE

Catalogue of Works of Art contributed by Members of the Artists' Fund Society, to Be Sold at Auction, for the Benefit of the Fund, at the National Academy of Design (New York: G. A. Whitehorne, 1865), no. 76.

EXHIBITED

Artists' Fund Society Annual Exhibition, New York, 1865.

ND.7

Hood Mountain, undated

PROVENANCE

Unlocated

LITERATURE

Catalogue of Paintings exhibited in the Ladies' Reception, Union League Club, 1875.

EXHIBITED

Union League Club, New York, 1875.

Note: Title possibly a misprint of 1863.1

ND.8

Landscape, undated

Pencil on paper with white, 6⅞ x 10 inches Initialed, l.l.

PROVENANCE

Collection of Kenneth and Janet Maddox (current)

ND.9

Landscape, undated

Oil on canvas, 12½ x 22 inches

PROVENANCE

National Academy Museum, New York (current)

LITERATURE

Dearinger, 524.

ND.10

Landscape, Afternoon, undated

PROVENANCE

Unlocated

LITERATURE

Artist's Fund Society, *Catalogue of Works of Art contributed by Members of the Artists' Fund Society, to Be Sold at Auction, for the Benefit of the Fund, at the National Academy of Design* (New York: G. A. Whitehorne, 1865), no. 229.

EXHIBITED

Artists' Fund Society Annual Exhibition, New York, 1865.

ND.11

A Landscape at Sunset with Sailboats in the Distance, undated

Oil on board, 7½ x 6 inches

Signed

PROVENANCE

Butterfields, CA (1999)

ND.12

Landscape with Cattle, not listed

Oil on canvas, 22¼ x 36¼ inches

PROVENANCE

Doyle, NY (2000)

ND.13

The Lighthouse, undated

PROVENANCE

Unlocated

LITERATURE

Naylor, 2:907.

EXHIBITED

National Academy of Design Annual Exhibition, New York, 1865.

ND.14

Lily Pond, Newport, undated

PROVENANCE

National Academy of Design, New York, Bequest of
James A. Suydam (1865; unlocated)

LITERATURE

Artists' Fund Society, *Catalogue of Works of Art
contributed by Members of the Artists' Fund Society,
to Be Sold at Auction, for the Benefit of the Fund, at
the National Academy of Design* (New York: G. A.
Whitehorne, 1865), no. 15.

EXHIBITED

Artists' Fund society Annual Exhibition, New York,
1865.

ND.15

Long Island Coast, undated

PROVENANCE

S. P. Avery (1875)

LITERATURE

Industrial Exposition, 1875, Art Catalogue (Chicago:
Rand, McNally & Co., 1875), no. 475.

EXHIBITED

Chicago Interstate Industrial Exposition, Chicago, 1875.

ND.16

Manchester Beach, undated

PROVENANCE

S. P. Avery (1864/1880)

ND.17

Moonlit Scene, undated

Oil on canvas mounted on masonite, 6¼ x 10¼ inches

PROVENANCE

Private collection (current)

Sotheby Parke Bernet, NY (1979)

Estate of John J. Gordon, FL (1979)

ND.18

Moonrise on Coast, undated

Oil, 17 x 29 inches

PROVENANCE

Collection S. D. Babcock (1875)

LITERATURE

*Catalogue of the Loan Exhibitions of Paintings and
Statuary at the Metropolitan Museum of Art* (New
York: The Metropolitan Museum of Art, 1875),
no. 76.

EXHIBITED

The Metropolitan Museum of Art, New York, 1875.

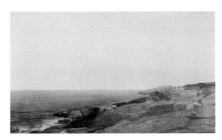

ND.19

Narragansett, undated

Oil on canvas, 12 x 21 inches

PROVENANCE

National Academy Museum, New York, Bequest of
James A. Suydam (current)

LITERATURE

Dearinger, 524.

Artists' Fund Society, *Catalogue of Works of Art
contributed by Members of the Artists' Fund Society,
to Be Sold at Auction, for the Benefit of the Fund, at
the National Academy of Design* (New York: G. A.
Whitehorne, 1865), no. 33.

EXHIBITED

Artists' Fund Society Annual Exhibition, New York,
1865.

ND.20

Near Cold Spring, undated

Oil

PROVENANCE

S. P. Avery (1864/1880)

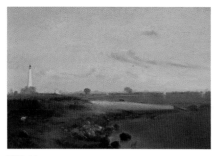

ND.21
New London Lighthouse, undated
Oil, 9 x 12 inches
Initialed
PROVENANCE
Robert S. Peiser, Jr. Collection (current)

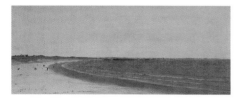

ND.22
Ocean Beach, undated
Oil on canvas, 9 x 21 inches
PROVENANCE
National Academy Museum, New York (current)
LITERATURE
Dearinger, 524 (illus.)

ND.23
On the Beach, undated
PROVENANCE
H. W. Derby's New Art Rooms, NY (1867)
W. P. Wright, NJ (ca. 1867)
LITERATURE
Catalogue of Paintings, H. W. Derby's New Art Rooms
 (New York: Baldwin & Jones, 1867), no. 125.
EXHIBITED
Derby Gallery, New York, 1867.

ND.24
On the Hudson, undated
PROVENANCE
National Academy of Design, New York, Bequest of
 James A. Suydam (1865; unlocated)
LITERATURE
Artists' Fund Society *Catalogue of Works of Art*
 contributed by Members of the Artists' Fund Society,
 to Be Sold at Auction, for the Benefit of the Fund, at
 the National Academy of Design (New York: G. A.
 Whitehorne, 1865), no. 83.
EXHIBITED
Artists' Fund Society Annual Exhibition, New York, 1865

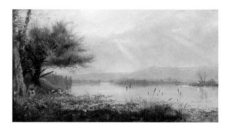

ND.25
River Landscape, undated
Oil on canvas, 8½ x 17 1/16 inches
Signed, on reverse, u.c.: "James A. Suydam"
PROVENANCE
Mr. and Mrs. William Berger and Mr. and Mrs.
 Richard Simmons (current)

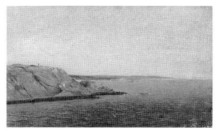

ND.26
Rocks and Sea, undated
Oil on canvas, 12 x 21 inches
PROVENANCE
National Academy Museum, New York (current)
LITERATURE
Dearinger, 524.

ND.27

Scene Near Fort Hamilton, N.Y., undated

Oil, 10½ x 19½ inches

PROVENANCE

John F. Kensett (1872)

LITERATURE

Executor's Sale. The Collection of over Five Hundred
Paintings and Studies, by the late John F. Kensett,
will be sold at Auction . . ., (New York: Robert
Somerville, 1873), no. 625.

ND.28

Sea Coast, undated

PROVENANCE

National Academy of Design, New York, Suydam
Collection (1865; unlocated)

LITERATURE

Artists' Fund Society, *Catalogue of Works of Art*
contributed by Members of the Artists' Fund Society,
to Be Sold at Auction, for the Benefit of the Fund, at
the National Academy of Design (New York: G. A.
Whitehorne, 1865), no. 34.

EXHIBITED

Artists' Fund Society Annual Exhibition, New York,
1865.

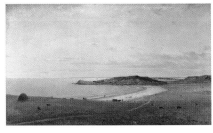

ND.29

Spouting Rock Beach, undated

Oil on canvas, 18 x 30 inches

PROVENANCE

Private collection (current)

ND.30

Spouting Rock, Newport, undated

PROVENANCE

Wellington Gallery, NY (1866)

LITERATURE

Catalogue of the Wellington Gallery (New York: Daily
Union Job Print, 1866), no. 50.

EXHIBITED

Wellington Gallery, New York, 1866.

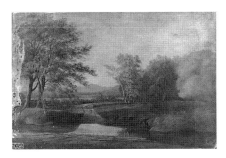

ND.31

A Study (Landscape, A Study), undated

Oil on canvas, 16 x 23⅝ inches

PROVENANCE

National Academy Museum, New York, Bequest of
James A. Suydam

LITERATURE

Dearinger, 524.

Artists' Fund Society, *Catalogue of Works of Art*
contributed by Members of the Artists' Fund Society,
to Be Sold at Auction, for the Benefit of the Fund, at
the National Academy of Design (New York: G. A.
Whitehorne, 1865), no. 38.

EXHIBITED

Artists' Fund Society Annual Exhibition, New York,
1865.

National Academy of Design Winter Exhibition,
New York, 1867–68, no. 230.

ND.32

Study at North Conway, Mass., undated
PROVENANCE
John F. Kensett (1872)
LITERATURE
Executor's Sale. The Collection of over Five Hundred Paintings and Studies by the late John F. Kensett, will be sold at Auction. . . , (New York: Robert Somerville 1873), no. 590.

ND.33

Salt Meadow, Long Island (Study, Autumn, Landscape View of Marshfield, Northern Massachusetts or Long Island), undated
Oil on canvas, 9 x 18 inches
Signed on reverse
PROVENANCE
Private collection (current)
Alan Pensler, Washington, DC (1995)

ND.34

Study Near North Conway, undated
PROVENANCE
National Academy of Design, New York, Suydam Collection (1865; unlocated)
LITERATURE
Artists' Fund Society, *Catalogue of the Sixth Annual Exhibition at the National Academy of Design* (New York: G. A. Whitehorne, 1865), no. 68.
EXHIBITED
Artists' Fund Society Annual Exhibition, New York, 1865

ND.35

Summer Sailing on the Hudson, undated
Oil, 7⅞ x 14¼ inches
Signed, l.c.
PROVENANCE
Christie's, NY (1986)

ND.36

Sunset Landscape, undated
Oil on canvas, 7⅝ x 6¼ inches (oval)
PROVENANCE
Shannon's, CT (2004)

ND.37

Twilight, undated
Oil on canvas, 6 x 12 inches
PROVENANCE
National Academy Museum, New York (current)
LITERATURE
Dearinger, 391–92. [attributed to Louis Rémy Mignot].

ND.38

Twilight on the Beverly Shore, undated
PROVENANCE
Unlocated
LITERATURE
Naylor, 2:907.
EXHIBITED
National Academy of Design Annual Exhibition, New York, 1866.

ND.39

Twilight on the Coast, undated

PROVENANCE

R. M. Olyphant (1876)

LITERATURE

Champlin, John Denison, ed., *Cyclopedia of Painters and Paintings*, 4 vols. (New York: Charles Scribner's Sons, 1886–1887), 4:247.

Clement, Clara Erskine and Laurence Hutton. *Artists of the Nineteenth Century and their Works*, 2 vols. (1879; Boston: Houghton, Mifflin and Company, 1896), 2:280.

United States Centennial Commission, International Exhibition, Official Catalogue, Part II (Philadelphia: John R. Nagle and Company, 1876), no. 437.

EXHIBITED

"International Exhibition," United States Centennial Commission, Philadelphia, PA, 1876.

National Academy of Design.

CATALOGUE

OF

THE SUYDAM COLLECTION,

(Bequeathed to the Academy by the late JAS. A. SUYDAM, N. A.)

NO.	SUBJECT.	ARTIST.
1	Jas. A. Suydam, N. A.,	D. Huntington, N. A.
2	Paradise Rocks, Newport,	J. A. Suydam, "
3	Juliet,	D. Huntington, "
4	Female Head,	W. O. Stone, "
5	Wild Flowers,	Alfred Jones, "
6	"The Melancholy Days have come,"	J. McEntee, "
7	Coast Scene,	Jules Noel.
8	Landscape,	E. Lambinet.
9	Speranza,	E. D. E. Greene, "
10	The Widow,	W. O. Stone, "
11	The Young Cook,	Seignac.
12	The Charitable Visit,	Alfred Jones, "
13	Twilight,	R. W. Hubbard, "
14	Swiss Scene,	J. W. Casilear, "
15	Lily Pond, Newport,	Jas. A. Suydam, "
16	The Home Guard,	T. Hicks, "
17	Bull attacked by Dogs,	E. Ockel.
18	Landscape,	W. T. Richards, "
19	Greek Girl,	M. K. Kellogg.
20	Madonna,	----------------
21	Bash Bish,	J. F. Kensett, "
22	Glimpse through the Wood,	J. F. Kensett, "
23	The Art Lover,	E. Johnson, "
24	Barn Yard,	E. Lemmens.
25	Village,	E. Lambinet.
26	Brook Scene,	R. W. Hubbard, "
27	Marriage of St. Catharine,	Coreggio.
98	Landscape,	L. R. Mignot, "
29	The Fair Student,	D. Huntington, "
30	Admirals in Embryo,	W. P. W. Dana, "
31	Ennui,	E. Benson, A.
32	The Fainting Spell,	L. Lang, N. A.
33	Narragansett,	J. A. Suydam, "
34	Sea Coast,	J. A. Suydam, "
35	The Bird Cage,	A. Guillemin.
36	Landscape,	A. Calame.
37	Spring Flowers,	Geo. C. Lambdin, "
38	A Study,	J. A. Suydam, "
39	Dressing the Doll,	E. Frère.
40	Twilight,	William Hart, "
41	Scene among the Andes,	F. E. Church, "
42	Landscape,	D. Huntington, "
43	Repose,	E. D. E. Greene, "
44	An Autumn Twilight,	J. McEntee, "
45	Scene on the Magdalene,	F. E. Church, "
46	Italian Study,	T. Hicks, "
47	Mt. Mansfield,	S. R. Gifford, N. A.
48	Poverty,	Oct. Tassaert.
49	Fidelity,	Diaz.
50	Madonna and Child,	----------------
51	Cavaliers,	----------------
52	Off Ostend,	A. Achenbach.
53	Wandering Thoughts,	G. H. Boughton, "
54	Madonna and Child,	----------------
55	A Study from Nature,	J. F. Kensett, "
56	On the Narragansett Coast,	J. F. Kensett, "
57	Drawing the Elephant,	Geo. C. Lambdin, "
58	Landscape,	A. B. Durand, "
50	Conway Valley,	B. Champney.
60	Mrs. H. B. Stowe,	T. Hicks, "
61	On the Saco, North Conway,	A. D. Shattuck, "
62	Approaching Shower,	J. F. Kensett, "
63	Lake of Nemi,	J. F. Cropsey, "
64	The Ravine,	R. W. Hubbard, "
65	The Music Lesson,	Duverger.
66	The Fair Penitent,	L. Lang, "
67	Coast Scene,	J. F. Cropsey, "
68	Study near North Conway,	J. A. Suydam, "
69	Study from Nature,	W. Whittredge, "
70	The Victim,	J. G. Brown, "
71	Finishing the Meal,	E. Frère.
72	Roman Campagna,	A. Flamm.
73	The Circassian Girl,	M. K. Kellogg.
74	"The Sweetest Songs are those that tell of saddest thoughts"	Geo. C. Lambdin, "
75	Winter Scene,	G. H. Boughton, "
76	Conway Valley,	J. A. Suydam, "
77	River Scene,	A. D. Shattuck, "
78	Landscape,	William Hart, "
79	Neapolitan Girl,	Carl Becker.
80	The Pet,	J. T. Peele, A.
81	Landscape,	J. W. Casilear, N. A.
82	Pull up the Hill,	Lamenias.
83	On the Hudson,	J. A. Suydam, "
84	Head of Madonna,	----------------
85	Winter Scene,	G. H. Boughton, "
86	The Pet Child,	A. Guillemin.
87	Along the Saco,	A. D. Shattuck, "
88	Greek Girl,	M. K. Kellogg.
89	Sybil,	----------------
90	St. Cecelia,	----------------
91	Charge of Cavalry,	----------------
92	Holy Family,	----------------

Broadside inventory of the Suydam Collection, printed on the occasion of the Artists' Fund Society Exhibition, December 1865, National Academy Museum Archive.

Appendix 2

INVENTORY OF THE SUYDAM BEQUEST, 1865

After Suydam's death in September 1865, a memorial exhibition of ninety-two paintings that he bequeathed to the National Academy of Design was mounted during the Artists' Fund Society Exhibition in December of that year. The catalogue of that exhibition is accepted as the authoritative inventory of the Suydam Collection and the inventory numbers (inv. no.) associated with it are retained in this listing for reference. In virtually all cases, the titles used for the exhibition are retained and alternate titles appear in parenthesis. (The National Academy's early twentieth-century registration records ascribed an additional twenty-seven "studies" by Suydam to the collection, but no specific evidence ties individual works to those records.)

Andreas Achenbach (1815–1910),
 German
Off Ostend, 1859
Oil on canvas, 49¾ x 68 inches
Acc. no. 2-P
Inv. no. 52

Karl Ludwig Friedrich Becker
 (1820–1900), German
Neapolitan Girl, ca. 1864
Oil on canvas, 20 x 16 inches
Acc. no. 72-P
Inv. no. 79

———

Eugene Benson (1839–1908),
 American
Ennui
Unlocated
Inv. no. 31

George Henry Boughton
 (1833–1905), American
Wandering Thoughts, 1865
Oil on canvas, 16¼ x 13¼ inches
Acc. no. 139-P
Inv. no. 53

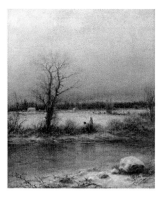

George Henry Boughton
 (1833–1905), American
Winter Scene, 1860
Oil on canvas, 15⅛ x 12¼ inches
Acc. no. 137-P
Inv. no. 75 (or 85)

John George Brown
 (1831–1913), American
The Victim, 1861
Oil on canvas, 14 x 12 inches
Acc. no. 164-P
Inv. no. 70

John William Casilear
 (1811–1893), American
Landscape (Fall of the Year), 1862
Oil on canvas, 10 x 18 inches
Acc. no. 203-P
Inv. no. 81

George Henry Boughton
 (1833–1905), American
Winter Scene, undated
Oil on cardboard, 6⅜ x 8⅝ inches
Acc. no. 138-P
Inv. no. 85 (or 75)

Alexandre Calame (1810–1864),
 Swiss
Landscape, ca. 1855–60
Oil on canvas, 22 x 32 inches
Acc. no. 190-P
Inv. no. 36

John William Casilear
 (1811–1893), American
Swiss Scene, 1859
Oil on canvas, 18¼ x 30 inches
Unlocated (historic photograph)
Inv. no. 14

Benjamin Champney
(1817–1907), American
Conway Valley, 1855–57
Oil on canvas, 23¾ x 30¼ inches
Acc. no. 207-P
Inv. no. 59

Frederic Edwin Church
(1826–1900), American
Scene on the Magdalene, 1854
Oil on canvas, 28¼ x 42 inches
Acc. no. 232-P
Inv. no. 45

Jasper Francis Cropsey
(1823–1900), American
The Lake of Nemi, 1848
Oil on canvas, 15⅜ x 22¼ inches
Acc. no. 307-P
Inv. no. 63

Frederic Edwin Church
(1826–1900), American
Scene among the Andes, 1854
Oil on canvas, 15⅞ x 24 inches
Acc. no. 233-P
Inv. no. 41

Jasper Francis Cropsey
(1823–1900), American
Coast Scene, 1855
Oil on canvas, 17 x 26¼ inches
Acc. no. 308-P
Inv. no. 67

William Parsons Winchester Dana
(1833–1927), American
Admirals in Embryo, ca. 1862
Oil on linen, 10⁵⁄₁₆ x 16 inches
Acc. no. 323-P
Inv. no. 30

Narcisse-Virgile Díaz de la Peña
(1807–1876), French
Fidelity
Unlocated
Inv. no. 49

Asher B. Durand (1796–1886),
 American
Landscape, 1850
Oil on canvas, 27¼ x 38½ inches
Acc. no. 386-P
Inv. no. 58

Albert Flamm (1823–1906),
 German
The Roman Campagna, 1859
Oil on canvas, 43 x 62¾ inches
Acc. no. 448-P
Inv. no. 72

Edouard Frère (1819–1886),
 French
*Finishing the Meal (The
 Breakfast),* possibly 1855
Oil on panel, 15 x 11¾ inches
Acc. no. 477-P
Inv. no. 71

Théophile Emmanuel Duverger
 (1821–ca. 1901), French
The Music Lesson, undated
Oil on panel, 12⅞ x 9½ inches
Acc. no. 397-P
Inv. no. 65

Edouard Frère (1819–1886),
 French
Dressing the Doll, 1857
Oil on panel, 13¾ x 9¼ inches
Acc. no. 478-P
Inv. no. 39

Sanford R. Gifford (1823–1880),
 American
Mt. Mansfield, Vermont, 1859
Oil on canvas, 10½ x 20 inches
Acc. no. 493-P
Inv. no. 47

Edward Dana Erving Greene
 (1823–1879), American
Repose, undated
Oil on canvas, 22 x 18 inches
Acc. no. 1281-P (or 1299-P)
Inv. no. 9

Alexandre-Marie Guillemin
 (1817–1880), French
The Bird Cage, 1855
Oil on panel, 11¼ x 8⅝ inches
Acc. no. 521-P
Inv. no. 35

William Hart (1823–1894),
 American
Landscape, undated
Oil on canvas, 9 x 18 inches
Acc. no. 1492-P
Inv. no. 78

Edward Dana Erving Greene
 (1823–1879), American
Speranza, undated
Oil on canvas, 22 x 18 inches
Acc. no. 1299-P (or 1281-P)
Inv. no. 43

Alexandre-Marie Guillemin
 (1817–1880), French
The Pet Child
Watercolor
Unlocated (historic photograph)
Inv. no. 86

William Hart (1823–1894),
 American
Twilight (*Landscape—Sunset on
 Long Island*), undated
Oil on canvas, 12 x 22 inches
Acc. no. 546-P
Inv. no. 40

Thomas Hicks(1823–1890),
 American
Italian Study (*Italian Landscape*),
 1847–48
Oil on paper, mounted on com-
 position board, 15 x 21 inches
Acc. no. 570-P
Inv. no. 46

Thomas Hicks (1823–1890),
 American
The Home Guard, 1863
Oil on canvas, 18 x 24 inches
Acc. no. 571-P
Inv. no. 16

Richard William Hubbard
 (1816–1888), American
The Ravine (*Landscape Sketch:
 Ravine*), undated
Oil on canvas, 17 x 14 inches
Acc. no. 1495-P
Inv. no. 64

Thomas Hicks (1823–1890),
 American
Harriet Beecher Stowe, 1855
Oil on canvas, 20 x 16⅝ inches
Acc. no. 574-P
Inv. no. 60

Richard William Hubbard
 (1816–1888), American
Brook Scene (*Crossing the Bridge*),
 undated
Oil on canvas, 14 x 13⅜ inches
Acc. no. 599-P
Inv. no. 26

Richard William Hubbard
 (1816–1888), American
Twilight, undated
Oil on canvas, 20 x 30 inches
Acc. no. 600-P
Inv. no. 13

Daniel Huntington (1816–1906),
 American
Glimpses from the Forest
 (*Landscape*), 1856
Oil on canvas, 17¼ x 21 inches
Acc. no. 603-P
Inv. no. 42

Daniel Huntington (1816–1906),
 American
Juliet (*Juliet on the Balcony*), 1862
Oil on canvas, 12 x 10 inches
Acc. no. 605-P
Inv. no. 3

Eastman Johnson (1824–1906),
 American
The Art Lover, 1859
Oil on canvas, 12⅜ x 15½ inches
Acc. no. 670-P
Inv. no. 23

Daniel Huntington (1816–1906),
 American
James Augustus Suydam, N.A.,
 1862
Oil on canvas, 30 x 25 inches
Acc. no. 611-P
Inv. no. 1

Daniel Huntington (1816–1906),
 American
The Fair Student (*Girl Reading*),
 1858
Oil on canvas, 30 x 25 inches
Acc. no. 604-P
Inv. no. 29

Alfred Jones (1819–1900),
 American
The Charitable Visit, undated
Oil on canvas, 10½ x 7¾ inches
Acc. no. 676-P
Inv. no. 12

Alfred Jones (1819–1900),
 American
Wild Flowers, undated
Oil on panel, 10⅜ x 8¼ inches
Acc. no. 677-P
Inv. no. 5

Miner K. Kellogg (1814–1889),
 American
Greek Girl
Unlocated (or acc. no. 1326-P)
Inv. no. 88 (or 19)

John F. Kensett (1816–1872),
 American
Approaching Shower (*A Passing
 Shower*), 1859
Oil on canvas, 18 x 27 inches
Acc. no. 697-P
Inv. no. 62

Miner K. Kellogg (1814–1889),
 American
Greek Girl, undated
Oil on cardboard, 12⅜ x 9⅞ inches
Acc. no. 1326-P (or unlocated)
Inv. no. 19 (or 88)

Miner K. Kellogg (1814–1889),
 American
Circassian Girl, undated
Oil on panel, 9¼ x 6⅞ inches
Acc. no. 692-P
Inv. no. 73

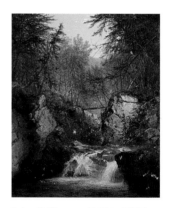

John F. Kensett (1816–1872),
 American
Bash Bish, 1855
Oil on canvas, 36 x 29 inches
Acc. no. 700-P
Inv. no. 21

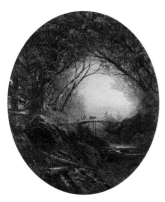

John F. Kensett (1816–1872),
 American
Glimpse through the Wood,
 undated
Oil on canvas, 12 x 10 inches
Acc. no. 699-P
Inv. no. 22

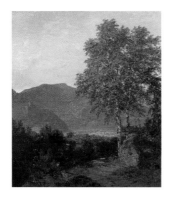

John F. Kensett (1816–1872),
 American
Study from Nature, ca. 1852
Oil on canvas, 19½ x 16⅛ inches
Acc. no. 701-P
Inv. no. 55

George Cochran Lambdin
 (1830–1896), American
Drawing the Elephant, 1859
Oil on canvas, 24 x 20 inches
Acc. no. 726-P
Inv. no. 57

John F. Kensett (1816–1872),
 American
On the Narragansett Coast, 1864
Oil on canvas, 9¾ x 20½ inches
Acc. no. 696-P
Inv. no. 56

George Cochran Lambdin
 (1830–1896), American
*The Sweetest Songs Are Those That
 Tell of Saddest Thoughts*, 1857
Oil on canvas, 17¼ x 14 inches
Acc. no. 723-P
Inv. no. 74

George Cochran Lambdin
 (1830–1896), American
Spring Flowers (May Flowers),
 1863
Oil on canvas, 42 x 33 inches
Acc. no. 722-P
Inv. no. 37

Emile Charles Lambinet
(1815–1877), French
Landscape, 1856
Oil on canvas, 15 x 24 inches
Acc. no. 728-P
Inv. no. 8

Louis Lang (1814–1893),
German-American
The Fainting Spell, 1860
Oil on canvas, 10 x 8 inches
Acc. no. 731-P
Inv. no. 32

Théophile Victor Emile Lemmens
(1821–1867), French
Barn Yard, undated
Oil on canvas, 7⅝ x 9⅝ inches
Acc. no. 763-P
Inv. no. 24.

Emile Charles Lambinet
(1815–1877), French
The Village at Datchet (*Village*),
1857
Oil on panel, 10 x 14 inches
Acc. no. 729-P
Inv. no. 25

Louis Lang (1814–1893),
German-American
The Fair Penitent, 1857
Oil on canvas, 40 x 32 inches
Acc. no. 1501-P
Inv. no. 66

Evariste Vital Luminias
(1822–1896), French
Pull Up the Hill, 1858
Oil on canvas, 13 x 16⅛ inches
Acc. no. 800-P
Inv. no. 82

Jervis McEntee (1828–1891),
 American
An Autumn Twilight, undated
Oil on canvas, 20¼ x 36 inches
Acc. no. 1389-P
Inv. no. 44

———————

Jervis McEntee (1828–1891),
 American
The Melancholy Days Have Come
Unlocated
Inv. no. 6

Jules Achille Noël (1815–1881),
 French
Coast Scene, 1857
Oil on canvas, 16¼ x 24⅜ inches
Acc. no. 943-P
Inv. no. 7

John Thomas Peele (1822–1897),
 American
The Pet, 1853
Oil on canvas, 36 x 28 inches
Acc. no. 988-P
Inv. no. 80

Louis Rémy Mignot (1831–1870),
 American
Sources of the Susquehanna
 (*Landscape*), 1857
Oil on canvas, 24¼ x 36½ inches
Acc. no. 864-P
Inv. no. 28

Eduard Ockel (1834–1910),
 German
Bull Attacked by Dogs, undated
Oil on canvas, 11 x 14¼ inches
Acc. no. 951-P
Inv. no. 17

William Trost Richards
 (1833–1905), American
Coastal Scene (*Landscape*), 1862
Oil on cardboard, 8 x 12 inches
Acc. no. 1067-P
Inv. no. 18

Paul Seignac (1826–1904),
 French
The Young Cook, undated
Oil on panel, 10¾ x 8¼ inches
Acc. no. 1143-P
Inv. no. 11

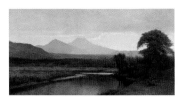

Aaron Draper Shattuck
 (1832–1928), American
On the Saco, North Conway, 1857
Oil on canvas, 14 x 26¼ inches
Acc. no. 1227-P
Inv. no. 61

William Oliver Stone
 (1830–1875), American
Female Head, undated
Oil on panel, 12 x 9¾ inches
Acc. no. 1219-P
Inv. no. 4

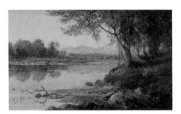

Aaron Draper Shattuck
 (1832–1928), American
Along the Saco, undated
Oil on canvas, 5 x 8 inches
Acc. no. 1157-P
Inv. no. 87

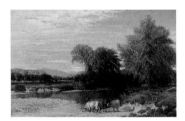

Aaron Draper Shattuck
 (1832–1928), American
The Ford (*River Scene*), 1856
Oil on canvas, 16 x 24 inches
Acc. no. 1156-P
Inv. no. 77

William Oliver Stone
 (1830–1875), American
The Widow, 1856
Oil on panel, 12½ x 10 inches
Acc. no. 1218-P
Inv. no. 10

James A. Suydam (1819–1865),
 American
Conway Valley
Unlocated
Inv. no. 76

———————

James A. Suydam (1819–1865),
 American
Lily Pond, Newport
Unlocated
Inv. no. 15

James A. Suydam (1819–1865),
 American
Paradise Rocks, Newport, 1860
Oil on canvas, 25⅛ x 45⅛ inches
Acc. no. 1226-P
Inv. no. 2

James A. Suydam (1819–1865),
 American
A Study, (*Landscape, A Study*)
 undated
Oil on canvas, 16 x 23⅝ inches
Acc. no. 1231-P
Inv. no. 38

James A. Suydam (1819–1865),
 American
Narragansett, undated
Oil on canvas, 12 x 21 inches
Acc. no. 1229-P
Inv. no. 33

———————

James A. Suydam (1819–1865),
 American
On the Hudson
Unlocated
Inv. no. 83

James A. Suydam (1819–1865),
 American
Sea Coast
Unlocated (possibly acc. no.
 1306-P or 1318-P)
Inv. no. 34

———————

James A. Suydam (1819–1865),
 American
Study near North Conway
Unlocated
Inv. no. 68

Octave Tassaert (1800–1874),
 French
Poverty (Distress), 1856
Oil on canvas, 22 x 18¼ inches
Acc. no. 1242-P
Inv. no. 48

Worthington Whittredge
 (1820–1910), American
Study from Nature, 1863
Oil on canvas, 19¾ x 15¾ inches
Acc. no. 1520-P
Inv. no. 69

Unknown artist
Charge of Cavalry, undated
Oil on canvas, 19½ x 29½ inches
Acc. no. 1454-P
Inv. no. 91

Unknown artist
Head of Madonna
Unlocated
Inv. no. 84

Unknown artist
Madonna, undated
Oil on canvas, 25¼ x 19⅛ inches
Acc. no. 1274-P
Inv. no. 20

Unknown artist
Cavaliers, undated
Oil on canvas, 25¼ x 50½ inches
Acc. no. 1453-P
Inv. no. 51

Unknown artist
Holy Family (*Christ in Carpenter's
 Shop*), undated
Oil on canvas, 38⅜ x 29½ inches
Acc. no. 1279-P (or unlocated)
Inv. no. 92

Unknown artist
Madonna and Child, undated
Oil on panel, 16¼ x 11⅞ inches
Acc. no. 1280-P (or 1284-P)
Inv. no. 50

Unknown artist
Madonna and Child, undated
Oil on canvas, 16 x 12 inches
Acc. no. 1284-P (or 1280-P)
Inv. no. 54

Unknown artist
Sybil (*Allegorical Figure*), undated
Oil on canvas, 38½ x 29½ inches
Acc. no. 1278-P or lost
Inv. no. 89

Unknown artist
St. Cecelia
Unlocated
Inv. no. 90

Unknown artist, after Correggio
Marriage of Saint Catherine,
 undated
Oil on canvas, 10¾ x 8¹³⁄₁₆ inches
Acc. no. 1330-P
Inv. no. 27

Cover of the auction catalogue of Suydam's library, November 22-23, 1865, Rare Books Division, The New York Public Library, Astor, Lenox and Tilden Foundation.

Appendix 3

JAMES A. SUYDAM'S LIBRARY

The following inventory of Suydam's personal library is a transcription based upon the catalogue of his estate auction, held by Bangs, Merwin & Co. on November 22–23, 1865. The catalogue documents Suydam's interests in English, American and French literature, history, geography, and, of course, art, among other fields. Incomplete or incorrect titles and lacking diacritical marks are given as they appear in the Bangs, Merwin catalogue.

Entries are organized alphabetically according to the first letter as they appear in the catalogue, followed by lot numbers for the auction in parentheses. The catalogue also includes over one hundred mixed lots of prints, which have been omitted from this listing because so few are identified except by title.

Adams. Roman Antiquities. N.Y., 1815. (367)

Miss Adams' Letters. (18)

Addison. Anecdotes, Memoirs, Allegories, Essays, and Poetical Fragments. London. (65)

Addison's Works, with Notes, by Richard Hurd. 6 vols. London. (74)

The Albion. Vols. 2, 3, 4, 10. 5 vols. (372)

Allom. Constantinople and the Scenery of the Seven Churches of Asia Minor. Illustrated. 2 vols. London. (204)

Allston. Lectures on Art; and Poems. N.Y., 1850. (243)

Alone. By Marion Harland. N.Y. (338)

American Art Union. 8 odd Nos. (208)

Ancient Coins and Medals. An Historical Sketch of the Origin and Progress of Coining Money in Greece and her Colonies . . . By Henry Noel Humphreys. Illustrated. London, 1850. (222)

Anecdotes of the Life of Lord Chatham. 4 vols. London, 1792. (103)

The Anniversary. London, 1829. (364)

Arabian Nights. 2 vols. N.Y., 1848. (251)

The Art of Painting Restored. From the German of Libertat Hundertpfund. Illustrated with Colored Plates. London. (236)

Atlas pittoresque du Rhin. (390)

The Attache. (20)

Bailey. English Dictionary. 2 vols. London, 1726. (94)

Bailey. Festus. Boston, 1848. (312)

Balzac. Le Lys dans la Vallee. Eugenie Grandet. 2 vols. Paris. (143)

Balzac. La Peau de Chagrin. Paris. (129)

Bancroft. History of the United States. 7 vols. (82)

Bancroft. Miscellanies. N.Y., 1855. (250)

Beattie. Life of Thomas Campbell. 3 vols. London. (62)

Beattie. Scotland Illustrated. 2 vols. London, 1843. (203)

Beauties of the Bosphorus. By Miss Pardoe. From Drawings by William H. Bartlett. London, 1848. (205)

Bell on the Hand. London, 1852. (308)

Belles-Lettres. N.Y. Literary Journal. 4 vols. N.Y., 1820. (377)

Ben Jonson. Dramatic Works. London. (164)

Beranger. Oeuvres Completes. 2 vols. Paris. (137)

Bertini. Piano-Forte Method. (116)

Beaumont and Fletcher. Moxen's edition. 2 vols. London. (162)

Biographica Dramatica, by Baker, Reed and Jones. 2 vols. London. (93)

Biographical Anecdotes of Wm. Hogarth, with Catalogue of his Works. Nichols' Edition. London, 1782. (257)

Blackwood's Magazine. 7 Nos. (397)

Blunt. Bodies of the Heavens. Colored plates. (34)

Bolton. History of Westchester. 2 vols. N.Y. (113)

Bonomi. Nineveh and its Palaces. Illustrated. London. (224)

Borrow. Lavengro. (27)

Brewster. Optics. (32)

Bridgewater Treatises. 5 vols. Bohn. (301)
 Kirby on Animals. 2 vols.
 Chalmers on Man.
 Whewell's Astronomy.
 Kidd on Man.

Brodie. Mind and Matter. N.Y., 1857. (306)

Buckingham. Memoirs of Mary Stuart. 2 vols. London, 1844. (263)

Bulletin of the American Art Union. 1851. (207)

Bulwer. My Novels, &c. 8 vols. Tachnitz. (325)

Bulwer. New Timon. (11)

Bulwer. Rienzi, &c. 9 vols. (386)

Burton. Anatomy of Melancholy. Philadelphia. (59).

Business Man's Law Library. (14)

Butler. Hudibras, with Notes. By Gray. Hogarth's illustrations. 2 vols. London. (57)

Butler. Two Millions. (327)

Byron. Childe Harold. London. (382)

Byron. Works. Edited by Moore. Murray's edition. 17 vols. (284)

Carlyle. Critical and Miscellaneous Essays. 4 vols. London. (66)

Carlyle. French Revolution. 3 vols. London. (69)

Carlyle. Goethe's Wilhelm Meister. 2 vols. Boston, 1851. (290)

Carlyle. Latter Day Pamphlets. London. (68)

Carlyle. Past and Present. London. (67)

Catalogue of New York Society Library, 1850. (326)

Catlin. North American Indian Portfolio. Hunting Scenes and Amusements of the Rocky Mountains and Prairies of America. 48 plates. (180)

Catlin. North American Indians. Manners, Customs and Conditions. 360 engravings. 2 vols. London. (194)

Chambers. Pictures of Scotland. (124)

Chaucer. Poetical Works. Moxon's edition. London. (159)

China Illustrated. From Sketches by Thomas Allom. 4 vols. London. (196)

Claude. Liber Veritatis. A Collection of Prints after the Original Designs of Claude Le Lorraine . . . 3 vols. (178)

Coleridge. Poems. Moxon's edition. 2 vols. London, 1851. (276)

Coleridge. Essays and Marginalia. 2 vols. London, 1851. (277)

A Collection of Fac-Similes of scarce and curious Prints by the Early Masters of Italian, German and Flemish Schools . . . 100 Plates. Mounted. London, 1828. (185)

Collier. Notes and Emendations. London, 1853. (228)

Conybeare and Howson. Life and Epistles of St Paul. 2 vols. London, 1854. (211)

Cooper. The Headsman. (357)

Costello. Memoirs of Eminent Englishwomen. 4 vols. London. (154)

The Country Gentleman. Vols. 1 & 2. Albany, 1853. (373)

———. lot of Nos. (398)

Course of Empire, Voyage of Life, and other Pictures, by Thomas Cole. N.Y., 1853. (242)

Courtney. Treatise on Mechanics. N.Y. (369)

The Crayon. 1855 to July 1861. 5 1/2 vols. in Nos. (322)

The Cultivator. Vol. 5. (334)

Cummings. Historical Annals of the National Academy of Design. Philadelphia, 1865. (328)

Currer Bell. Villette and Shirley. 2 vols. N.Y., 1857. (317)

Curzon. Monasteries of the Levant. N.Y. (232)

Dana. Seaman's Friend. (350)

Daniels. Oriental Annual, 1834. (337)

Debates of Lincoln and Douglas. (354)

DeFoe. Notes and Miscellaneous Works. 20 vols. Oxford, 1840. (288)

Delafield. Art of War in Europe. (376)

DeQuincey. Works. 20 vols. Boston. (289)

Dickens. Dombey & Son. 2 vols. (2)

Dictionaries, 8 pocket. Italian, French, &c. (385)

The Discourses of Sir Joshua Reynolds. Illustrated with Notes and Plates by John Burnet. 12 Plates. London, 1842. (187)

D'Israeli. Curiosities of Literature. Edited by R. W. Griswold. (83)

Dr. Gully on Water Cure. N.Y. (335)

Dramatic Works of Wycherly, Congreve, Van Brugh, and Farquhar. Moxon's edition. London. (161)

Dryden. Miscellaneous Works. 4 vols. London, 1817. (214)

Dufief. Nature Displayed. 2 vols. Philadelphia, 1837. (370)

Duncan. Caesar and Sallust. Philadelphia. (121)

Dunlap. History of the Arts of Design. 12 vols. N.Y. (100)

Duyckinck. Cyclopaedia of American Literature. 2 vols. N.Y. (89)

Eckerman. Conversations with Goethe. By S. M. Fuller. Boston, 1852. (292)

Mrs. Ellet. Women of the Revolution. 2 vols. N.Y., 1849. (313)

Ellis. Specimens of Early English Metrical Romances. London, 1848. (256)

Emory. California. Maps. Washington. (104)

The English Annual, 1835. (336)

Esmond. Thackeray. 2 vols. Leipsic, 1852. (265)

Eustace. Classical Tour through Italy. 2 vols. Paris, 1837. (310)

Fairfax. Tasso. 2 vols. N.Y., 1845. (281)

Feltham Resolves. (366)

Fielding on the Theory and Practice of Painting in Oil and Water Colors for Landscape and Portraits. Illustrated. London, 1846. (226)

Fleming and Gibbin's French and English Dictionary. 2 vols. Paris, 1844. (213)

Following the Drum. (15)

Francis, John W. New York during the Last Half Century. A Discourse in Commemoration of the Fifty-third Anniversary of the New-York Historical Society. . . . N.Y., 1857. (179)

Frost. Pictorial History of the World. 3 vols. Philadelphia. (118)

Galerie du Palais Pitti. Gravee sur cuivre par les Meilleurs Artistes Italiens . . . par Louis Bardi. Calcographe royal. Upwards of 500 plates. Florence, 1842. (179)

Gaskell. Life of Charlotte Bronte. 2 vols. N.Y., 1857. (318)

Gems of European Art. 4 Nos. 12 Fine Steel Plates. (321)

Gibbs. Administrations of Washington and Adams. 2 vols. N.Y., 1846. (112)

Gil Blas in French. Illustrated. Paris. (127)

Goethe. Faust. Lowell, 1846. (219)

Goldsmith. Poems and Essays. N.Y. (345)

Guide Books, Maps &c. 42 vols. (388)

Gummere. Astronomy. (35)

Gurowski. Russia as it Is. (3)

Guy Livingstone. (60)

Hallam. Literature of Europe. N.Y. (87)

————. Middle Ages. N.Y. (88)

Hand-Book of Oil Painting. N.Y., 1848. (237)

Harper. Family Library. 14 vols. (343)

Hawks. Egypt and its Monuments. London. (150)

Haydon. Autobiography. 3 vols. London, 1853. (234)

Hazlitt. Lectures on English Comic Writers. (46)

Hazlitt. Miscellanies. 5 vols. Philadelphia. (50)

Headley's Life of Cromwell. (7)

————. Life of Washington. Vol. 1. (8)

Hedge. Prose Writings of Germany. (91)

Herbert. Works. London, 1853. (218)

Herculanaeum et Pompeii. Recueil General des Peintures, Bronzes, Mosaiques &c . . . Grave au trait sur cuivre par H. Roux Aine. Texte Explicatif par M. L. Barre. 8 vols. Paris, 1840. (126)

Highways and Byways. 2 vols. Boston. (362)

Les Hindous. Par F. Baltazard Solvyns. Tome premier. 72 Colored Plates. Paris, 1808. (183)

Histoire des Antiquities de la Ville de Nismes. Illustrated par J. F. A. Perrot. Nismes. (145)

History of Art by its Monuments, from its Decline in the Fourth Century to its Restoration in the Sixteenth. Vol. 1, Architecture, 78 plates. London, 1847. (182)

History of English Poetry. Thomas Warton. 2 vols. London, 1840. (267)

Hitchcock. Geology. (28)

Holbein. Portraits of Illustrious Personages in the Court Henry VIII. (175)

Holy Bible. Rubricated. London, 1671. (221)

Homer. Iliad. 2 vols.. (356)

Hoole. Orlando Furioso. Illustrated. 5 vols. London. (63)

The Horticulturalist. Vols. 1, 2, 3. (102)

Howitt. Homes and Haunts. 2 vols. N.Y. (43)

Huc. Tartary. 2 vols. Illustrated. London. (42)

Hudson. Doctrine of a Future Life. (330)

Victor Hugo. Notre Dame. 3 vols. Paris. (140)

Humboldt. Vols. I, II, III, and IV. Bohn. (303)

Humphrey and Jones. Illustrated Books of the Middle Ages. (174)

Hunt. Merchant's Magazine. 32 Nos. (395)

Iconographia Scotia: or, Portraits of Illustrious Persons of Scotland. . . . London. (180)

D'Illustration. French Pictorial. 14 vols. (120)

Ireland. Shakespeare Papers. (173)

Irving. Conquest of Florida. (348)

Irving's Works. 17 vols. (55)

James Montjoy. I've been Thinking. (13)

Mrs. Jameson. Legends of the Madonna as represented in the Fine Arts. Illustrated. London, 1852. (247)

Mrs. Jameson. Legends of the Monastic Orders. London, 1852. (248)

Mrs. Jameson. The Poetry of Sacred and Legendary Art. Illustrated. 2 vols. London, 1848. (249)

Jarves. Art Hints: Architecture, Sculpture and Painting. N.Y., 1855. (244)

Kane's First Expedition. N.Y. (85)

———. Second Expedition. 2 vols. Philadelphia. (86)

Karr. Sous les Tilleus. Paris. (147)

Knickerbocker Magazine. 42 nos. (396)

Knight. Half Hours with the Best Authors. London. (304)

Knight. Old England. A Pictorial Museum of Regal, Ecclesiastical, Baronial, Municipal and Popular Antiquities. 2 vols. London, 1844. (188)

———. Pictorial Gallery of Art. 2 vols. (189)

Knight. Pictorial History of England. 4 vols. N.Y. (76)

Knight. Pictorial Shakespeare. 8 vols. London. (165)

Paul de Kock. Novels in French. 17 vols. (323)

Kugler. Hand-Book of Painting in Italy. Edited By Sir Charles Eastlake. 2 vols. London, 1851. (233)

Lady Alice. (17)

Lady Blessington. Journal, Correspondence and Conversations. Cincinnati, 1851. (287)

Lamartine. Histoire des Girondins. 2 vols. Paris. (128)

Lanzi. History of Painting in Italy. By Thomas Roscoe. 6 vols. London, 1828. (231)

Layard. Nineveh. 2 vols. N.Y. (108)

Leberotti Impromte. A series of 362 Plaster Medallions of Distinguished Personages, Curiosities, Antiquities and Statuary. In nine cases. (114)

Lectures to Young Ladies. (351)

Mrs. Lee. Kreuitzner. N.Y. (346)

Lempriere. Biographical Dictionary. (97)

Leslie. Memoirs of the Life of John Constable. London, 1845. (245)

Letters of Horace Walpole. 6 vols. London. (152)

Lettres de Madame de Sevigne. Paris. (146)

Lewis. Chess for Beginners. (342)

Lewis. Life and Works of Goethe. 2 vols. Boston, 1856. (291)

Lewis. Sketches of Constantinople made during a residence in 1835, '36. 28 plates. (171)

Liber Fluviorum: The Rivers of France. 61 Line Engravings from Drawings by J. W. M. Turner. London, 1858. (201)

Life and Letters of Irving. Vols. 1 and 2. (56)

Life and Remains of Theodore Edward Hook. 2 vols. London, 1849. (252)

Life and Works of Robert Burns. Edited by the Ettrick Shepherd and William Motherwell. 5 vols. Edinburgh, 1852. (270)

Life and Works of William Cowper. By Robert Southey. 15 vols. London, 1835. (283)

Life, Letters, and Literary Remains of John Keats. By R. M. Milnes. 2 vols. London, 1848. (274)

Life of Dr. Band. N.Y., 1822. (349)

Life of Mrs. Siddons. Thomas Campbell. 2 vols. London, 1834. (261)

Lilly, Geo. The Works of. 2 vols. London, 1775. (216)

Literary Works of Sir Joshua Reynolds. 2 vols. London, 1852. (239)

Lives and Works of Michael Angelo and Raphael. London, 1856. (241)

Livingstone. South Africa. N.Y. (92)

Locke. Epitome of English Literature. (33)

Lodge. Portraits of Illustrious Personages of Great Britain, 8 vols. London. (36)

London Art Journal. 1848–52. 5 vols. (191)

———. The same. In Nos. for 1853, '54, '55, '56 and '58. 1857 and 1859 9 Nos. incomplete. (192)

London Art Union Prize Annual for 1845. 250 plates. (170)

London Exhibition Catalogue. 1851. (193)

Longfellow. Courtship of Miles Standish. (298)

———. Kavanagh. (299)

Lord. Geography. N.Y., 1855. (329)

Lorenzo Benoni. (21)

The Lorgnette. Vol. 2. (122)

Lossing. Pictorial Field Book of the Revolution. First edition. 2 vols. N.Y., 1851. (95)

Lot of Magazines, &c. 40 Nos. (394)

Loudon. Encyclopaedia of Cottage, Farm and Villa Architecture. London, 1839. (101)

Loyola and Jesuitism. (12)

Lynch. Expedition to Dead Sea. London. (225)

McCrie. Life of John Knox. 2 vols. Edinburgh, 1818. (262)

Macaulay. England. 4 vols. London. (156)

Macaulay. Essays. 5 vols. Philadelphia. (49)

Machiavel. Florentine History. London, 1674. (217)

Madden. Life and Literary Correspondence of the Countess of Blessington. 2 vols. N.Y. (315)

Mansfield. Mexican War. (19)

Margaret Maitland. N.Y. (365)

Massinger and Ford. Moxon's edition. London. (163)

Matthew. Bible and Men of Learning. (333)

Matthew Prior. Poems. 2 vols. Pickering, 1855. (286)

Maury. Geography of the Sea. New York. (58)

Maxwell. Czar, his Court and People. (25)

Memoires de Grammont. Paris. (148)

Memoires D'Outre-Tombe de Chateaubriand. 12 vols. Paris. (132)

Memoirs of Empress Josephine. 4 vols. Philadelphia. (135)

Memoirs of Margaret Fuller Ossoli. 2 vols. Boston, 1852. (316)

Memoirs of the History of France during the Reign of Napoleon. 7 vols. (136)

Memoirs of the Life of Wm. Collins. By his son, Wilkie Collins. 2 vols. London, 1848. (236)

Memoirs of William Wordsworth. 2 vols. Boston, 1851. (269)

Merick. Ancient Armour as it Existed in Europe . . . Illustrated. Second edition. 3 vols. London, 1842. (177)

Method of Vocal Music in French. (383)

Milman. Life of Tasso. 2 vols. London, 1851. (280)

Miscellaneous and School Books. 60 vols. (387)

Mitchell. Planetary and Stellar World. (1)

Moore. Lalla Rookh. London, 1824. (344)

Moore. Life of Sheridan. 2 vols. London, 1827. (268)

Thomas Moore. Memoirs, Journal and Correspondence, by Lord Russell. 8 vols. (64).

Moore. Poetical Works. 10 vols. N.Y., 1853. (273)

Morse. Universal Gazetteer. N.H., 1823. (355)

Moss Side, by Marion Harland. (6)

Motley. Dutch Republic. 3 vols. N.Y. (81)

Motley, J. L. History of the United Netherlands. 2 vols. N.Y. (119)

Murray. Hand-Book for the Continent and the East. 2 vols. (123)

Murray. Hand-Book of the History Painting in Italy. By Dr. F. Kugler. London, 1842. (309)

Musee Royal, ou Recueil de Gravures d'apres les Plus Beaux Tableaux Statues et Bas Reliefs, de la Collection Royale . . . 2 vols. Paris, 1816. (181)

Musical Bijou. Illustrated. (117)

The National Gallery of pictures by Great Masters. 2 vols. London. (209)

Neal. Residence in Siam. Illustrated. London. (40)

New York Mirror. Vols. 9, 11, 12, 14. 4 vols. (371)

Nile Notes of a Howadji. (23)

Nineveh and Babylon. London. (109)

Nodier, C. Oeuvres de. Paris. (141)

Northcote. Life of Titian. With Anecdotes of the distinguished Persons of his Times. 2 vols. London, 1830. (235)

Nott and Gliddon. Types of Mankind. Philadelphia. (84)

Oersted. Soul in Nature. Bohn. (302)

Oeuvres Completes de Chateaubriand. 5 vols. Paris. (131)

Oeuvres de Mesdames de la Fayette. 2 vols. Paris. (139)

Oeuvres de Racine. 6 vols. Paris. (133)

Old New York, by Dr. Francis. (24)

Old Wine in New Bottles. (26)

Oliver Twist. (378)

Oriental Album. Characters, Costumes and Modes of Life in the Valley of the Nile . . . 30 colored plates mounted on Bristol Board. (169)

Origin and History of British Constitution. London. (341)

Paley. Evidences. Philadelphia. (361)

Paper Novels. 16 vols. (391)

Paper Novels. 10 vols. (399)

Paradise Lost. 2 vols. N.Y., 1831. (363)

Pardoe. Louis XIV. and Court of France. 2 vols. (37)

Parker. Signal Book. Boston, 1841. (358)

Paxton. Human Anatomy. Illustrated. 2 vols. (105)

Peintres Primitifs. Collection de Tableaux Rapportie d'Italie. Paris, 1843. (197)

Perry. Expedition to Japan. Illustrated. (90)

Peter Pindar's Works. 5 vols. London. (70)

Peter Schlemihl in America. (10)

Petite Miseres de la Vie Humaine par Old Nick et Grandville. Illustrated. Paris. (134)

Piano Forte Music. 5 vols. (115)

Pictures of the French. A Series of Literary and Graphic Delineations of French Character. Illustrated with upwards of 200 Engravings. London. (107)

Plays. 15 vols. (392)

Poems by William Cullen Bryant. N.Y., 1855. (266)

Poetical Works of Thomas Gray. Pickering, 1851. (285)

Pompeii. Boston, 1833. (347)

Pope. Works. By Warburton. 6 vols. London, 1788. (215)

Practical Tourist. 2 vols. Boston, 1822. (379)

Pratt on the Sublime and Beautiful in Scripture. London, 1783. (339)

Prescott. Ferdinand and Isabella. 3 vols. N.Y. (77)

————. Miscellanies. (79)

————. Peru. 2 vols. N.Y. (78)

The Princess of Virna. N.Y., 1857. (319)

Print Collector. An Introduction to the Knowledge Necessary to forming a collection of Ancient Prints &c. London, 1844. (244)

Prior. Life of Edmund Burke. London, 1854. (255)

Raccolta dei monumenti piu interessanti de RL. Museo Borbonico e di varie Collezioni private. 160 Plates. Napoli, 1842. (200)

Ranke. History of the Popes. Vols. 1 and 2. London, 1853. (253)

Recollections of the Last Days of Shelley and Byron. By Trelawney. Boston, 1858. (300)

Redfield. Comparative Physiognomy. Illustrated. (110)

Report of the Committee appointed by the Philomathean Society of the University of Pennsylvania, to Translate the Inscription on the Rosetta Stone. 2nd edition. (223)

The Rhine, Italy and Greece, in a series of Drawings by Bartlett and others. 2 vols. in 1. (210)

Rhymings. By Howard Wainwright. N.Y., 1860. (259)

Richardson. English Dictionary. 2 vols. Philadelphia, 1846. (212)

Riker. Annals of Newtown. N.Y. (106)

Roscoe. Life of Benvenuto Cellini. London, 1847. (240)

Roscoe. Life of Lorenzo de Medici. London, 1857. (254)

Ruskin. Modern Painters. 5 vols. London. (166)

————. Seven Lamps of Architecture. London. (167)

————. Stones of Venice. 3 vols. London. (168)

Russell. Egypt and Palestine. 2 vols. (96)

St. Pierre. Works. 2 vols. London, 1846. (305)

Samuel Johnson's Works, by Arthur Murphy. London. (73)

G. Sand. Valentine. 2 vols. Leone Leoni. Andre. Paris. (142)

The Satirist. A Monthly Mentor. 6 vols. London. (75)

Scenes in Scotland and North Wales. 2 vols. Illustrated. London. (389)

Scott. Miscellaneous Essays. 3 vols. Philadelphia. (47)

Scott. Poetical Works &c. 7 vols. (393)

Scott. Translation of Martial's Epigrams, with Mottoes from Horace, &c. London, 1783. (220)

Scott. Waverly Novels. Parker's edition. 27 vols. Boston, 1845. (264)

A Select Collection of Landscapes from the best Old Masters. Engraved by L. Zeutner. 55 Plates. London, 1791. (184)

Selections from the Vienna Gallery. 252 Engravings. Mounted. (202)

Shakespeare and his Friends. N.Y., 1848. (229)

Shakespearean Society Publications. 18 vols. (227)

 Dramatic Works of Thomas Heywood. 2 vols.

 Early Prose and Poetical Tracts. 2 vols.

 Early Treatises on the Stage.

 Extracts from the Registers of the Stationers' Company.

 Fairy Mythology of Shakespeare.

 Henalowe and Alleyn. By Collier. 2 vols.

 Karl Simrock.

 Life of Inigo Jones.

 Original Actors of the Plays of Shakespeare.

 Papers of the Shakespearean Society.

Rebels at Court.

 Supplement to Dodsley's Old Plays. By Dyee. 4 vols.

The Sheet Anchor. N.Y., 1843. (374)

Shelley. Poetical Works. Moxon's edition. 3 vols. London, 1851. (278)

Shelley. Essays and Letters. 2 vols. London, 1851. (279)

Shepard. Mineralogy. 2 vols. (30)

————. (31)

Sigourney. Sketches. N.Y. (368)

Sir Roland Ashton. (9)

Smart. Horace. Oxford. (340)

Smith. American Historical and Literary Curiosities. Fac-similes of Original Documents relating to the Revolution. (190)

Souvestre. Scenes. Paris, 1857. (324)

Sparks. Life and Writings of Washington. 12 vols. N.Y. (80)

Spaulding. Historical Relics of the White Mountains. Boston, 1855. (311)

Spencer. Poetical Works. Moxon's edition. London. (160)

Sporting Scenes, by Frank Forrester. 2 vols. (29)

Stark. Travels in Italy. Paris. (125)

Stephens. Essays. Philadelphia. (51)

Mrs. Stone. Chronicles of Fashion; English Society from the Time of Queen Elizabeth to Present Day. 2 vols. London, 1846. (153)

Story. Exposition of the Constitution of the United States. N.Y., 1864. (332)

Stothard. Monumental Effigies of Great Britain . . . Upwards of 140 plates. London, 1817. (176)

Strutt. Sylvia Brittanica; or, Portraits of Forest Trees, distinguished for their Antiquity, Magnitude, and Beauty. Drawn from Nature, and etched by Jacob George Strutt. (172)

Swift's Works, with Notes and Life by Walter Scott. 10 vols. Edinburgh. (72)

Sydney Smith. Wit and Wisdom. With Memoir and Notes, by E. A. Duyckinck. N.Y, 1850. (258)

Sydney Smith's Works. 3 vols. Philadelphia. (53)

Talfourd. Essays. Philadelphia. (52)

Telemaque. Paris. (130)

Tennyson. Enoch Arden. Boston, 1864. (297)

————. In Memoriam. Boston, 1855. (294)

————. Maud. Boston. (295)

————. Poems. 2 vols. Boston. (296)

Thackeray. Vanity Fair. (99)

Thackeray. Men's Wives; Powell's Maiden and Married Life. 2 vols. N.Y. (320)

There and Back again in Search of Beauty. 2 vols. London. (39)

Thiers. Consulate and Empire, &c. 12 vols. In French. (384)

Thiers. Histoire de la Revolution Française. Illustrated. 10 vols. Paris. (149)

Tomkins's Poems. Oxford, 1800. (360)

The Tour of Dr. Syntax, in search of the Picturesque. Illustrated by Crowquill. London, 1844. (314)

Mrs. Trollope. Paris and Parisians. N.Y., 1836. (352)

Trumps. A Novel. By Curtis. (45)

Turner. Harbours of England. Engraved by Thomas Lupton, with text by Ruskin. 12 Plates. London, 1856. (186)

Turner and his Works. London, 1852. (198)

————. Antiquarian and Descriptive Tour round the Southern Coast of England. Illustrated with 84 Plates from Drawings by Turner, Collins, Prout, Westall and others. London, 1849. (199)

Twelfth Night at the Century Club, January 6, 1858. N.Y. (98)

Tyrone Power. Impressions of America. London, 1836. (353)

Undine and Sintram. N.Y., 1848. (293)

Vale of Cedars. (16).

Valentine. History of New York. (111)

Vestiges of Creation. (4)

————. Sequel. (5)

Virgil. Delphini. Philadelphia, 1822. (359)

Voltaire. Contes et Satires, Le Henriade. Romans. 3 vols. Paris. (144)

Voyages en Italie par Valery. Paris. (138)

Walker and Boyen's Dictionary. 2 vols.. (375)

Wallis. Glimpses in Spain. N.Y. (380)

Walpole. Anecdotes of Painting. Illustrated. 3 vols. London. (157)

The War. By Russell, Times Correspondent. 2 vols. London, 1856. (307)

Washburton. Crescent and Cross. (22)

Wilkinson. Manners and Customs of the Ancient Egyptians. Murray's edition. 5 vols. London. (151)

Willett's Narrative. . . . N.Y., 1831. (181)

Williams. Middle Kingdom. 2 vols. N.Y. (41)

Willis's Poems. N.Y., 1831. (381)

Wilson. Essays. 3 vols. Philadelphia. (48)

Wilson. Noctes Ambrosianae. 4 vols. Philadelphia. (54)

Women in France During the 18th Century. 2 vols. London. (44)

Woodbury. Plain Words to Young Men. (331)

Wordsworth. Greece, Pictorial, Descriptive and Historical. 350 Engravings on wood; 28 on steel. London, 1844. (195)

William Wordsworth. Poetical Works. 7 vols. Boston, 1854. (275)

Works of Allan Ramsay. 3 vols. Edinburgh, 1852. (271)

Works of Charles Lamb. Moxon's edition. 4 vols. (282)

Works of Henry Fielding, by Arthur Murphy. 10 vols. London. (71)

Works of John Milton. With Life of the author by John Mitford. Pickering's edition. Uncut. London, 1851. (230)

Works of Lawrence Sterne. Philadelphia. (61)

Works of Robert Ferguson. Edinburgh, 1851. (272)

Works of Samuel Richardson. 19 vols. London. Best edition. (38)

The Works of Sir Joshua Reynolds. Edited by Edmund Malone. 8 vols. London. (158)

Works of Thomas Gray: Poems, Correspondence &c. Memoir by W. Mason. 2 vols. London, 1807. (260)

The Works of William Hogarth. In a series of 150 Steel Engravings. 2 vols. London. (206)

Wright. England under the House of Hanover. 2 vols. London. (155)

CHRONOLOGY

1819 Born March 27, 1819, in New York City to John and Jane Mesier Suydam.

Late 1830s–1840s Attends the University of the City of New York. First studied medicine, then architecture.

1841 Death of his father, John Suydam.

1842–45 Travels in Europe; begins instruction in art with Miner K. Kellogg.

ca. 1845–54 Business partnership in dry goods with his brother John.

1849 Elected to membership in the Century Association.

Early to mid-1850s Suydam begins seriously to take up oil painting. Commences study at least informally with Asher B. Durand and John F. Kensett, who becomes an especially close friend.

1856 *Spring.* Debut at the National Academy of Design Annual Exhibition: *From North Conway*, cat. no. 152.

 August to October 1856. Visits North Conway and environs, New Hampshire.

1857 *February 6.* First recorded participation in the Sketch Club.

 October 1857 to March 1858. Exhibition of French Paintings, Goupil & Co, American Art-Union, where Suydam is an active buyer.

1858 Elected Honorary Member of the National Academy at annual meeting.

 Joins the Baltimore & Ohio Railroad's "Excursion for Artists."

 Summer. Works at Ramapo, in Rockland County, New York, and at Narragansett, Rhode Island, with Kensett.

 Autumn. Begins renting a studio in the Tenth Street Studio Building.

1859 *Summer.* Sketches in upstate New York, then along the coast of Massachusetts. For most of the season is with Kensett in the valley of Ramapo and in Narragansett, Rhode Island.

 Early July. Durand, Hotchkiss, and Suydam visit Geneseo in the New York Finger Lakes region. While there, they visit Mount Morris.

1860 *January 11.* Attends Louis Rémy Mignot's wedding in Baltimore with Kensett.

 October/November. Three-week sojourn with Kensett and Hubbard at Lake George, New York.

1863 Made Treasurer of the National Academy of Design's newly inaugurated Fellowship Fund.

1864 *April 16.* Death of his mother, Jane Mesier Suydam.

1865 *Summer.* Visits Newport, Rhode Island and Nahant, Massachusetts.

 September 15. Dies at North Conway, New Hampshire.

 October 14. Notice of Suydam's bequest of $50,000 and his art collection to the National Academy of Design.

1866 Suydam Collection shown at the Academy's Annual Exhibition hung together under a funeral canopy of black crepe.

Selected Bibliography

ARCHIVAL SOURCES

Catalogue of a Choice Private Library being the Collection of the Late Mr. James A. Suydam. To be sold at auction on Nov. 22 and 23, 1865. New York: Bangs, Merwin & Co., 1865.

Sanford Gifford, Manuscript Memoir of James A. Suydam, 1865. National Academy Museum Archive.

Daniel Huntington, Manuscript Memoir of James A. Suydam, ca. 1865. National Academy Museum Archive.

Fellowship Fund Records, National Academy Museum Archive.

Miner K. Kellogg, Letter to Daniel Huntington. Baltimore, 1 May 1866. National Academy Museum Archive.

John F. Kensett Correspondence, Edwin D. Morgan Collection, New York State Library at Albany. Copies, Archives of American Art, Smithsonian Institution, Washington, DC.

John F. Kensett Papers. Archives of American Art, Smithsonian Institution, Washington, DC.

BOOKS AND ARTICLES

Baur, John I. H. "American Luminism." *Perspectives U.S.A.*, no. 9 (Autumn 1954): 90–98.

———. "A Tonal Realist: James Suydam." *Art Quarterly* (Summer 1950): 221–27.

Blaugrund, Annette. *The Tenth Street Studio Building: Artist-Entrepreneurs from the Hudson River School to the American Impressionists.* Exh. cat. Southampton, NY: The Parrish Art Museum, 1997.

Clement, Clara Erskine, and Laurence Hutton. *Artists of the Nineteenth Century and their Works.* First ed., 1879. Reprint ed., St. Louis: North Point, Inc., 1969.

Cummings, Thomas Seir. *Historic Annals of the National Academy of Design, New-York Drawing Association, Etc., with Occasional Dottings by the Way-Side, from 1825 to the Present Time.* Philadelphia: George W. Childs, 1865.

Dearinger, David B., ed. *Paintings and Sculpture in the Collection of the National Academy of Design. Volume 1, 1826–1925.* New York and Manchester, VT: Hudson Hills Press, 2004.

Driscoll, John Paul, and John K. Howat, *John Frederick Kensett: An American Master.* Exh. cat. Worcester, MA: Worcester Art Museum, 1985.

Howat, John. *American Paradise: The World of the Hudson River School.* Exh. cat. New York: The Metropolitan Museum of Art, 1987.

Menand, Louis. *The Metaphysical Club: A Story of Ideas in America.* New York: Farrar, Straus and Giroux, 2001.

Miller, Angela. *The Empire of the Eye: Landscape Representation and American Cultural Politics, 1825–1875.* Ithaca, NY: Cornell University Press, 1993.

Novak, Barbara. *American Painting of the Nineteenth Century: Realism, Idealism, and the American Experience.* New York: Praeger, 1969.

Novak, Barbara, and Annette Blaugrund, eds. *Next to Nature: Landscape Paintings from the National Academy of Design.* Exh. cat. New York: National Academy of Design and Harper and Row, 1980.

Tuckerman, Henry T. *Book of the Artists.* New York: G. P. Putnam, 1867.

Voorsanger, Catherine Hoover, and John K. Howat, eds. *Art and the Empire City: New York, 1825–1861.* Exh. cat. New York: The Metropolitan Museum of Art; New Haven, CT: Yale University Press, 2000.

Weiss, Ila. *Poetic Landscape: The Art and Experience of Sanford R. Gifford.* Newark, DE: University of Delaware Press, 1987.

Wilmerding, John. *American Light: The Luminist Movement, 1850–1875.* Exh. cat. Washington, DC: National Gallery of Art, 1980.

Wilton, Andrew, and Tim Barringer. *American Sublime: Landscape Painting in the United States, 1820–1880.* Exh. cat. Princeton, NJ: Princeton University Press, 2002.

Index

The following index lists artists (other than Suydam) mentioned in the text, excluding the appendices.

PHOTOGRAPHY CREDITS

Photographs were in most cases provided by the owners of the works and are published with their permission; their courtesy is gratefully acknowledged. Additional credits follow: Glenn Castellano: figs. 1.1, 1.4, 1.14, 2.1, 2.9, 2.10, 2.11, 2.12, 2.15, 2.16, 2.18, 3.1, 3.7, 3.21, 3.22, 4.2, 4.3, 4.4, 4.5, 4.6, 4.7, 4.8, 4.9, 4.10, 4.12, 4.13, 4.15, 4.17, 4.18, 4.19, 4.23, 5.2, 5.3, 5.9, 1860.5, 1860.12, 1864.4, ND.2, ND.9, ND.19, ND.21, ND.22, ND.25, ND.26, and all color images in Appendix 2; Geoffrey Clements: fig. 1.6, ND.11; Christopher Gamboni: fig. 5.5, 1862.8; Patrick Goley: fig. 5.1, 1860.1; Thomas Palmer: fig. 3.11; Michael Tropea: fig. 1.5, 1857.1; Graydon Wood: fig. 3.14.